Product Design, Technology, and Social Change

Product Design, Technology, and Social Change

A Short Cultural History

Laura S. Scherling

intellect

Bristol, UK / Chicago, USA

First published in the UK in 2024 by
Intellect, The Mill, Parnall Road, Fishponds, Bristol, BS16 3JG, UK

First published in the USA in 2024 by
Intellect, The University of Chicago Press, 1427 E. 60th Street,
Chicago, IL 60637, USA

A catalogue record for this book is available from
the British Library.

Copy editor: MPS Limited
Cover designer: Tanya Montefusco
Cover image: An Egyptian pendant, The Metropolitan Museum of Art,
Anonymous Gift, 1923. This is a public domain image.
Production manager: Julie Willis (Westchester Publishing Services UK)
Typesetter: MPS Limited

Hardback ISBN 978-1-83595-022-7
Paperback ISBN 978-1-83595-023-4
ePDF ISBN 978-1-83595-025-8
ePUB ISBN 978-1-83595-024-1

To find out about all our publications, please visit our website.
There you can subscribe to our e-newsletter, browse or download our current
catalogue and buy any titles that are in print.

www.intellectbooks.com

This is a peer-reviewed publication.

Contents

Figures

Acknowledgements

This research was inspired by an expanding movement to decentre global history. It was also motivated by my personal experiences growing up in a multi-racial family. These events shaped my viewpoint as a designer and researcher. I would like to thank several people for supporting my interest in historical research, Dr. Shannon Mattern, Dr. Judith M. Burton, and Dr. Ami Kantawala. These influential women taught me a great deal about conducting historical research during my Master's studies at The New School and doctoral studies at Columbia University Teachers College. I would also like to thank my husband Dr. Laurence Wilse-Samson and my mother Susan Scherling for their critical feedback and editing. Finally, I would like to recognize the generosity of the photographers, archives, and museum collections from where the images in this book come from. The Metropolitan Museum of Art, Smithsonian National Museum of African American History and Culture, the New York Public Library, Library of Congress, the Wellcome Museum Collection, Jonathan Lin, Fast Retailing Co., Ltd., Marcin Wichary, Jochem Koole, The Fashion Revolution, Tomas Prochazk and Trashy Bags Africa, Holger Ellgaard, Tara Taylor, Michael Matkin, Mumtahina Rahman, the Imperial War Museum, Melissa Johnson, the Rwanda Green Fund, Kevin Eng, and Nicolás Pérez.

Preface

This is a 'pocket history' about product design, technology, and social change. It is a short history that critically examines product design from pre-industrial times to our current digital age. I consider major milestones in the production of goods and services while aiming to incorporate a more inclusive and plural view. Specifically, this book explores product design as part of an interconnected and interdisciplinary history that has shaped the societies and cultures in which we live. In order to examine these milestones, this book is divided into five parts and thirteen chapters, covering a wide breadth of product design history. It begins by providing an introduction to product design in the context of contemporary issues before examining the broader sweep of history and pre-industrial products, industrialization and mass production, and products in the context of an Information Age.

Products have long supported the integration and interpretation of emerging technologies into our lives. These objects include everything from tools, accessories, furniture, and clothing, to types of transportation, websites, and mobile apps. Products provide singular or multiple functions, are tangible and intangible, and in many instances have impacted the quality of our lives by saving time or money or by increasing feelings of personal satisfaction. At the same time, many products have also done harm by negatively impacting people and the environment. For nearly every product that makes it into the hands of a consumer, there is a designer who created it and/or someone who laboured to make it. Whether the social conditions that a person laboured within were fair or humane can depend on a number of factors like degree of autonomy, income, and location. The role of the product designer has been both essential and multi-disciplinary. Designs of every shape, size, and function have stretched the imagination and pushed the conception of what was once believed to be scientifically and visually possible. Where would we be today without these creators and makers who have worked tirelessly (and often anonymously) as product designers? What lives did they lead, and what skills and abilities did they have? What social injustices have been overlooked in order to create 'good' designs between designers, producers, and their consumers? With what feels like an infinite number of products circulating the world, it can be daunting to

know which to purchase or study. There is still much to be studied when it comes to product design culture and its history.

To date, there is limited cultural and historical research that takes into account broader economic and social conditions related to the design of products. This includes colonial studies' acknowledgement of designers of colour (Smith 2021; Tlostanova 2017, p. 60). It is acknowledged that 'western forms of knowledge' are often still pervasive in history which means that much important information is omitted from mainstream accounts (Sim 2021). These omissions include cultural knowledge that can vary according to different countries, ethnicities, ideas, and belief systems. While designers of products have not always gone by the professional title of 'Designer', they have also taken similar roles as craftspeople, artisans, and industrial designers. Their direct involvement in the creation, production, and manufacture of goods and services has occurred all over the world – from African guilds to the pre-Columbian 'telpochcalli' where Mexican artisans could specialize in a single craft.

The concept of 'decentering' is important to this book's main thesis, which seeks to include more diverse perspectives. 'Decentering' fundamentally means to break away or depart from a practical idea or assumption commonly held. Different accounts of product design history illustrate different viewpoints. Understanding our implicit biases in relation to product design, history can help us better understand why we might favour specific products, cultures, or design movements. Essentially, the idea is to retain important facts while integrating and broadening the scope to include diverse global perspectives. By doing so, we can uncover a wealth of new information. When we 'decentre' history, we also have the opportunity to move away from a 'hero syndrome'. This can be challenging to accomplish. The goal is not to specifically omit crucial parts of a historical account. Traditionally, product design 'credits' may only be given to a small group of people or even one particular person. In some cases, no credits are attributed at all. While well-known historical accounts may be accurate, they may not always be fully inclusive. There are limitations on the extent of what is covered and included in this short history, and a primary aim is to be independent of dominant narratives and more in touch and inclusive, global, and pluralistic views and events.

Social and cultural conditions are not always featured in traditional histories, but the intent here is to consider historical circumstances like movements in human rights, gender equality, globalization, and environmental sustainability as they relate to product design. The hope is to provide a short history of product design that appeals to a diverse set of readers to engage with product design in a meaningful way and to engage more deeply in the varied histories of the products we interact with on a daily basis.

Foreword

Don A. Norman, Ph.D.

The word 'product' is ambiguous because one could say any output from a designer is a product. We tend to think of a product as something physical, but actually, banks offer products like a savings plan. And so, a product is actually something one delivers to a people that will change their lives. They are useful in life, and they have value. That is one of the greatest benefits of design; designers create products that actually make a difference in people's lives. You really should not be trying to make the prettiest computer, cell phone, or device in the world. You should be doing something that really solves the problems that people have. It is the most important component of what designers do.

With design, we are trying to change people's behaviour for the good. But we have to realize that people are part of a complex system in the world and we all interact with each other, and the things that we make can have other kinds of implications. The product designer, no matter what kind of product they make, whether it is software or hardware or new ideas or new procedures, has to think about what are the *implications for society*, for humanity, and for the world? Does it destroy the ecosystem? Does it increase the inequities that exist in the world?

I had a really incredible range of students during the last part of 2021. A commonly asked question was where they could work to make a difference in the world. The problem is when you take a job and try to say 'no' to building a product because it is going to damage the ecosystem, you might get fired. To make a difference, you either have to select a company very carefully or wait to move up in the hierarchy. This demonstrates the importance of having more designers at high levels of decision-making. Even in the universities, the design department is not always well regarded. It is situated in the arts, and it is unknown what to do with it. If you list all the important departments, you might list art and design, but you almost never list design by itself. Why is that? Very seldom do you have a designer at the top level of a company, a chief design officer who is in the C-suite who actually meets with the people who are making the important decisions for a company.

One of the few companies that does this is the company Phillips, which is located in the Netherlands and has global offices. Nowadays, it is focused almost entirely

on health technologies. The design officer meets with the CEO regularly, and their job is not to make a design look 'pretty'. Their job is to figure out what the company ought to be doing, and how they should do it. But that is rare. Designers are not at the table saying what they think ought to be done. Designers are often told what the product is after it is already too late to make a difference. Why were designers not involved earlier? It is a rare company where that is possible. It also means we have to take into account business, economics, finance, the sales cycle, marketing, and sales. One also has to understand supply chains and understand where materials come from, and what happens when a product becomes obsolete.

Some of the very first 'designers' were in companies like Wedgwood in England. Some of the Wedgwood apprentices and craftspeople were painters. They did not have much input into what was being made and how the pottery was created. But they made a big difference. They took expensive dishware for the wealthy and remade it inexpensively for middle- and low-income people. It is the nature of capitalism.

What we do today often depends on what we have done in the past. Today we are doing things that destroy the environment. We are doing things that destroy people's lives. We are manufacturing products in factories that are really horrible. We go to other countries where the cost of labour is low, and people are not treated very well. We make products that basically force people into the western way of thinking and behaving. We do not always think of it that way, because highly educated people make these products. It is important to recognize the inequities that are being created and to recognize people with disabilities, indigenous people, and people from different classes.

It is not going to be easy to solve these problems. For example, the upsetting thing about climate change is that it is already happening, destroying crops, and people are dying. We have heat waves and we have floods, we have droughts, and we have hunger. People are going after the short-term, as opposed to the long-term benefit, because it is going to take 10–20 years to change the climate. That is the bad part. The good part is that people are now being forced to take it seriously.

Studying the history of the world is very important. Every country is different. Every culture is different. What you grow up with you might assume is normal and natural. A product designer might think they are building something new. The notion of 'new' is actually very much altered by what you have been doing with your life. It is difficult to not rely on previous thoughts or actions when it is necessary to do something in an unfamiliar way. When I take a look at the famous product designers normally studied in product design history, that is not what is important. What is important is how design evolved over the thousands of years before 'designers' existed.

PART 1

PRODUCT DESIGN IN SOCIETY:
AN INTRODUCTION

1

Product Design and Its Impact

Understanding Product Types

Our lives have been re-fashioned by the mobility of products. Through trade, culture sharing, and the exchange of knowledge and values, many products have become 'cross-cultural'. While products meet fundamental needs, they also incorporate our feelings and values, offer comfort, test, and validate technology change. Products reflect brands and lifestyles and are created through expertise from 'domains' of industrial and engineering design, ergonomics, user experience and psychology, digital design, visual design, and market research (Luchs & Swan, p. 327).

Products can be physical or digital goods and have different classifications. Convenience products, like food and staple items, are purchased without too much consideration in convenience stores like bodegas (see Figure 1.1) and are usually non-durable, meaning they can be consumed or have a shorter life span. Products that are purchased less frequently like clothing, electronics, cars, and other one-off purchases are durable products and also known as 'shopping goods'. Other product classifications include speciality or niche products, raw goods like unprocessed materials, and capital goods like tools, machinery, and factories. Digital transformation has brought a new dimension, introducing new digital product types. Digital goods like audio products, e-books, videos, photos, and graphics have been designed and developed in a relatively short time since the mid-twentieth century.

Today, many products have gained international recognition with an increasingly borderless familiarity. Brands and their product lines have widened in close proximity to globalization, internet use, and the rise of multinational corporations and global consumer culture. Oluwafemi Samuel Adelabu, Toshimasa Yamanaka, and Richie Moalosi (2013) described that 'design is a phenomenon that never exists in isolation but rather is interdependent on both global and local histories, cultures and politics' (p. 136). The rise of cross-cultural products has signified evolving consumer preferences, a way to signal social status, and has bolstered brand credibility (or lack thereof) to the masses (Dong & Yu 2020, p. 53).

The number of products in circulation is so vast that it is hard to grasp. Today, hundreds of millions of people use social media platforms like TikTok, Instagram,

FIGURE 1.1: A bodega, or convenience store, in New York City, 2018. Convenience products that can be quickly consumed are typically purchased at these corner stores. The word 'bodega' originates from the Spanish word for 'store' or 'cellar'.

and Telegram. It is estimated that '1.9 billion servings' of Coca-Cola products are consumed in 'more than 200 countries' daily, making it one of the most consumed beverages in the world (Coca-Cola 2024). The three-dimensional game *Minecraft*, released in 2011, has become one of the best-selling video games of all time. Known for its blocky aesthetic and open-ended gameplay, *Minecraft* has generated extensive global interest from the United Kingdom and the United States, to Iceland and Saudi Arabia.

Some products have become integral to daily life. 'Everyday' products can undergo a long process before they become accessible and adopted for regular use. For instance, household products like flatware, including items as ordinary as spoons and forks, became ubiquitous as electroplating processes lowered manufacturing costs. Owning a sterling silver serving implement, like a ladle or a cake knife, can be prohibitively expensive, and coating a utensil with metal made them significantly cheaper. Likewise, soap had a long history before its integration into daily hygiene routines. Long before our modern conception, early types of soap were developed

among the Egyptians, the Gauls, and other civilizations who advanced soap making as a type of artisan craft (Watt 1885, B). Impacted by rationing during World War I and II, detergent soap was invented as an alternative to animal fat soaps and soon became widely available. Still, many people lack access to basic hygiene products and household goods, pointing to the fact that products exist as a 'material dimension' that can impact the quality of a person's life (Cambir & Vasil 2015, p. 933).

Products also carry sentimental or 'emotional' qualities. Whether it is a team jersey, a stack of vinyl records, one's mobile phone, or a well-worn pair of sneakers, products can evoke feelings of loyalty, conjure up specific memories, and shape a person's preferences for particular functional and aesthetic attributes. Industrial designer Wolfgang Joensson (2020) illustrated that there are many personal and psychological aspects of owning a product and that products possess 'content to which we can emotionally respond' (p. 9). Joensson cited how the 'transportability' and shape of the Valentine typewriter, created by the Italian manufacturer The Olivetti Company in 1969, 'turned the mundane typewriter into a fun tool' (p. 170) (see Figure 1.2). In her historical research about typewriters, María Ramos Silva

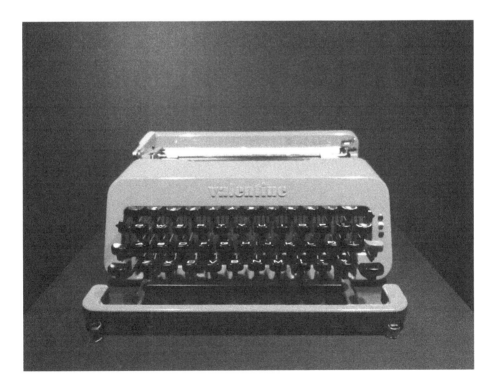

FIGURE 1.2: An Olivetti Valentine typewriter designed by Ettore Sottsass and Perry A. King, released in 1969 by The Olivetti Company.

(2015) called the Valentine model a 'design icon' and noted that 'the advertising of this machine brought pop art into the typewriter industry' (p. 18). Eating a certain type of food that you enjoy and eating with others is also an emotional act and brings out the social qualities of food products. Researchers Sheere Ng and Justin Zhuang (2016) pointed out that 'design turns food into every meal' with the dining table serving as a place where meals 'play out'. Ng and Zhuang (2016) elaborated on this point by depicting the Singaporean kopitiams. They described, 'In Singapore's coffee shops, better known as *kopitiams*, round tables with accompanying portable polypropylene chairs are favored by proprietors because of the flexibility it offers. They maximize seating capacity and also inadvertently encourage strangers to dine with one another'.

Just as the warmth of a Singaporean kopitiam or the playfulness of Olivetti Valentine might evoke feelings like delight, other products can provide a sense of comfort or convenience (see Figure 1.3). A staple like a breakfast bakery product can support morning routines and participation in 'regular family meals' (Pirani, Harman, & Cappellini 2022, p. 215). Some products are purchased impulsively. Products that are spontaneously purchased at times come from your local 'convenience shop', which appear almost universally on street corners, at petrol stations and

FIGURE 1.3: Hill Street Kopitiam in Singapore, 2006. Kopitiams often consist of round tables and 'portable polypropylene chairs' favoured by proprietors (Ng & Zhuang, 2016).

train stations, and even informally out of people's homes. Assortments of everyday products are sold in 7-Elevens (across seventeen countries), New York City bodegas, and South African spazas or 'tuck' shops (see Figure 1.4). Inside convenience stores the shelves are lined with bottles of water, sweets, magazines, and newspapers. Small, informal grocery stores can help to support food security but simultaneously are faced with the challenge to stock healthy foods (Lenk et al. 2020).

Products needed in an emergency are categorized as convenience products. An umbrella is needed in the rain. Flashlights and candles are used during power outages. As a result of the COVID-19 pandemic, emergency care items or personal protective equipment (PPE) entered into our everyday 'product vocabulary'. The face mask became symbolic of the pandemic, decades after the N95 filtering facepiece respirator was patented by material scientist Peter Tsai. At the start of the pandemic, communities faced severe mask and PPE shortages. Researcher Erin Blakemore (2020), who referred to the 'simple face mask' as a pandemic mascot, investigated how shortages of medical-grade masks led to rapid collaborations between designers and physicists. The design of built environments such as parks, walkways, and roads, and emergency preparedness supplies have also become increasingly urgent in response to climate emergencies, as weather-related disasters have surged 'five-fold over 50 years' (United Nations 2021).

FIGURE 1.4: A 'tuck' shop in South Africa, 2014.

In contrast to convenience products, 'durable' products – like appliances, vehicles, computers, machinery, clothing, and accessories – are purchased less frequently by consumers and businesses. They are designed to last for a longer period of time. Elias Thabiso Mashao and Nita Sukdeo (2018) described a mix of factors that can influence buyers when they purchase durable goods. These can be cultural, social, psychological, and personal factors. The decision to purchase a durable product can be driven by perceptions of cost, quality, value, and risk (p. 1669). In terms of perception, the buyer may have a price in mind that they want, while the true retail price is the 'objective price' (p. 1669). When it comes to perceived 'quality' consumers may judge a number of features, like the materials a product is made of, or its labelling.

'Made-In-Country' labels, for example, are increasingly significant to consumers. By creating a 'Made-In-Country' index to study 'perception of country images', researcher Nicolas Loose (2017) found that consumers have biased tendencies. These may include viewing Japanese-made products as being 'technologically advanced', Chinese-made products as 'providing great value for money', and Swiss luxury products. The economic and cultural ties between countries have helped to establish these powerful perceptions. Unfortunately, it also means that certain brand stereotypes can be perpetuated by companies and consumers, dating back to histories between the 'colonizer' and 'the colonized'. Loose (2017) observed that French products enjoy an 'above average reputation' in former French colonies as a result of continuous 'cultural and economic exchange'.

As the international transport of goods continues to climb, consumers have increased exposure to global products, both durable and non-durable. Understanding the globalization of product design is layered and complex, as it speaks to the interdependence between countries and companies, and how widespread design and production networks are. From towns and villages to mega-cities like São Paulo and Jakarta, a mix of international and local products are now displayed. The resulting mélange can include items from familiar brands like Hennes & Mauritz (H&M), Starbucks, Samsung, and UNIQLO prominently juxtaposed with local products and hybrid products that are a confluence of functionality, style, and appearance, and local and international identities (Jackson 2004, p. 168).

For many transnational businesses, the growth of businesses has been remarkable, with a number of small businesses becoming the 'global goliath of modern times' (Brookings Institution Press 2021, p. 3). H&M, the Swedish fast fashion company, was founded by Erling Persson in 1947. H&M branched out from selling women's clothing to include men's and children's clothing lines by the late 1960s. At that time they expanded to outside of Scandinavia in the 1990s, and to Hong Kong and Shanghai by 2007 (Arrigo 2018, p. 127). Starbucks was founded in 1971 by Gordon Bowker, Jerry Baldwin, and Zev Sieglat at Seattle's Pike Place Market 'on hardly

any cash' and has grown to 33,000 locations in 80 countries by 2021 (Farr 2017). Samsung (which means 'three stars') found its start as a grocery trading company in 1938 and entered the electronics industry by 1969.

UNIQLO found its humble beginnings in 1949 as a men's clothing company; it was founded by Hitoshi Yanai and later re-designed by his son, Tadashi Yanai (see Figure 1.5). On his family business, Yanai described in a 2020 interview, 'My father was an old-fashioned merchant, and he didn't think of himself as an entrepreneur or a manager. But, it was my father who taught me what doing business was all about – that it was a practice' (Yoshimura 2020). He began operating the family business as the Unique Clothing Warehouse in 1984, which would later be renamed as UNIQLO and would go on to become one of the most successful businesses in Japan.

The evolution of a small business into a large transnational corporation selling global products is a 'relative rarity' and can be a 'complex, difficult, and hostile' journey (Li & Tan 2004, pp. 195–196). Hui-Hong JK Li and Kim Hua Tan (2004) argue that there are four stages in developing a successful transnational business: The first stage includes the 'conception and development' stage that focuses on 'product development and design', securing funding, and 'developing a market' (197). During the second stage, there is a commercialization phase, where a product can potentially do well and 'meet a need in the marketplace' (197). The third stage

FIGURE 1.5: The first UNIQLO store, 1984. Hiroshima, Japan. Fast Retailing Co., Ltd.

is the 'growth' stage, with a focus on selling products 'in volume', and the fourth stage is about 'stability' and creating 'generation products', 'new product lines', and 'penetrating new geographic territories' (p. 197).

In many ways, products undergo a remarkable journey – from local to international spaces, and now through digital spaces. Products are created, exchanged, and innovated upon and transcend many different types of domains and conditions. Each product bears a unique story of innovation, intertwined with economies and trade. Once, ancient trade routes like that along the Silk Routes enabled the exchange of goods between countries, while fostering the exchange of 'new ideas, literature, knowledge, beliefs, arts, religions, and cultural values and norms' (Gursoy & Altinay 2021, p. 442). In stark comparison, digital products are transmitted through servers and routers. They are made of code, experienced in imagery and audio, and often lack a physical, tangible form.

Digital products are an important departure from traditional physical products. Physical products are 'touchable', require some sort of storage, and they have to be shipped to the end-user or the customer. Digital products, in contrast, do not have traditional delivery or storage costs and are rarely out of stock. Smartphones, a hybrid physical and digital product, have become a primary means of accessing the internet. The phone is also an example of a product that has been designed and re-designed and its 'everywhereness' makes it an illustrative example of technological advancements in product design (Figure 1.6).

In the twentieth century, Western Electric's rotary phone was once the ubiquitous standard domestic phone. Western Electric, a subsidiary of AT&T, had its first major telephone release with the Model 102 telephone. The company was founded in 1869 and notably was one of the first American companies to have a joint venture with Japan's Nippon Electric. It was also the first company to allow a female employee, Alice Heacock Seidel, to remain on staff after being married. In their remarkable tenure, the 'Dreyfuss team' would create the Western Electric model 500 telephone that design history professor Russell Flinchum (2017) described as a post-World War II technological advancement. It included a shorter height, better visibility of numbers, and a 'cross-licensing patent agreement' that 'made this design an industry standard' to be manufactured by companies like Stromberg-Carlson, Automatic Electric, and Kellogg (p. 185).

In a 1999 *New York Times* article, Catherine Greenman reflected on 'when dials were round and clicks were plentiful' and wrote:

> It's hard to imagine Jon Walz, a film producer and vintage-phone collector in Los Angeles, getting as worked up in 20 years about today's cordless telephones as he does about his Western Electric 302 rotary dial phone [...] Mr. Walz is one of a dying breed of people who still use rotary phones in their daily lives. Like other touch-tone

COLOR, EVERYONE?

Sure, but which? Here they are: nine of the glowing colors you may select in the handsome new phones Western Electric makes for Bell telephone companies. The picture chart above shows the relative public popularity of these telephone colors. Have you seen them lately at your Bell business office?

The trend in telephones is definitely to color—in both home and office —to complement any decor, or just for the sheer fun of it. And we at Western Electric are happy to oblige; in fact, *two-thirds* of all new telephones we'll make this year will be in color. The rest will be in traditional black.

Producing good looking, dependable telephones and the equipment needed to serve you, is one of our main jobs as part of the Bell System.

Western Electric manufacturing and supply unit of the Bell System

FIGURE 1.6: A 1960s advertisement for Western Electric. For decades, models of the Western Electric were a standard North American telephone.

avoiders, he will gladly wait the extra seconds it takes for the dial to twirl back and forth between the numbers and its starting position in exchange for the feeling of nostalgia that the phones evoke.

Decades later, rotary phones have become outmoded, replaced first by cordless, portable phones, and then by mobile phones. In 2023, around 70 per cent of people on Earth owned a smartphone. As much as 97 per cent of Americans and 95 per cent of households in the United Kingdom owned some type of mobile phone (Pew Research 2021). User experience designer and cyborg anthropologist Amber Case (2010) described that humans act like cyborgs every time they look at one of their mobile devices. While she has some reservations about 'instantaneous button click-ing culture', she also sees that it is the 'first time in the entire history of humanity that we've connected in this way'. Other products like music, film, and books have undergone a similar process of digitization, and are largely available on demand.

Instantaneous consumerism can be not only largely gratifying but can also increase some risks of anxiety and depression and of engaging in excessive amounts of screen time. While smartphone ownership continues to grow globally, in countries such as Senegal and Ghana, for example, fewer than 40 per cent of adults own one (Poushter, Bishop, & Chwe 2018). Even as innovative leaps are taken, it is important to address the disparities between those with and without access to the internet and communication infrastructure like computers and phones. With so many products and product types now available, we are immersed in a multi-faceted consumer and design culture. Patterns in design and production, consumption, and the way one navigates affordability have drastically shifted in the past century.

2

Production and Consumption in Design

Changing Patterns in Mass Production, Consumption,
and Affordability

Mass production of goods has made products more affordable and accessible. Prior to mass production processes, many products were made on demand and by hand. In pre-industrial societies, clothing was sewn or produced with hand looms. In Egypt, one of the earliest civilizations to manufacture textiles, the weavers were well-versed in making tapestry textiles and complex textiles like towels and velvet cloths (Marouf 2008, p. 18; see Figure 2.1). Products were meticulously crafted by lamp makers, potters, metalworkers, cobblers, and jewellers, to mention a few.

FIGURE 2.1: A facsimile painting of Egyptian weavers depicted on the tomb of Khnumhotep around 1897–1878 B.C.E. The weavers are plying thread and weaving with a ground loom, 1931.

Nevertheless, early 'making' and manufacturing processes could not 'approximate to mass production', and small batch production was frequently 'aimed at narrow, privileged groups' (Reynard 2000, p. 512). For many households, possessions were sparse and the majority could only afford 'a tiny space in which to live' with a limited heating capacity. Nutritious food was usually unaffordable, and possibly unavailable (Moatsos 2021). Before industrialization and electrification, candles were too expensive for many people to afford to use to light homes. Southern European peasants used oil lamps while traditional Asian households were furnished with lanterns known as the 'andon' in Japan, or the 'chorong' in Korea (see Figure 2.2).

Pre-industrial or agriculturally dependent households might only see a modest surplus of food or goods given their limited production capabilities. Families were tightly knit and worked together as an economic unit where they might operate a farm, work as contract labourers, or be bound by slavery. The division of labour and lack of social class mobility was a 'societal labour process' that was often 'based on *ascription* (being born into one's role and status), not on *achievement*' (Littek 2001, p. 8220–8226). After thousands of years where many households scarcely managed at a subsistence level, industrialization and the availability of mass-produced goods transformed societies all over the world. Increased manufacturing led to proportionate savings and lowered prices through 'economies of scale', or savings that were gained by increased production. With goods built at greater speeds, thanks to steam engine power and the development of assembly lines, mass-made goods added comfort, affordability, and functionality to households that once lacked necessities.

Researcher James Manyika et al. (2020) described that the global twenty-first-century 'social contract' has given consumers access to inexpensive options for 'discretionary goods and services' (p. vi). Researchers also pointed out that

> Globalisation has increased competition in traded goods such as clothing and electronic goods leading to significant price improvements. China, Vietnam, and other emerging economies have become key lower-cost manufacturing centres, and this has both driven down prices and increased offerings to consumers.
>
> (p. 10)

In response to these changes, the globalization of products has presented a number of advantages as well as a number of challenges. It has decreased the time to make a product. The output is higher and the cost per unit is lower. Creating a consistently high-quality product can be a challenging prospect for the product designer and the manufacturers. Designers and manufacturers are under the pressure of time and the ability to make cross-cultural products that suit many audiences around the world simultaneously. Mass-produced goods also consume energy, cause pollution, and can lack the individuality of handcrafted products. Yet one particularly important

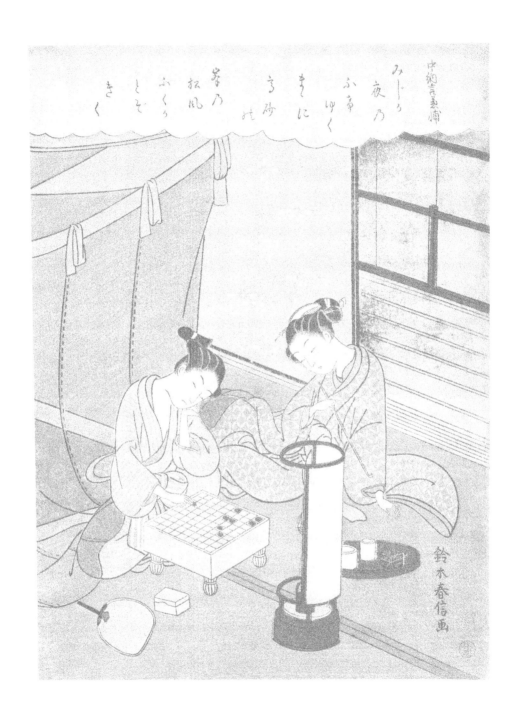

FIGURE 2.2: A young woman and a man playing shōgi (Japanese chess) beside an and on floor lamp. Artwork by Suzuki Harunobu, Japan, 1767–1769.

advantage in lowering the costs of products has been affordability. More affordable goods have contributed to improving quality of life and material living standards and have also enabled people to save money and accrue more wealth to purchase other products and services.

One global trend developing between the twentieth and twenty-first centuries has been consumers' loyalty to specific brands and a willingness to 'trade up'. Trading up is a behaviour where consumers 'purchase higher priced products or more expensive brands instead of less expensive products' (Silverstein & Fisk 2008, p. XV1). Michael J. Silverstein, Neil Fisk, and John Butman (2003) observed that consumers with some discretionary wealth will buy premium or luxury goods. Consumers can get an emotional boost by trading up to purchase a premium product that they view as higher performance than a generic brand (Silverstein et al. 2008).

'Trading up' among consumers gradually evolved – especially in response to ideological shifts that took place after World War II (Scherling 2021). The post-World War II consumer wanted televisions, cars, furniture, kitchen appliances, and new homes. Buying a home and filling it with durable goods symbolized a level of stability after the war. Social historian Matthew Hilton (2017) highlighted that governments all over the world promoted 'a vision of consumer society based on access and participation; affluence for all rather than choice and luxury for the few' (p. 66). Product demand called for *hurry-up production* post-World War II, where manufacturing processes needed to be accelerated. Mass production models helped to pave the way for industrial expansion and 'the creation of the middle class' (Prisecaru 2017, p. 67).

After World War II, not all Americans equally benefited from the Servicemen's Readjustment Act of 22 June 1944, commonly referred to as the G.I. Bill. The bill funded housing, education, and unemployment insurance. Upon returning to civilian life, many African American, women, and LGBTQ veterans were given 'blue' discharges or dishonourable discharges that barred them from receiving G.I. benefits and attending vocational programmes (Blakemore 2019). Civil rights groups and African American veterans protested, but a combination of segregation laws in southern states, along with redlining and racially restrictive covenants, made it nearly impossible for Black veterans and veterans of colour to secure benefits and live a more comfortable and secure life.

For many women, the culture of post-World War II consumerism could be socially oppressive, especially after an impressive tenure when taking wartime jobs (see Figure 2.3). During World War II, approximately 2.8 million women worked in factories, transportation, agriculture, and office work. National Geographic (1944) recorded women taking roles to help design planes in the engineering department at Marietta Corporation, which would later merge into Lockheed Martin in 1995. After the war, many women were called upon to return to duties as a housewife, whose main responsibility was to care for the family and their home.

FIGURE 2.3: Women in India preparing for air raid duties in Bombay, 1942.

Design, Manufacturing, and the Supply Chain

Global consumer movements that have developed over the past century saw companies and politicians promising the public a better life. More people were able to fulfil the cost of their basic needs and were able to move out of 'extreme poverty' (Moatsos 2021). Today much of the world's goods are made in China (see Figure 2.4). Data journalist, Felix Richter (2021) outlined that China has 'accounted for 28.7 percent of global manufacturing output' ahead of the United States, Japan, Germany, South Korea, India, Italy, France, and the United Kingdom.

Summarizing some facts about rapid industrialization in China, researcher Yi Wen (2016) noted that China's industrial revolution is perhaps one of the most important economic and geopolitical phenomena since the original Industrial Revolution centuries ago. China is the world's largest 'manufacturing powerhouse and produces nearly 50 per cent of the world's major industrial goods' (p. 9). While China has the largest manufacturing output globally, the exact number of products that a person might own that were either fully or partially manufactured in China is debatable. For example, a consumer may spend more on clothing and shoes made in China than in other household product categories (Goldstein 2011).

Historically, mass manufacturing of goods began in the 1760s in England before these production processes developed in the United States in the late nineteenth century. The British and American industrial revolutions were followed by industrialization in Mexico, Brazil, and parts of South America in the late nineteenth century. The twentieth century saw some industrialization in Africa and rapid industrialization in Japan, South Korea, Taiwan, and Singapore after World War II. It was not until the late 1980s that China's industrialization exploded into the mass production of textiles, furniture, toys, and varied consumer goods (see Wen 2016). These 'pathways' towards industrialization have taken place in much of the world. The number of countries that remain highly underdeveloped, or 'least developed' continues to shrink (United Nations Conference on Trade and Development 2021, p. ix).

Southeast Asian Nations have also moved up the manufacturing 'value chain' developing full capabilities to create products and services to meet global needs. In earlier years, Southeast Asian manufacturing locations were often viewed as primarily a location for 'low-wage assembly work'. New trade pacts, including the Regional Comprehensive Economic Partnership, have helped to move 'finished goods, inputs, and investments between Southeast Asia and trade partners such as China, Japan, South Korea, and Australia' (Meyer et al. 2021). In 2018, the African Continental Free Trade Area (AfCFTA) was established to help support the growth of the manufacturing sector in African nations with the goal to drive industrialization and job growth (Signé 2018). With a population surge expected in Africa, the manufacturing sector holds a lot of potential. Meanwhile, Rolando Avendano et al. (2019) described that Latin America has experienced some stagnation and 'lost ground in natural resource-based, low- and high-technology manufactures' (p. 7).

In an interactive global economy with accelerated flows of goods and services, there has also been an urgent requirement to see greater quantities of products designed, manufactured, and delivered. It is not a simple problem to think of product design in relation to the supply chain and all the behind-the-scenes steps taken to get an item shelved in-store or to a household doorstep on time and in good condition. Fundamentally 'a supply chain is a sequence of events that covers a product's entire life cycle from conception to consumption' (Blanchard 2021, p. 3). Steps in a supply chain can include design, demand planning, procurement (obtaining the raw materials and components needed in the design), manufacturing, warehousing, and delivery to the customer. A variety of channel distribution partners are involved, including suppliers and intermediaries. As a framework, the supply chain is built on inbound and outbound logistics, sales, marketing, and operations.

With a mechanical aptitude, and the ability to visually model a product, designers and engineers are able to prototype and test new products. Together with businesses, they can then bring them into the market assuming responsibility for manufacturability, cost, and performance. Through supply chain managers

FIGURE 2.4: A knife factory in Guangzhou, China, 2016.

and sourcing networks, products go to factories all over the world in a vast and complex system. Some products are made in a 'continuous stream' (like chemicals and papermaking), while others are made through repetitive or discrete processes (Gunn 1982, pp. 115, 116). In a repetitive process, the same product is made on an assembly line again and again. In discrete manufacturing (or the manufacturing of 'distinct' objects), various types of products are produced in the same factory location. Global product development has remapped the landscape of product design and retailing at every stage.

Through 'fragmentation' production processes are split across locations throughout different countries in order to reduce costs. In one view, the system is a testament to global cooperation and living in a connected world. Different components of an iPhone are manufactured in Taiwan, South Korea, China, Germany, Japan, and India. In another view, global supply chain systems can be jolted by delays, and labour and material shortages. Supply chain disruption have been prevalent during the COVID-19 pandemic, natural disasters, and through political conflicts and warfare. Product returns further complicate the global supply chain. As much as 10–30 per cent of items ordered online are returned, with some items going to bulk resellers. This splits the consumer goods market supply chain into 'forward logistics' (items going to the customer) and 'reverse logistics' items going back to the warehouse at any given time (Mull 2021).

Prior to the use of computer software in supply chain management, systems scientist Jay Forrester theorized the 'bullwhip effect'. The bullwhip effect demonstrated demand signals can become exaggerated as they move through a supply chain resulting in less forecasting accuracy (Lee, Padmanabhan, & Whang 1997, p. 3). Such up-stream and down-stream fluctuations were a hindrance throughout the pandemic, sparking temporary shortages and consumer panic. During lockdowns, some shipping lines cut service only to face wild swings in demand (Irwin 2021). Globally, some of the largest e-commerce platforms, including Amazon, Flipkart, and Otto, had to quickly calculate how to replenish stocks with as few shortages as possible. With billions of people following stay-at-home orders and many facing unemployment, product supply chains were negatively impacted and grocery store shelves were emptied of food staples, bottled water, toilet paper, and other essential day-to-day products.

In response to the pandemic, many countries around the world had to consider their supply chains, while further developing their food aid services. A 'flagship' family card was issued to vulnerable families in Madrid. Aid initiatives in Paris included economic support, 'shared kitchens', and 'community kitchens' (Eurocities Working Group Food 2021). In the United States, the National Guard was activated to support grocery stores and food banks (see Figure 2.5). In another example, Shanghai residents on strict COVID-19 lockdowns began circulating a 'Shanghai Grocery Shopping

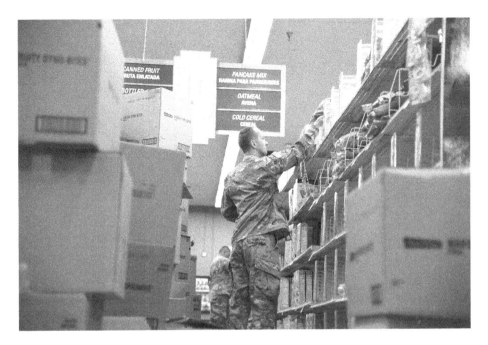

FIGURE 2.5: A combat engineer stocks shelves at a local grocery store in Phoenix, Arizona during the COVID-19 pandemic (2020).

Guideline' to try to access popular delivery apps to buy food, however many of these apps would 'run out of food within only a few minutes of opening' (Liu 2022). Human Rights Watch (2021) interviewed '270 people in Cameroon, Ghana, Kenya, Nigeria, and Uganda' about how the pandemic impacted 'access to food and livelihoods', and found evidence of 'widespread hunger', difficulty accessing government support, and a rise in child labour.

Disruptions related to disasters are one major example of supply chain management issues. A long-standing challenge concerns that the 'backend' of the supply chain remains opaque in the mass production of products. Robust due diligence is required to ensure the ethical treatment of workers and to minimize environmental harm. Product design teams and manufacturers are continuously challenged to save on costs, which can be in direct conflict with minimizing risks. Those working in the supply chain may lack oversight and might not be aware of what other producers, designers, distributors, and retailers are doing. Serpil Erdönmez and Serkan Güneş (2016) described that designers are deeply embedded in this flow of goods and production cycles. Their decisions can improve the quality of living, or impact it inversely. With this in mind, making sense of opaque and difficult-to-reach parts of the supply chain is especially important.

PART 2

PRODUCT DESIGN AND ETHICAL CONSIDERATIONS

3

Product Design and Environmental Sustainability

Design and Pollution

As the world's population continues to grow, so has the creation of waste. Waste is typically garbage that is thrown away. It is material that has been deemed worthless or unusable, either at some point in the production process or by a person. These discarded items are products like clothes, furniture, appliances, food wrappers, and bottles (see Figure 3.1). The World Bank (n.d.) estimated that people produce as much as '0.11 to 4.54 kilograms' of trash per day. By 2050, they estimate that the

FIGURE 3.1: Waste disposal site in Bangladesh, 2020.

world will generate 3.4 billion tonnes of waste per year. Yet, less than 33 per cent of the 2.1 billion tonnes of solid waste the world generates annually is safely handled (World Bank n.d., also see Kaza et al. 2018). These statistics speak to the tenuous relationship between product design and sustainability, a largely under-addressed environmental and ethical concern.

Solid waste includes food and green waste, plastics, papers, metals, glass, wood, rubber, and other miscellaneous items. Additionally, there are special categories of 'industrial, medical, e-waste, hazardous, and agricultural waste'. In 2017, the United States 'generated approximately 8.4 billion tonnes in this category of waste' (Sebastian 2021). Along with the United States, countries such as Canada, Bulgaria, and Estonia are some of the 'leading waste producing' countries for generating both solid and special types of waste. Among the many egregious types of waste that exist, electronics waste and plastics are some of the most difficult to process (see Figure 3.2).

Plastics, once viewed as state-of-the-art, have become one of the most commonly used materials used globally, and have many well-known varieties. Polyethylene terephthalate, abbreviated as PET or PETE, is found in polyester textiles and clothing, beverage bottles, and plastic jars. Polyvinyl chloride, PVC, or vinyl, known for

FIGURE 3.2: An e-waste facility in Rwanda, the second largest in Africa. Electronics waste is particularly difficult to process and contains a number of toxic materials.

its versatility, is used to construct electronic and automotive parts, toys, medical devices, cables, construction materials, credit cards, and pipes. The production of PVCs is linked to health risks like liver problems through exposure to vinyl chloride monomer (VCM) which is a plastic component (Barsouk et al. 2020, p. 181). Polypropylene (PP) is highly durable and heat resistant. It is used in tape, food containers, housewares, utensils, toys, and automotive parts.

The amount of plastics and human-made materials now 'outweighs' human life (Aridi 2020). Rasha Aridi (2020) noted that scientists recently estimated that 'human-made materials reached 1.1 trillion tons' surpassing the mass of all living things on earth. Historian Philippe Chalmin (2019) described that plastic, in particular, has become 'a symbol of the crisis of our postmodern society and one of the major challenges of the 21st century', with few materials seeing such major growth in production and adoption into international designs (p. 11).

Many plastic products have gained a 'cult' status and were widely adopted, from nylon bristle toothbrushes, disposable diapers, and disposable razors, to single-use plastics like plastic bags (Chalmin 2019, p. 9). Before toothbrushes were designed with synthetic components, they were made from materials like pig bristles, badger hair, ivory, and boar hair. Through the 1960s, plastic furniture like the Herman Miller and Panton stacking chairs (see Figure 3.3), and Goyana's melamine dinnerware, became popular for their modern appearance, bright colour palette, and durability. Acrylic lights and artificial leather products also became fashionable, and by the 1970s, plastics were the most used and desired material in the world (Hervé Millet et al. 2018).

At the same time that innovative and stylish plastic goods and more affordable mass-produced products provided a new level of comfort and convenience, products have also encouraged a 'throwaway' culture, where the accumulation of waste has caused great harm to the environment. Purchasing goods that can be quickly discarded is contradictory to the notion of maintaining and repairing products. As repair costs now frequently exceed the cost of buying a new product, many consumers forgo more environmentally friendly repairs. Single-use products like bottles and containers have also become emblematic of an 'on-the-go' model, and can be difficult to recycle and end up incinerated or in landfills (Winton, Marazzi, & Loiselle 2022, p. 1). For some households, the use of takeaway containers 'doubled' during COVID-19-related lockdowns (p. 1). E-wastes, or electronic products at the end of their lifecycle, are hazardous and difficult to recycle and repair. Many countries lack the infrastructure to safely dismantle monitors, electronic equipment, and lamps.

Some of the largest landfills in the world, in acreage, include Apex Regional (United States), Laogang (China), and Sudokwon (South Korea). Waste that is landfilled or incinerated, rather than recycled, gives off methane gas and is the

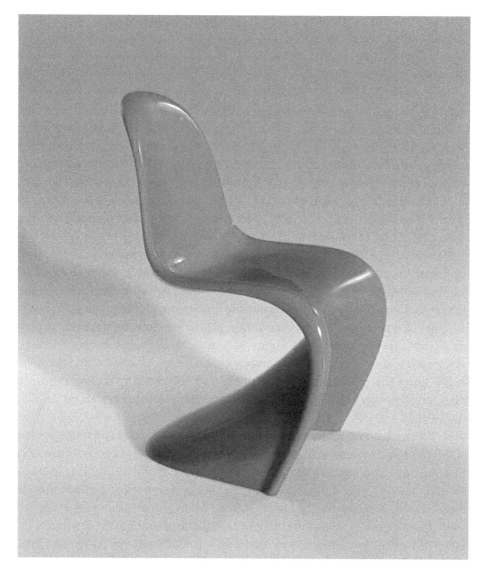

FIGURE 3.3: The Panton chair was designed by Danish architect Verner Panton, 1963–1967. It was one of the first injection-moulded plastic chairs.

fourth leading cause of carbon emissions after fuels, agriculture, and industrial processes.

　　With all the products discarded, the work of a product designer directly and indirectly impacts the environment. For example, the apparel industry alone consumes about 'one-fourth of chemicals worldwide' while releasing microfibers into water

(Thomas 2019, p. 4). Product and industrial design, particularly apparel design, have energy-intensive practices that 'consume more energy than the aviation and shipping industry combined' (United Nations Climate Change 2018). Emissions concentrate in the earth's atmosphere and warm the climate, leading to many other changes around the world impacting the atmosphere, on land, and in the oceans (EPA 2021). Consequently, many production processes in product design, particularly in sourcing, are riddled with sustainability challenges.

Poor waste management practices are also highly damaging to social institutions like homes, schools, the workplace, and public spaces. Low-income communities are disproportionately impacted by pollution and waste mismanagement. They receive less funding to address environmental concerns and receive fewer investments in urban greening and revitalization projects. People living in poverty are also more likely to live in closer proximity to industrial areas, like manufacturing and dump sites. In their study of solid waste management throughout Africa, Linda Godfrey et al. (2019) also described mismanagement practices due to 'weak legislation; lack of enforcement; low public awareness; corruption, conflict; political instability; and lack of political will'. The United Nations Environmental Programme (UNEP) (2015) pointed out a high profile case where the Payatas municipal dump site collapsed in a slum community in Quezon City, Philippines that led to hundreds of deaths and homeless families (p. 6). UNEP also cited seasonal floods in Accra, Ghana that have been 'exacerbated' by drains being blocked by litter-like sachet drinking water containers used to store safe drinking water. Faced with rising amounts of global waste, climate change and extreme weather events, disasters like those in Quezon City and Accra become increasingly common. To see significant and meaningful changes, access to 'modern' energy services and sustainable design processes that reduce waste and harmful emissions will be vital to meeting global sustainability goals.

Environmentally Responsible Product Design

For centuries there were warnings about the need for more environmentally responsible products that would be less damaging to the planet. Philosophy professor Munamato Chemhuru (2017) detailed that environmental ethics were evident in ancient Greek philosophies such as the writings of Thales that grappled with 'the moral status of animals and that of non-human animals'. In 1877, British textile designer and environmentalist William Morris wrote in his essay 'Lesser Arts' that 'manufacturers are so set on carrying out competition to the utmost, competition of cheapness, not of excellence' (Gorman 2003, p. 35). Morris collaborated with designers like his wife and embroidery designer May Morris, Thomas Carlyle, Mary Lowndes, and John Ruskin.

They were prominent designers in the Arts and Crafts Movement who collectively challenged the environmental impacts of industrialization and factory production.

Across different cultures, some designers and craftspeople took more eco-friendly approaches to product design, and have lived more sustainably. Seble Samuel (2019) highlighted that 'climate knowledge' often privileges the views of those from mainly western and industrialized countries, and that improving our understanding of local, indigenous 'ecological knowledge' can strengthen approaches to climate resilience (p. 51). The author researched the Sapara Nation of the Ecuadorian Amazon, which struggled for 'cultural survival' against colonization and disease, but maintained belief systems in 'ecological stewardship' and economic models that promote ecotourism and food sovereignty (the right to ecologically sound agricultural systems and food products) (p. 61). In another example, the Mohawk Nation (located in New York, Vermont, and Canada) have led 'learner-apprentice' initiatives to uphold traditional cultural practices in water use, woodwork, and basket making, along with hunting and trapping (Tom, Huamen & McCarty 2019, p. 6). Mohawk craftwork has included the creation of a wooden cradleboard, used to carry and protect infants, used while planting or harvesting crops (see Figure 3.4).

Designer and educator Victor Papanek was also a strong advocate for socially responsible design and warned about how harmful product design could be. In the book *Design for the Real World* Papanek (1972) described:

> In an age of mass production, when everything must be planned and designed, design has become the most powerful tool with which man shapes his tools and environments (and, by extension, society and himself). This demands high social and moral responsibility from the designer. It also demands greater understanding of the people by those who practise design and more insight into the design process by the public.
>
> (p. 1)

Papanek (1972) anticipated the impact that mass-produced products could have in the long run, and also reflected that design 'must be more research-oriented' and to 'stop defiling the earth itself with poorly designed objects and structures'. Just as society has reaped the benefits of an interconnected world of global trade and access to goods and services, designers and researchers saw that consumer culture would require major changes in manufacturing and recycling in order to protect global resources.

While Papanek's criticisms of profit-led design were initially seen as divisive, his central aim was to interrogate the social purpose of design. Papanek's ideas were later well received, with many designers rethinking waste management practices. The aim of 'green' or sustainable product design is to prevent and limit waste and implement more environmentally friendly processes. While companies and design

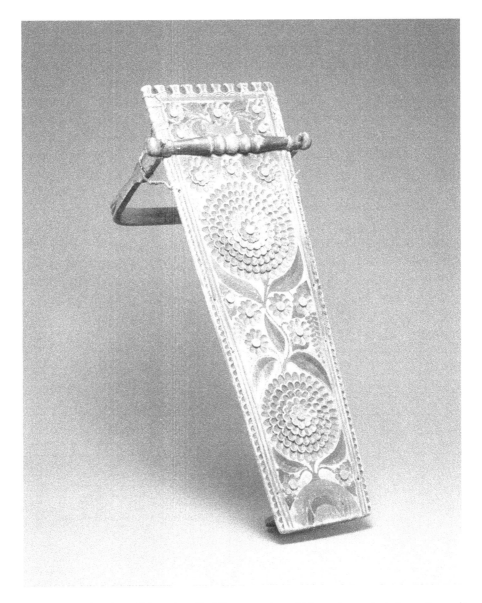

FIGURE 3.4: Mohawk cradleboard crafted from wood, rawhide, and assorted pigments used to carry and protect an infant and provide the parent with more mobility, 1860, Canada.

studios have begun prioritizing waste-limiting practices through ethical material sourcing, small-batch production, plastic-free shipping, and the creation of jobs for artisans in low-income countries, many companies still have yet to set targets for reducing emissions.

According to designer and sociologist Leyla Acaroglu (2020), sustainable design must consider aspects like a product's longevity, reusability, dematerialization, disassembly, and modularity. On sustainable product-service systems, Acaroglu (2020) outlined that 'one of the main ideas of the circular economy is moving from single-use products to products that fit within a beautifully designed and integrated closed-loop system which is enabled through this approach'. Product longevity can mean creating a durable and long-lasting product that does not need to be replaced as often. Reusability can also have a lot to do with recyclability and repairability. Products are more *reusable* to the extent they can be easily recycled, remanufactured, or repaired. Dematerialization can mean that by 'reducing the overall size, weight, and number of materials incorporated into a design, is a simple way of keeping down the environmental impact'. Designers and the organizations they work with can collaborate to promote zero-waste practices by using upcycled materials to reduce waste. Accessories company Suave Kenya has deconstructed used garments and re-invented them into crossbody bags, messenger bags, and tote bags. Another social enterprise called Trashy Bags Africa, located in Ghana, upcycles plastic waste into making eco-friendly bags like rucksacks, cosmetic cases, and laptop sleeves (see Figure 3.5).

FIGURE 3.5: Plastic sachets typically used as containers for safe drinking water are upcycled into the base material for making bags, by the social enterprise Trashy Bags Africa, 2011.

The move to embrace sustainable product design practices has been tentative. Companies like Patagonia, Seventh Generation, Stella McCartney, Adidas, and Nike have been cited for more transparent sustainability practices, representing a small fraction of companies that publish data on their sustainability and labour practices. In reality, many companies are in the early stages of engaging with socially responsible sourcing and manufacturing. However, sustainability-driven behaviours and messaging and some notable challenges have emerged. For instance, there has been a challenge with 'greenwashing' or promoting 'deceptive eco-friendly jargon' without substantial evidence of environmentally sound practices (Mendez 2020). The UK's Advertising Standards Authority (ASA) has cited companies for their exaggeration of the use of recycled materials in their products. In one citation, the ASA challenged LVMH's 'advertisements featuring a photograph of a woman stitching the handle of a handbag and another of a woman creating the folds of a wallet' as misleading (Johnson 2010). Consumers could misperceive that 'Louis Vuitton products were handcrafted throughout most or all of the entire production process' (Fashion United 2010).

Greenwashing can deter sustainability initiatives, especially given the fact that consumers already find it difficult to assess which products meet higher ethical standards than others. While greener products are generally viewed as important to fighting environmental degradation, sustainable product lines are not widely implemented in markets (Vezzoli et al. 2015, p. 1). In their research on 'new design challenges' Carlo Vezolli et al. (2015) saw that a product's life cycle costs are not always well understood by consumers, which can hinder consumer adoption. Sustainable consumption and production, also abbreviated as 'SCP', calls for companies and consumers to improve the management of resources in both the production and consumption phases of a product life cycle (UNEP 2022).

Faced with a global environmental crisis, product design is increasingly a driving factor in sustainability problems, yet also important in containing them. On the one hand, socially responsible product design can improve food, water, and household security, fight environmental degradation, and play an important role in providing goods to alleviate the impacts of natural disasters and extreme weather events. On the other hand, unethical design practices can contribute to accelerating climate change and directly promote an increase in global waste with the design and manufacturing of single-use products, products that break easily or are difficult to repair, and designs made with materials and chemicals that are unhealthy.

Sustainability issues are also increasingly linked to the broader monitoring of supply chains to ensure the proper treatment of workers across the supply chain. It is to these dimensions of labour that we now turn.

4

Product Design and Labour

Labour in Design

At the heart of product innovation are systems of design and manufacturing, which are inextricably built on systems of labour. In the product design process, a legion of jobs is undertaken to research, design, engineer, plan, manufacture, and distribute products. The roles that people assume in design and production can create disparity in average pay, health benefits, working conditions, and opportunities to advance. It can also lead to a debate about who is a designer and who is not.

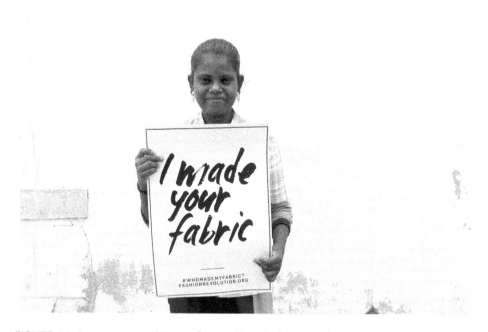

FIGURE 4.1: A woman named Prema featured in a Fashion Revolution campaign, #IMadeYour-Fabric. When Prema participated in #IMadeYourFabric she was seeking compensation for a hand injury at a spinning mill in Virudhunagar, India.

While some designers benefit from above-average pay and generous bene-fits and work for well-established companies that exemplify job security and employee development programmes, others may work in places that disregard ethical labour standards like fair wages. Standards are necessary to ensure safety and the well-being of workers. Gig economy platforms that hire product design-ers on a 'per-task-basis' can offer flexibility, but can be lacking in social protec-tions (Schwellnus et al. 2019, p. 5). In their research, Raphaële Chappe and Cynthia Lawson (2020) highlighted economic data that suggested that prod-uct designers working as artisans in low-income countries are still likely to deal with 'persistent' poverty, and are not necessarily gaining significant 'economic benefits' (p. 85).

In workplace reform history significant changes took place between the late nineteenth and twentieth centuries. Product creation was for a long time associ-ated with systems of apprenticeships and even coerced labor. When the rise of a 'free wage-labour market' and trade unionism occurred, artisans and craftspeople began participating in the fight for reforms alongside non-craft industries. In 1848, the London Trades' Council began meeting and was formalized in the 1850s. In the United States, the Mechanics' Union of Trade Associations (MUTA) was formed in Philadelphia in 1827 and was followed by the creation of the International Typographical Union (ITU) in New York City in 1852. MUTA demanded a reduction in dawn-to-dusk working hours which could last up to fourteen hours in warmer months. The ITU, one of the first unions to accept female members, saw victories in campaigning for a 48-hour work week and standardized wage scales. Notably, even as craft unions fought for labour reforms, women and people of colour were often omitted from membership. A more expanded view on some of these histor-ical developments in 'artisan/craftsperson' educational and labour practices is addressed in Chapter 7.

Other international work standards would emerge after The Treaty of Versailles, which was signed in 1919, and brought an end to World War I. As part of the Peace Treaty, the International Labour Organization (ILO) was established. Faced with a more interconnected and globalized world, the ILO functioned as part of the League of Nations, and later, as part of the United Nations, and was challenged to advance economic and social justice in labour standards. The ILO's eight essential core standards (Burtless 2001) included conventions related to human rights like the 'abolition of child labour', 'the elimination of all forms of forced or compulsory labour', 'freedom of association and the effective recognition of the right to collec-tive bargaining', and 'elimination of discrimination in respect of employment and occupation' (International Labour Organization n.d.). Over time 189 ILO conven-tions were introduced and amended. The amendment included a 2022 resolution to ensure healthy and safe working environments.

Depending on the country, union membership can also vary greatly. These differences can be based on the type of jobs held in design. In England, where trade unions were largely suppressed until their legalization in 1824, trade union membership saw a peak in the 1970s but has since declined. Many industrialized nations have followed a similar pattern, with 'dramatic declines in union strength since 1980' (Wallerstein & West 2000, p. 355). The International Trade Union Confederation (2019) warned of an increase in countries excluding workers from the right to establish or join a trade union, rising from 92 to 107 countries between 2018 and 2019 (ITUC 2019, p. 4).

Through a decline in trade unionism and the rise of the tech sector, there has also been a significant trend in design work as freelance work. While not all product designs can be made remotely, it has become common for designers to take jobs as independent contractors, temporary workers, or start their own agencies or studios. In many ways, freelance work has become emblematic of a 'gig economy', where temporary work provides a wide array of services and offers workers some flexibility and independence, but doesn't necessarily offer competitive pay or benefits. Zhi Ming Tan et al. (2021) wrote that 'the gig economy is a significant and expanding phenomenon that is rapidly re-shaping one of the most fundamental aspects of the economy and society.'

One concern is that gig work mediated by digital platforms can make workers subject to algorithm-based 'reputation scores', fewer 'legal protections', and precarity (Tan et al. 2021, pp. 3–4). Those who are not digitally connected can also easily miss out on work opportunities. In a study of 192 freelancers doing work for fashion brands, *Vogue Business* discovered reports of late payments, pressure, and loneliness that were further agitated by the Pandemic (Webb 2021). The Freelancers Union, which works to ensure 'healthcare for all', 'parity of wages', and 'racial justice' for workers, conducted a study of 'Freelancing in America' in 2019. It was found that as many as 57 million Americans, or approximately 35 per cent of the US workforce, performed some kind of temporary work (p. 5). In 2021, Eurostat observed that across the European Union, about 32 per cent of cultural workers (including craftspeople) were self-employed with higher levels in the Netherlands (47 per cent) and Italy (46 per cent). Across African countries, which have some of the highest unemployment rates in the world, around 4.8 million Africans made an income from freelance work in 2019 (Anwar & Graham 2021, p. 238).

In interviews with 65 African gig workers, Mohammad Amir Anwar and Mark Graham (2021) witnessed that gig work could be financially lucrative. It was deemed to be challenged by 'variable working hours', the need for high-speed internet requirements, and negative perceptions by family and friends who did not understand the work (pp. 247, 248).

Supply Chain Workers

For workers in the manufacturing stage of design, life can be particularly challenging, given 'fragmented global sourcing networks' and lack of government regulation (Perry & Wood 2019, pp. 12, 13). While some progress has been made in labour reform, expanding consumer goods markets and the factory work needed to make these products can be simultaneously harmful to the environment and to workers. Many companies use agencies to have designs outsourced or offshored. Outsourcing can mean sending work to a third-party company, while offshoring typically means sending products to be fabricated in developing countries in order to be cost-competitive. In some cases, product designers working in one part of the supply chain might have infrequent contact with the workers manufacturing the goods they are creating. Instead they may be communicating product design and manufacturing needs to vendors and other intermediaries. However, some product designers may work in-house or near the factories where designs are made. And some designers make their own products.

Product manufacturing, from household goods to clothes, was once more vertically integrated. Before industrialization, local family-owned enterprises and artisan shops were more common, and there were limitations on business output. Therefore, prior to the rise of mass production and consumer cultures, more companies had tighter control and oversight of a product, from the time it was designed to distribution into the hands of the 'end' user. Throughout industrialization and the globalization of products, a combination of benchmarking studies, press coverage, and reports by consumer activists also revealed that companies don't always understand their own 'worker recruitment processes'. Additionally, companies often lack the ability in order to have a clear understanding of who works in their supply chain or how their waste reduction processes operate (KnowtheChain 2018; Patsy & Wood 2019, p. 1). In practice, sustainable supply chain management can be challenging to untangle, implement, and monitor, particularly for multinational corporations.

In a study of 31 suppliers across consumer goods, electronics, automotive, and pharmaceutical industries – including 'a total of nine top-tier and 22 lower-tier suppliers' – management professors Verónica Villena and Dennis Gioia (2020) found that temporary workers made up nearly 50 per cent of the workforce and that 'turnover rates sometimes reached 100%'. They found that suppliers realized that it was difficult to implement sound environmental, health, and safety programmes. Problems frequently stemmed from orders which were beyond their capacity and the suppliers were not aware of acceptable 'social and environmental practices and regulations'. They also found that in the most successful workplace environments, companies and suppliers collaboratively monitored both 'social and

environmental targets'. A more robust supplier-monitoring system that evaluates 'sub-tier dependencies' has rapidly grown into a supply chain evaluation need (Linton & Vakil 2020). It can be beneficial for companies and suppliers to commit to The United Nations Global Compact and CDP (formerly known as the Carbon Disclosure Project) sustainability reporting criteria to uphold and promote corporate social responsibility.

Gender also plays a role in many supply chain positions. As many as 190 million women work in global supply chains in factories, farms, and packing houses where they produce a wide array of products; from well-known clothing brands to essential food products. This represents an enormous number of workers who generally work without sufficient legal protections nor hope to advance to higher-paid roles (Ethical Trading Initiative 2020). Studying the 'promise and perils' of Nike's business model, entrepreneurship professor Richard M. Locke (2003) wrote that on the one hand, designers could easily 'create new footwear styles' and quickly transmit these for production to plants across Southeast Asia, thereby enabling growth at an impressive rate (p. 8). On the other hand, the 1980s saw Nike 'criticized for sourcing its products in factories/countries where low wages, poor working conditions, and human rights problems were rampant'. This practice evolved into incidents of child labour in Pakistan and safety problems in Vietnam. In 1992, this situation led Nike to sign a code of conduct to implement basic labour, environmental, and health standards (p. 15).

Campaigns like #WhoMadeYourClothes, #WhoMadeYourFabric, and #IMade YourFabric by the organization Fashion Revolution have resulted in the public developing a better understanding of supply chain work. This has created a demand for greater transparency from companies. In the campaign #WhoMadeYourFabric, it was described (The Fashion Revolution 2021):

> While a growing number of brands and retailers have published a list of the factories where their garments are cut and sewn, the vast majority of brands are not yet disclosing the facilities where fabrics and yarns are made. When you look further down the supply chain, where fabrics are knitted or woven, textiles are treated and laundered, yarns are spun and dyed, fibres are sorted and processed and raw materials are grown and picked; there remains a widespread lack of transparency. We need brands to provide more visibility and take more responsibility for their entire global supply chain, including processing facilities and textile mills.

The Fashion Revolution, run by Fashion Revolution CIC and the Fashion Revolution Foundation in the United Kingdom, was created in response to the collapse of the Rana Plaza in Bangladesh, where thousands of garment workers were injured or killed. After the collapse, it took companies weeks to determine what types

of purchasing agreements they had with those suppliers and specifically, where the garments were being made. It was a 'catastrophic collapse', one of the most destructive in the history of the garment industry. As a result, workers protested and demanded factory safety and higher wages (Chowdhury 2017, p. 938). Motivated by this tragic event, The Fashion Revolution developed a 'Fashion Transparency Index' to push brands to be more transparent and disclose information about labour policies and sustainability practices (The Fashion Revolution 2021).

The Fashion Revolution and organizations like the World Fair Trade Organization (WFTO), Verité, Fairtrade International, and The Cooperation for Fair Trade in Africa have dedicated their work to helping vulnerable workers, improving labour and trade conditions, and obtaining more robust sustainability practices. Founded in 1989, the WFTO, a global community of social enterprises, promotes fair trade practices and awareness through design-led organizations like Earth Heir (Malaysia) and Intercrafts Peru. Verité was founded as a civil society organization to support businesses to 'eliminate labour abuses', and to support workers in supply chains to advance their rights (Verité 2022). Verité (2022) has conducted forced labour audits and 'social responsibility assessments' across sectors, including electronics, textiles, and apparel manufacturing. In their research, Verité has developed tools to help companies analyse 'human trafficking risks', evaluate suppliers and labour agents, and audit ongoing compliance. Risk management tools can help protect workers who are susceptible to paying recruitment agents and end up in debt, a type of debt bondage (Verité 2017, p. 59; Scherling 2021).

There is a strong case for ethical products that embed supply chain practices that address labour and environmental concerns. Jia et al. (2018, p. 15) observe that companies' ethical supply chain management 'outperforms their competitors economically', and these companies can benefit from 'a better reputation and gaining market shares'. Organizations like The Fashion Revolution, Verité, and apps like *Good on You* and *Done Good* have helped companies and their consumers take steps towards more ethical behaviour, but applications like these continue to be fairly obscure. Unfortunately, it remains surprisingly difficult to easily access research about ethical and sustainable products. This difficulty relates especially to initiatives that incorporate the 'buyers' and suppliers' perspectives', particularly in developing countries (Jia et al. 2018, p. 20). Research has indicated that sustainability, both social and environmental, might mean the need to slow down production and consumption altogether (McEachern, Middleton, & Cassidy 2020, p. 398). The United Nations has described 'responsible consumption' where people need to consider how to live 'better with less'.

5

Design, Politics, and Social Movements

Products and Political Conflict

Products are not only linked to ethical issues like environmental and labour challenges. They are also linked to global politics. Designs are influenced by governing powers and are shaped by political ideologies. Since the beginning of recorded history, products have been embedded as political tools and as parts of broader systems. Political systems (like a democracy or a monarchy) have their own legislation and approach to trade and negotiations, supply chain management, and transport logistics. On the periphery of large-scale systems, researcher P. Nick Kardulias (2002) pointed out that 'small-scale societies' have been challenged to retain their cultural identities while simultaneously working to meet the demands of capitalist market economies (p. 11). This was the case with indigenous American tribes who sold fur, textiles, and precious stones, like turquoise, to European traders. Indigenous American shared their craft specializations with their colonizers after centuries of exclusively designing and trading products through their own inter-tribe relationships (see Figure 5.1). Nevertheless, violent disputes between French, English, and Dutch traders and indigenous American tribes resulted in rivalries, war, overhunting, and cultural suppression.

Such devastating and politicized events are not rare. There are few parts of the world free from political conflicts. Conflicts can stem from disagreements about territory, resources, design, production, and manufacturing. Part 1 of this book explored how product design has the power to meet our fundamental needs, provide comfort and convenience, and aid us in emergencies. Yet, as recounted by author and designer Carl Disalvo, design can also be 'adversarial', meaning a 'designed thing' can incite 'contestational relations and experiences' (p. 7). Products like tea, textiles, and spices have been the focal point of wars, tariffs, embargoes, boycotts, and activist movements.

Spices were a highly politicized product between the fifteenth and seventeenth centuries. Amidst a more recent and brutal Syrian conflict, the Aleppo peppers underwent a serious decline, with crops devastated. In the twenty-first century, political tensions have emerged regarding different products like oil and petroleum,

FIGURE 5.1: A flat rawhide case frequently designed by women in the Comanche Nation. These cases, known as parfleche, were named by French fur traders and used to carry belongings between camps from the pommel of a horse saddle, 1850.

food commodities, electronics, and microchips. International disagreements on the usage of oil have risen time and again, demonstrating how energy use can simultaneously be geopolitical and cultural (Wellum 2022). These concerns have been heavily amplified by the 2022 Russian invasion of Ukraine that has resulted in human fatalities and mass displacement, with widespread attacks on infrastructure like energy infrastructure, hospitals, farms, and crop storage facilities. Rallying against Russia's invasions, many western countries imposed oil and gas sanctions upon them. The Russia–Ukraine War has also endangered farming operations which has disrupted the availability of wheat, barley, and sunflower seed oil. The European Council (2022) reported a dramatic decrease in the export of Ukrainian grains to

countries like Egypt, the Philippines, and Indonesia which, among many countries, rely on the output of the Ukrainian 'bread basket'.

The semiconductor chip shortage is also heavily politicized and has been described by author Chris Miller (2022) as a 'chip war'. This outlines how multiple countries battle for 'the world's most critical resource – microchip technology'. The dispute over design and manufacturing has been particularly heated between the United States, the European Union, China, and Taiwan. However, the shortage is global. Chips are an essential component of many products across hundreds of industries. These industries include products needed for smartphones, appliances, cars, video games, and toys. Military gear and weapons also rely on these products. Miller (2022) pointed out that chips are also a testament to a country's technological 'superiority' (p. 100).

To an extent, the political disputes over products like oil and semiconductor chips in contemporary societies echo some of the same political struggles of those seen in ancient times. Nations have traditionally sought out economic stability, adequate resources, and opportunities for growth. The Agricultural Revolution meant that groups of people could settle after a prolonged existence in various hunter-gatherer cultures. Geographical stability spurred population growth and the increasing need for more goods and competition.

The spice trade was a lucrative and power-motivated industry. As a product, spices have historically had diverse uses. Now generally seen as a convenience product, essential spices were once a highly sought-after luxury item (see Figure 5.2). Spices were used in cooking, food preservation, deodorization, religious practices, embalming, cosmetics, aphrodisiacs, and in the treatment of a variety of medical conditions. Spices also encouraged cross-cultural interactions and were also used as a form of currency. India, described as the Kingdom of Spices, was a major cultivator and attracted invasions by Greco-Roman merchants who were drawn by the 'pungent taste of pepper'. Pepper had 'non-perishable and unbreakable qualities', making it a prestigious commodity to own (Narsimhan 2009, pp. 126–129). Like pepper, nutmeg was a luxury item historically used in food, beverages, and medicine. It was used to treat everything from the common cold to the plague.

The Portuguese, English, Spanish, and Dutch waged wars to occupy different areas of Indonesia, including the Banda Islands and the Maluku Islands (known as the 'Spice Islands'). Though the Indonesian Bandanese and Ambonese organized anti-colonial resistance movements, European colonists were in fierce competition to cultivate and sell their native cloves, nutmeg, and mace. They ultimately lost to the Dutch and an unknown number of Indonesian islanders were killed and imprisoned during the conquest of the Banda Islands.

Early consumer activism and boycotts were fundamentally developed in reaction to human rights violations like attacks on the Spice Islands. Subsequently, products designed for social movements have also served as focal points for action.

FIGURE 5.2: A British nutmeg or spice box made of silver, 1743–1768.

Product Design for Social Movements

Product design has not only been situated within political disputes but has also been extensively used in the design of social movements. Designers create everything from tools, publications, and information graphics, to 'symbolic products' which address social injustices. Some products have been created on an impromptu or 'Do-It-Yourself' (DIY) basis. Other products have been intentionally banned in order for oppressed groups to express their discontent and organize commercial-oriented acts of political resistance. A lot of creativity and resourcefulness is required for products to be designed or repurposed for social causes.

Printed products and DIY design have played a particularly potent role in activist interventions that favoured nonviolence, from the late eighteenth century to the 1863 Emancipation Proclamation, which abolished slavery in the United States.

Pamphleteering helped 'black protest culture' to thrive, led by prominent figures like James Forten, Daniel Coker, and Richard Allen (Newman 2013, p. 168; Spires 2019). In the nineteenth century, sub-Saharan African mission presses and independent protest presses were formed to preserve 'indigenous black literary tradition' and aided in the resistance of the segregated 'apartheid' state (Switzer 1997, p. 3). Leading up to India's Independence Day on 15 August 1947, civil rights leader Mahatma Gandhi promoted boycotts and nonviolent protests. One of Gandhi's many accomplishments included a product-focused angle of the 'Swadeshi' movement which aimed at curbing British imports while increasing domestic textile production. As an early development in consumer rights, the Swadeshi movement also asked Indians to buy indigenous products and to be self-sufficient, teaching them the use of a handloom in order to make handmade clothing (see Figure 5.3).

Self-sufficiency and the use of homesteading products have also served as a survival tactic for those looking to make ends meet while taking part in social movements. Practical projects that foster self-sustenance were once a require-ment for many households. War gardens, also known as 'liberty' or 'victory gardens',

FIGURE 5.3: Mahatma Gandhi weaving homespun cotton cloth called 'khadi' to promote self-sufficiency as part of the Indian independence movement in the late 1940s.

were planted in backyards, lots, and on rooftops during World War I and II to help communities aggregate their resources against wartime rationing and occupation. During World War II, there were also campaigns like Britain's 'Make-Do-and-Mend' public service announcement to encourage people to 'repair, reuse and reimagine their existing clothes' in light of new clothing rationing (Imperial War Museum n.d.). Gardening campaigns and community gardens continue to play a vital role in under-resourced communities, like the Hortas Cariocas programme in Rio de Janeiro and the 25-acre Alba Alfa Community Garden in Oyo state of Nigeria. There was also a surge of interest in DIY projects during the COVID-19 pandemic, with many people sheltering at home and developing skills in gardening, baking, and home repair.

After World War II and the fight against fascism, cultural activism saw growing momentum. With much of the world making sense of life after the war, designers found new ways of making cultural products to promote social change. While the relationship between product design, politics, and cultural activism was complicated, the 'notion' that design should be purpose-led and in alignment with ethical sustainability, labour, and socio-economic standards was becoming more urgent.

The 1960s turned out to be one of the most politically active decades. There was an unprecedented number of youth-led protests in the fight for democratic values, African Americans' civil rights, early progress in the gay rights movement, protests against the war in Vietnam, and the ongoing decolonization of Africa and Asia. Author Rachel Carson published *Silent Spring* in 1962 and testified on the harms of synthetic pesticides before a US Senate Committee. Her work invigorated a modern conception of environmental activism and a testament to the fact that technological innovation could in fact 'disrupt the natural systems' (Griswold 2012; Koo 2016, p. 50). In Los Angeles, artist, designer, and activist Corita Kent (also known as Sister Mary Corita) combined vibrant colours, typography, and popular media imagery to press for an anti-war movement, women's rights, and nuclear disarmament (Stromberg 2021). During her tenure, Sister Mary Corita collaborated with architect Buckminster Fuller and product designers Charles and Ray Eames.

Like Sister Mary Corita, others would take on an increasingly socially engaged approach to design that explored social issues. Product and architectural designs of Italy's radical design movement questioned the design of cities and living spaces and members of the short-lived movement also wrote an 'anti-design' manifesto (Capdevila 2019, p. 70). In another notable movement, protests by students at the University of Paris at Nanterre and the Sorbonne University erupted into large-scale protests and a general strike that included 10 million workers seeking more protection. Known as France's 'May 1968 movement', it served as a foundation for improving working conditions as well as realizing the need for women's and gay rights (Beardsley 2018). The Paris-located École des Beaux-Arts became the atelier at the centre for creating protest art.

Posters from a print shop at the school conveyed the political messages of the May 1968 movement with posters depicting imagery such as the importance of the union between factory workers and students and criticism of the oppressiveness of state-owned media. Throughout these cultural revolutions, interdisciplinary approaches to designing communications and products became central to sustaining public attention and visualizing social unrest. This helped pave the way for the future of social movements.

While documentation of design in social movements has been fairly limited, there has been a significant shift, thanks to smartphone ownership, internet use, and social media. The digital documentation of activist movements has been emotionally moving with media pouring out of the Arab Spring, Occupy Wall Street, and Black Lives Matter movements, combined with the Iranian protests in response to the death of Mahsa Amini. The blended use of physical and digital products, graphics, and messaging in social movements has been impressive. These movements have been energized by social media and digital products that enable supporters to discuss and make donations to social causes. By the start of the twenty-first century, there were 'anti-globalization' protests that challenged the growing gap between the rich and the poor and 'environmental, human rights, and labour standards'. This implementation of political websites and e-mail communications served as 'mobilization tools' in an unprecedented way (Van Aelst & Walgrave 2002, p. 472). Protests began with the 1999 'Battle of Seattle' and then mobilized in London after a G8 meeting in Cologne.

Counter-globalization protests reflected ethical concerns that remain important to this day. There were concerns about the loss of small businesses, income inequality, and increases in outsourced labour (Kristof & WuDunn 2000). Globalization presented designers with a fresh dilemma. Gone were the days of working in fairly isolated pre-internet studio settings. For product designers, globalization meant working with globally distributed goods, a 'unified market' and 'greater uniformity' (Razzaghi & Ramirez 2005, p. 4). Richard Locke asked (2003), 'How should global corporations behave in the new international world order? What constitutes good corporate citizenship in a world where the stakeholders are diverse and dispersed around the globe and where no clear or consensual rules and standards exist?' (p. 2).

These questions would linger through the 2008 Great Recession after the subprime mortgage market collapsed. In fact, following the turmoil of the financial crisis, mass protests increased 'by 11.5% per year on average' (Brennan et al. 2020). Following the Arab Spring, demonstrations spread from Tunisia to Egypt, Syria to Libya, then came to Europe and eventually reached the United States. At that point, a revolutionary movement emerged in Manhattan's financial headquarters, with Occupy Wall Street in Zuccotti Park. Encouraged by a poster and a manifesto published in the Vancouver-based magazine *Adbusters*, Occupy Wall Street spread to over 100 cities across the country and scattered to more than 1000 in the world.

Journalist Martin Kaste for NPR wrote (2011) that the 'Occupy protests seemed to come out of nowhere' and were 'inspired by a [Adbusters] blog post by Kalle Lasn', who worked in collaboration with Micah White. The objective was the same around the globe: to keep fighting against dominant cultures that dictated social, cultural, and economic rules.

Production and consumption in design have supported advancements in manufacturing and helped shape a growing middle class. At the same time, mass production of goods and a growing global population have contributed to large-scale waste creation. Sustainable design and supply chain management have become an urgent consideration. Ethical labour is a also a growing concern and the role of corporations in these matters is becoming more heavily scrutinized. Ethical issues like these can have a lasting global impact. However, there is still a lot of work to be done to address the ways in which the consumption of goods and services impacts the environment, labour, and supply chains. Products are closely linked to intertwining histories of design, colonization, trade, and culture. These histories are embedded in our consumption habits. In turn, consumption has shaped the history of product design that calls for more attention to marginalized groups of people including women designers and designers of colour.

PART 3

PRE-INDUSTRIAL PRODUCTS

6

Surveying Design History
from Prehistoric Times

From Human Prehistory to the Agricultural Revolution

Part 3 of this book considers connections between past and present iterations of product design, and surveying cultural and technological trends from prehistoric times to pre-industrial society. Product design took on radically different manifestations during the 'Prehistoric Period' – a vast period of time beginning millions of years ago with our modern human ancestors evolving between 200,000 and 300,000 years ago. In his article 'When humans became human', science journalist John Noble Wilford (2002) described that while evolution scientists can agree on the fact that our ancestors began to walk 'habitually on two legs' between five and seven million years ago and were 'flaking crude stone tools by 2.5 million years ago', understanding when modern humans began thinking more symbolically and creatively is contested. Likewise, a conception of the 'product' and the notion of the 'consumer' is also debatable in these ancient settings. Wilford (2002) asked, 'When, and where, was human culture born?'

The Palaeolithic period (known as the Old Stone Age or the 'Lithic' stage in the Americas) marked the time when our human ancestors began to fashion stone tools and formed cultures largely centred around foraging and hunting. It is important to point out that the Stone Age has often been categorized as part of a 'three-age system': the Stone, Bronze, and Iron Ages. These are the names of major archaeological periods and are also based on the types of tools that were designed and manufactured. However, because product design and manufacturing techniques vary by continent and region, not all global regions use Christian Jürgensen Thomsen's three-age system as a framework to summarize the evolution of human technologies and toolmaking. This tripartite system has in fact been questioned as being 'Eurocentric' and overly simplified, and speaks to an evolving body of knowledge around the history of prehistoric times (Connah 2010). North American, Australasian, Asian, African, and European archaeological periods are not only nuanced and share some major qualities but also differ in terms of material and technology use. It's important

to note that there here are limitations to the palaeo-archaeological insights and terminology that are explored in this chapter. For the purpose of illustrating the transition from nomadic life to a sedentary lifestyle, the terms 'Palaeolithic' and 'Neolithic' are used in conjunction with geological terms.

There was a remarkable progression with tool design from the Palaeolithic times, overlapping with the end of the Pleistocene 'epoch'. 'Epoch' refers to time measured against Earth's geological changes up to the Neolithic times lining up with the start of the Holocene epoch. As societies began farming and building permanent settlements, archaeological data suggests that the division of labour amongst groups in Palaeolithic times was more sophisticated than once viewed, and important for survival in the dryer and colder conditions of the Pleistocene dating from approximately 2,580,000 to approximately 11,700 years ago. This marked the transition for many cultures who shifted from nomadic lifestyles to agricultural societies.

While there is limited data on the early Palaeolithic social organization, a lot of research turns to 'hunter-gatherer studies' and 'generalised forager models', and it is generally agreed that hominins (species regarded as humans) would fish, hunt, and frequently assembled in small and geographically mobile groups (Singh & Glowacki 2022, pp. 418–419). Researchers Manvir Singh and Luke Glowacki (2022) have also argued that 'habitat quality' and 'seasonal variation' played an important role in the level of mobility of a pre-Holocene foraging group, indicating that lower mobility foragers may have had a greater capacity for 'building large, politically stratified societies' where 'large-scale cooperation' was possible (pp. 420–421). Douglas W. Bird et al. (2019) have also argued that pre-Holocene 'social networks' included smaller fluid groups working within larger communities in order to exchange information and resources and to survive changing environmental conditions. There is also a growing body of evidence that some pre-Holocene sites were more technologically advanced than others. This is seen in the case of the Göbekli Tepe temple and settlement. The temple was built more than 11,000 years ago with groups of people who likely experimented with domesticating plants and animals.

Archaeological sites all over the world illustrate what types of technologies were used in prehistory, the 'products' that existed, and the extent of toolmaking capabilities. In the book *Faster, Better, Cheaper*, Christoph Roser (2016) described that 'manufacturing' which emerged in Gona, Ethiopia produced more than 3000 of the oldest known tools that date back to approximately 2.6–1.6 million years ago (p. 11). The Gona assemblage included tools for daily tasks like cutting meat and extracting marrow from bones. The South African Blombos Cave, with artefacts dating back to Africa's 'Middle Stone Age' beginning about 280,000 years ago and ending around 50–25,000 years ago, not only boasts a variety of stone point tools but also engravings, shell beads, decorated ostrich eggshells, and what is thought to be the

world's oldest drawing (University of Bergen 2020). Researchers at the University of Bergen (2016) described that engravings on the ostrich eggs at the Blombos site have also been identified on artefacts from other sites, speaking to the importance of the exchange of early technologies and the sharing of 'symbolic material culture' (see Figure 6.1). They further highlighted that (2016):

> This sharing of symbolic material culture and technology also tells us more about *Homo sapiens*' journey from Africa, to Arabia and Europe. Contact between cultures has been vital to the survival and development of our common ancestors *Homo sapiens*. The more contact the groups had, the stronger their technology and culture became.

By the late Pleistocene era, about 126,000 to 12,000 years ago, utilitarian products grew more materially diverse and technologically advanced. Earth's surface had repeatedly glaciated during the Holocene era. This development preceded our current climatic crisis by thousands of years, i.e. 12,000 years. The Holocene Age coincided with the Neolithic or agricultural revolution, as groups of people around the world began cultivating crops, domesticating animals, expanding infrastructure, and developing crafts. The move from nomadic forager cultures, to small village cultures, and then to more advanced civilizations was remarkable. Permanent settlements evolved throughout the world forming in the following locations: present-day Yucatan; the Yangtze region; along the Indus River; Italy and North Africa; along the

FIGURE 6.1: Lithic assemblages, a range of different types of stone point tools, at Blombos Cave, Southern Cape, South Africa, 2019.

banks of the Nile; and in the Zagros mountains in present-day Iraq, Turkey, and Syria (Hole 2002; Smit 2019).

During this transition, our human ancestors gained greater control of fire, a key technology in flint knapping and firing clay to make pottery. Stone tools became more refined and were shaped into arrowheads. Arrowheads, a highly identifiable archaeological artefact, were also made of 'wood, bone, antler, copper, plant parts, and other raw material types' (Hirst 2019). Additionally, tool technologies expanded to include the manufacture of burins used for engraving and gouging, prismatic blades used for scraping and cutting, and the use of bone needles for sewing. Woodworking tools and drilling tools were developed. The axe and the sickle were highly versatile tools that dated back to the pre-Holocene (see Figure 6.2) The axe was vital for chopping down trees and clearing land for farming, while a sickle was used to cut grain and grass stalks.

These general-purpose hand tools gradually improved agricultural operations beginning around 12,000 years ago. There were new incentives to establish property and record transactions, resulting in innovative thinking about production technologies. Researchers Samuel Bowles and Jung-Kyoo Choi (2013) pointed out that farming and a 'new system of farming-friendly property rights nonetheless jointly emerged', supporting the establishment of a 'stable institution' after a long period of foraging and dealing with climate variability (p. 8830). With these advancements, a number of early civilizations emerged. The birth of 'differential land access' combined with heritable land and livestock also gave rise to new conceptions of social inequality, as well as the start of the patriarchal family system (Villarca 2019).

Around 10,000 to 9000 B.C.E., early settlements in China formed along the Yellow River, with breakthroughs in developing village life and material culture – as seen with evidence of pottery making and millet cultivation. The ancient Chinese would also go on to cultivate rice, to master bronze production, jade craftwork, iron smelting, silk and tea production, and early alcohol brewing. Like the Chinese, the Akkadians and Sumerians who settled in the historical region of Mesopotamia from around 3100 B.C.E. (located in present-day Iraq, Syria, and Turkey) were seasoned potters, farmers, and artisans, eventually learning to mass-produce pottery with the invention of a potter's wheel (Simpson 1997, p. 6). Archaeologist and museum curator St. John Simpson (1997) described that Mesopotamian ceramic industries gradually evolved to include varied specialized products like storage jars, wine jars, and multi-use bevelled rim bowls (p. 6). Workshops were typically situated on the peripheries of Mesopotamian towns and mass quantities of ceramic vessels were consumed – as evidenced by the amount of ceramics 'buried' in graves (Simpson 1997, p. 7).

The Indus Valley (or Harappan) civilization, forming around 3300 B.C.E., was one of the most geographically widespread ancient civilizations, spanning Pakistan and

FIGURE 6.2: A Neolithic–predynastic bifacial sickle insert used to cut grain, and 'some of the earliest evidence of farming in Egypt', Egypt, 6900–3100 B.C.E.

northeast Afghanistan, and is known for its elaborate city plans, with drainage and trash collection systems. Indus Valley industries were varied and included jewellery making as shown by their mastery of pyro-technologies. They also designed and manufactured 'uniform' bricks that were used to construct homes, streets, and fire-baked brick 'granary' platforms that may have served as protective walls; however, the main intended purpose of some of these structures is not fully understood (Vidale & Miller 1997, p. 41; Singh 2019, p. 1587). Like the Indus Valley civilizations, the Mesopotamians benefited from the mass production of goods, which produced a lasting impact on cognition and communication. As a result of these developments, a logo-syllabic script called cuneiform was devised (see Figure 6.3)

Regional urbanization and a growing population in Mesopotamia contributed to the need to record increasingly complex transactions. Initially, 'proto-cuneiform', used between around 3300 and 2900 B.C.E. was designed to document tasks like processing of raw materials, fruits, animal products, and the distribution of grain (Woods 2020). Economic 'data' was drawn into clay tablets, with symbols largely representing nouns. Fundamentally cuneiform was a system that 'could be read in any language' though today is mainly indecipherable (The Metropolitan Museum of Art n.d.). The significant evolution of writing across ancient societies witnessed with Mesopotamian pictographs was also seen with the development of Egyptian and Meroitic hieroglyphs, Chinese characters, Old Persian cuneiform, and Mesoamerican writing systems, such as Mayan writing systems. These ancient civilizations used writing to record 'transactions, convey messages, record ritual texts, celebrate rulers, and preserve knowledge' (Eskelson 2020, p. 34). Notably, by around the seventh century B.C.E. the Latin, or Roman alphabet would be created, and has continued to be one of the most widely used writing systems globally.

Early Innovations and Global Trade

The growth of agrarian and state-level societies drove greater product design innovation, and in turn new innovation drove more growth. There were a number of factors that helped to foster design innovation after societies became sedentary. Better agricultural yields supported the growth of more administrative and speciality roles like skilled craftspeople. Farming by all was no longer mandatory in order to ensure sufficient quantities of food for the remainder of the community. This arguably also contributed to deeper exploration into engineering and craft-oriented work. Across ancient societies, there were new and unprecedented ways of working with new materials. Design innovations were also driven by better control of water and irrigation, the beginnings of metallurgy, and the birth of 'international' trade.

FIGURE 6.3: A cuneiform tablet fashioned from clay used for administrative purposes used to record entities about barley groats and malt, Mesopotamia, probably from Uruk (modern Warka), 3100–2900 B.C.E.

Scientists R. E. Sojka et al. (2002) contended that 'irrigation may be the single most strategically important intentional environmental modification humans have learned to perform' (p. 745). Between approximately 6000 and 3100 B.C.E., there is archaeological evidence of irrigation in the Jordan Valley and Ancient Egypt – with the first Egyptian dynasty formed around 3200 B.C.E. after a period of war and unification. As a society, the Egyptians would develop everything from controlled irrigation systems and papyrus to state-sponsored healthcare, and household furniture. Irrigation systems would not begin undergoing modernization until the mid-nineteenth century. However, early irrigation technologies emerged globally. These developments occurred in areas such as China, India, Pakistan, Zimbabwe, and the eastern Highveld in South Africa. Irrigation processes were also adopted by the Aztec, Maya, and Inca civilizations (Tempelhoff 2009, pp. 121–122). Nevertheless, water management skills were not always sufficient, and R. E. Sojka et al. (2002) pointed out that there is evidence that 'some ancient schemes failed', where an understanding of drainage and salt management resulted in 'eventual permanent impairment of the land' in parts of Mesopotamia and the Middle East (p. 745).

Gaining greater control over metal was also critical to building more robust and efficient tools needed for farming. This metalworking skill was utilized in the making of weaponry, ornaments, wheels, capital goods, and components like the non-coiled spring. Along with agricultural advances, the 'metal age' contributed to shaping the growth of mining operations and military sectors where a 'social division' of labour was mandatory to carry out complex tasks (Carozza & Mille 2008, p. 20).

Gold is believed to be the earliest processed metal by our human ancestors. The creative and spiritual inclinations towards metalwork can be seen with artefacts like Varna gold jewellery dating back to around 4400 B.C.E. in present-day Bulgaria, and Egyptian funerary masks and pendants, along with statuettes from as early as 4000 to 3001 B.C.E. (see Figure 6.4). Conservationist Deborah Schorsch (2017) described that Egypt was a 'land rich with gold' where artefacts were used in rituals, and while 'gold as a commodity appears to have been largely controlled by the king, Egyptians of less than royal status also owned gold jewellery'. Gold work began in the ancient Americas in the Andes around 2000 to 1001 B.C.E. and similar to the Egyptians, it was viewed as a spiritually sacred and rare material with which to forge products (Pillsbury 2020).

It was also around this time that the Maya, indigenous people of Mexico and Central America, migrated into the Yucatan Peninsula and began cultivating crops, including maize, cassava, and squash. Unlike the Egyptians or their southern neighbours, the Mayans were less interested in gold and were masterful in designing non-metal tools like bone, flint, and obsidian implements. They also vulcanized rubber for use in apparel and the making of balls used in sports games (Harris 2020, p. 7; Pillsbury 2020).

FIGURE 6.4: An Egyptian pendant designed in the shape of a uraeus, 'a royal symbol of protection' typically used in a funerary context, Egypt, 2030–1650 B.C.E.

While gold was established early on as a high-status material in many cultures, its malleable properties did not offer the structural advantages of copper, bronze, or iron. Discoveries about how to work with copper, bronze, and iron, therefore, would become central to product development and the history of metallurgy. While the exact origins of copper firing are unknown, copper smelting techniques were independently invented at different times throughout the world. Notably this technique was utilized in Middle Eastern and European tool and blade designs, and in Chinese coinage and spear points. Some evidence has suggested that the Mesopotamians were one of the first civilizations to figure out how to add tin to copper to make the more durable and less corrosive alloy, bronze. They designed ploughs out of metal substrates to create furrows and fitted wheeled chariots with metal plaques needed for transportation and warfare (Bulliet 2016, p. 124). Geologist R. J. (Bob) Cathro (2005) reflected that:

> The early smiths must have been astounded to find that combining a bit of tin, which has a hardness of 5 on the Vickers scale, with copper (50) would produce a superior alloy with enhanced workability, durability, and appearance, and a hardness of about 90. It was named bronze. With annealing, copper could be raised to a hardness of 125, whereas bronze could be raised to 228 with hammering. For comparison, wrought iron has a hardness of 80 and rusts easily, and mild steel is only 140 (2).

The next phase in metallurgy was marked by the discovery of iron. The spread of iron technologies was perhaps the most democratizing and also heavily debated (Erb-Satullo et al. 2019). While copper and bronze tools were mainly available to elite classes, iron ore was more abundant, and would eventually be made into more affordable iron and steel tools. Science writer Boyce Rensberger (1977) described that the 'democratisation of metal implements and weapons spurred economic and social advances that transformed societies several times over'. As with the Copper and Bronze Ages, the 'Iron Age' took place at different times and locations, with evidence of iron-making in present-day Turkey dating back to around 2200 B.C.E., the Ganges Valley in India around 1800 B.C.E., and in the Nok civilization in sub-Saharan Africa sometime between 1000 and 550 B.C.E. The Nok were avid potters and used both iron and stone tools (Smith 2021). While many cultures transitioned from working with copper and bronze to iron, the Nok transitioned from the use of stone tools to iron tools, demonstrating the variation that exists in prehistoric technology development.

The exchange of goods and information between cultures was also vital to seeing technologies advance in early societies. It is possible that the ancient Egyptians learned metalworking techniques from the Mesopotamians (Dartmouth Toxic Metals 2022). Minoan artisans used Egyptian elements in their work, and Egyptians imported

'Minoan pottery, metal vessels, and jewellery, and probably also wine, olive oil, cosmetics, and timber' (Pfeiffer 2013, p. 2). As Minoan artisanship was absorbed by Mycenaean Greece, Greek craftsmen ventured to Egypt. The development of Greek commerce was also influenced by the Minoan civilization residing in Crete, and cultivated 'the craftsmanship of pottery and textiles between the two civilisations' (Pfeiffer 2013, p. 1). By the time the Greeks unified into city-states known as 'poleis' through the Archaic period beginning around 700 B.C.E., regional trade was already deeply embedded into its cultural identity (Krasilnikoff 2010). Reflecting on the growth of international relations in ancient times, author and historian Mark Cartwright depicted (2018):

> The earliest written sources of Homer and Hesiod attest to the existence of trade (emporia) and merchants (emporoi) from the 8th century BCE, although they often present the activity as unsuitable for the ruling and landed aristocracy. Nevertheless, international trade grew from 750 BCE, and contacts spread across the Mediterranean driven by social and political factors such as population movements, colonisation (especially in Magna Graecia), inter-state alliances, the spread of coinage, the gradual standardisation of measurements, warfare, and safer seas following the determination to eradicate piracy.

After ancient Rome was founded around 753 B.C.E., the Romans were avid traders while exhibiting a thirst for military power and economic growth. They strategically built roads and surrounded the Mediterranean with merchant ships and warships as they expanded. The early Republic benefitted from contact with the Greeks, leading up to the Battle of Corinth in 146 B.C.E. resulting in their later conquest (Gotter 2008). Adalberto Giovannini (1993) described that Roman governors 'stripped' Greece of its works of art and that at a point 'the Roman senate became the only arbiter of Greek affairs' (p. 267). They also conquered the Etruscans, the Samnites, Spain, the North African coast, parts of the Middle East, modern-day France, and the island of Britain. Prisoners were often taken as slaves into wide-ranging occupations as craftspeople, miners, agricultural workers, seamstresses, and even physicians (Lee 2014).

Slavery was integral to the Roman labour system, and craftspeople (whether captives or born into slavery) were exploited for specific tasks in workshops and businesses (Fleming 1999, p. vii; The British Museum, n.d.). Tawhida Akhter (2020) additionally pointed out that women in ancient Greece had few rights and rarely owned property, and similarly women in ancient Rome also had few legal rights, and often had to be accompanied by a male relative or their spouse outside of their homes. In Greek society, for example, 'artisanal sectors' had entire manufacturing workshops where both the 'workers and management' were entirely enslaved people with historical evidence that these non-agricultural goods and products would be 'sold on Athens' markets' (Porter 2019, p. 33).

Overreliance on slave labour would be one of the contributing factors to the decline of Roman civilization, still a number of major inventions were designed to meet the needs of the changing times. At its territorial peak around 117 C.E., the Roman Empire was approximately 5.9 million square kilometres. The Romans invented aqueducts, a newspaper system, the Julian calendar, and a postal system. They managed large-scale mining operations and designed glassware, papyrus, and textiles. Engaging in 'regional, inter-regional and international' trade, they exported large quantities of olive, wine, and grains (Cartright 2018). Roman pottery, like cooking pots and kitchen vessels called the mortarium, were so popular that their remnants have been found from the United Kingdom to northern Africa. The Roman glassworking industry was known for its distinctive aqua-blue or green-tinged glass designs (Freestone 2015, p. 30; see Figure 6.5). As trade routes covered longer distances, spices like Sri Lankan cinnamon and Roman glassware were 'among the prized possessions of the Asian elite' (Roos 2021). A typical Roman household might contain a simple mattress stuffed with straw reeds, wool, or down (depending on income level) and terra cotta jugs used as storage containers. Glass dishes like platters and shallow bowls became increasingly common, particularly in wealthy households.

Trade relations and the exchange of knowledge and goods began to take place at important hubs, overland and overseas. In pre-Columbian North America large trade networks were established through the Hopewell settlements in present-day Ohio between 200 B.C.E. and 300 C.E. Trade networks were also established in the urban centre of Cahokia, which flourished through 600–1350 C.E. Prior to European contact, extensive routes were also established along the Inca road system – a complex network of bridges and stairways stretching 25,000 miles – 'running north to south' across the Incan Empire ultimately traversing parts of 'ancient Peru, Ecuador, Chile, Bolivia, and Argentina' (Cartright 2014).

The economic importance of shipping was well established among ancient civilizations with evidence of shipbuilding among Egyptians as early as 3000 B.C.E., and Austronesian peoples developing maritime technologies around 2000 B.C.E. Indigenous people in the Americas began using rafts along the Pacific coast from around 120 B.C.E. or earlier. However, maritime trade was not built into a true global trade network until the thirteenth century when rivers, canals, and coastal waters became more navigable with the diffusion of compass technologies.

Notably, on the Silk Road, also known as the 'Silk Routes', a network of trade routes built between eastern Asia, the Middle East, and Europe began operating around 130 B.C.E. Goods were exchanged over distances with staggered checkpoints, with the 4000-mile length of the full route so vast that very few trade or craftspeople could make the full trek. East–west routes were gradually expanded by, for example, Chinese Han Dynasty Emperor Wu (who reigned from 141 to 87 B.C.E.). Researcher Sanjeez Sanyal (2012) noted the Silk routes were 'linear', where mainly

FIGURE 6.5: A translucent bluish-green Roman glass dish, commonly used as tableware in a Roman household, 301–400 C.E.

high-value items, like silk, spices, precious metals, and other non-perishable goods were brought to the end consumer. Sanyal (2012) described pre-industrial manufacturing processes:

> The production and consumption of most items was local. This meant that producer and consumer could directly communicate with each other, and the customer could specify exactly what he or she wanted. This was the world of the village weaver, potter, blacksmith and cobbler. The bulk of pre-industrial artisan manufacturing, therefore, was customized to the needs of the end consumer.

Through prehistoric times, agrarian development, and the birth of new urban centres, new technologies and the creation of products became central to the growth of thriving businesses. Cross-continental trade enabled new interactions between different cultures, even amidst the constant tide of political conflict. Exchanges between the craftsperson and the consumer 'constituted a process of cultural hybridity in its weaving together of differing cultural practices, peoples and products' (Barron 2020, p. 4).

7

Pre-industrial Design Processes and Craft Guilds

Pre-industrial Products and Commerce

By the time the western Roman Empire fell in 476 C.E., new cultures, trade networks, and inventions had emerged. The Byzantine Empire, which had been part of the eastern Roman Empire, split off into a new civilization. In the aftermath of the Roman collapse, a number of decentralized kingdoms arose. These kingdoms included the Germanic peoples known as the Franks and Visigoths, and the Anglo-Saxon kingdoms in England. In 618 C.E., the Tang Dynasty began in China – a period of 'cultural prosperity, and foreign exchange expansion' – which saw numerous innovations in printing, mechanical engineering, and the creation of its distinctive porcelain which was valued as trade goods and also used as diplomatic gifts (Li et al. 2017, p. 358; see Figure 7.1). Between the eighth and fourteenth centuries C.E., Baghdad would become one of the world's largest cities as Islamic Caliphates came into power and influence. An Islamic Golden Age prospered with important achievements in optics, chemistry, astronomy, and mathematics. These historical events were a part of a period known in western European history as the 'Middle Ages', beginning in the fifth century C.E. and lasting for approximately 1000 years.

The Italian humanists described the European Early Middle Ages as the 'Dark Ages'. The western Roman Empire had been defeated in several battles by Germanic tribes including the Visigoths and Vandals. It is possible that the originator of the term 'Dark Ages' should be credited to Italian scholar Francesco Petrarca, who lamented that post-Roman life was devoid of cultural vibrancy and good quality literature. The term has become less common as it runs counter to the increasing understanding of the global complexity of this era. It was a pivotal time with the invention of mechanical clocks, universities, the compass, and the printing press (Grollemond & Waldorf 2022; see Figure 7.2). These inventions fostered the development of technical and scientific knowledge, increased efficiency, and encouraged cultures of intellectual curiosity.

FIGURE 7.1: A Chinese Tang dynasty porcelain jar with a white glaze, seventh to early eighth century C.E. Ceramic wares were highly valued, at times used as 'diplomatic gifts' or 'trade goods'.

The mechanical clock, invented between the thirteenth and fourteenth centuries C.E., was an improvement from the sun clock known as the obelisk, and the water clock known as the clepsydra. Historian and watchmaker Víctor Pérez Álvarez (2015) described the invention and diffusion of the mechanical clock as a 'multi-faceted historical phenomenon' that may have been inspired by a growing interest in astronomy as well as 'non-scientific motives, such the construction of monastic alarms' (pp. 63–64). Similarly, the diffusion of print technologies was a gradual and complex shift that would begin to improve literacy through the Middle Ages.

Although books were a high-end item that many households could not afford, the growing interest in printed materials was significant. Increased literacy impacted craftspeople, merchants, and the general public and advanced their ability to handle work requirements and logistics. People also became interested in reading for cultural enrichment.

Before the mechanical printing press, printed materials were handmade, which also meant that they were laborious to copy, print, and assemble. Block printing was

FIGURE 7.2: A table clock watch, Germany, sixteenth century C.E. These portable clocks were likely intended to be carried and were foundational to the wristwatch.

a common early printing technique for texts in countries like Japan, Korea, China, and Vietnam. The Chinese printing industry flourished during the Tang Dynasty, with block cutters, printers, and apprentices engaging in rigorous training. This training met the needs of a growing industry of bookmaking, book collection, and the print trade. The Chinese incorporated innovative technologies such as xylography, movable earthenware type, and colour printing. In Korea, between the twelfth and thirteenth centuries C.E., techniques were further developed to include the use of moveable metal type printing. This reduced errors common in hand-produced texts and was more precise than the wood block type. Once 'exclusive' knowledge could be shared more easily (Cheongju Early Printing Museum n.d.). Moveable metal type was also more durable and could print smaller text.

Printing technologies diffused between Asia and Europe through travellers and traders. Eventually, there was a transition from movable type printing to the mechanical printing press with the invention of Johannes Gutenberg's mechanical movable-type printing press. Many historians agree that the mechanical printing press was one of the most important inventions. After an unsuccessful enterprise in producing metal hand mirrors, Gutenberg, in collaboration with financier Johannes Fust, invented the first mechanical movable-type printing press around 1434 C.E. This new technology gradually started an information technology revolution from Mainz, Germany to other parts of Europe, and eventually throughout the world (Aldis 2011). Gutenberg's new printing technology allowed mass production of books and printed materials at an 'unprecedented scale' (also see Scherling 2020, p. 61; see Figure 7.3).

Economist Jeremiah Dittmar (2011) observed that 'cities that adopted print media benefitted from positive spillovers in human capital accumulation' (p. 4). The spread of print media and culture, the development of public education systems, universities, and libraries, as well as schools sponsored by religious organizations, would spur more cultural and intellectual reasoning. In pursuit of knowledge, different cultures became interested in education and the way it could improve their day-to-day living circumstances.

As more people learned about 'useful or desirable items', many households wanted to own these products (Goldense 2019). Innovative products like textiles, wool, linen, leather, candles, and herbal medications were advertised via word of mouth by travelling merchants and sailors, at marketplaces and trade fairs. Linen, for example, which was produced from flax stems and known for its durability and light texture, had grown in popularity. It dates back to production in prehistoric dwellings in the Alps, parts of South Caucasus, and ancient Mesopotamia and Egypt. Its use was fairly common to make clothing like tunics and caftans, bed linens, fish nets, and sailcloths (Tedesco 2022, p. 134; see Figure 7.4). Candles, made from the time-consuming process of rendering tallow, were a luxury item used to light

FIGURE 7.3: A copy of the Gutenberg Bible displayed at the New York Public Library, printed in the 1450s C.E. Approximately 180 copies of the Gutenberg bible were published and around 48 have survived.

churches and the homes of wealthier households and augmented the use of fires, torches, and oil lamps.

Even against changing political powers and periods of war and migration, products were coveted and made everyday life a little bit easier. In much of the world, it was common to work as a craftsperson, soldier, or farmer. These workers typically reported to a lord or a noble person. They also may have reported to a government within a hierarchical structure. Although travel by water was still limited through the Middle Ages, it enabled trade to a point where consumers had access to a larger variety of consumer goods and the ability to map new territories (Cartright 2019).

While trade was disrupted in the aftermath of the collapse of the western Roman Empire, others saw it as an opportunity. The Byzantine Empire maintained an important economic position through the Middle Ages. Constantinople became a hub for trade and diplomatic relations – even in light of a plague in the sixth century and foreign invasions in the seventh century C.E. (Crawford 2020).

Beginning in the seventh century C.E., regional instabilities saw increasing trade power held by the Islamic Caliphates from the seventh and eighth centuries C.E., the Vikings from the eighth century C.E., and by private trading companies from Italian city-states like Venice in the ninth century C.E. The Vikings, who came from

FIGURE 7.4: An Alanic caftan (coat) made from linen, silk, and fur, seventh to ninth century C.E., Caucasus region. Caftans with stylized motifs were common in Central Asian and Iranian cultures.

Scandinavia, were known for their seafaring skills and for building fast, manoeuvrable warships called longships. They famously conducted raids throughout Europe and neighbouring regions, including in Paris and Wessex, before they would eventually create permanent settlements in England, France, Ireland, and Ukraine.

Between the High and Late Middle Ages (around 1050–1500 C.E.), many trade routes like the Silk Routes were restored, and additional routes expanded to include Mediterranean, Trans-Saharan, Indian Ocean, and Baltic Sea trade.

City ports were established and foreign merchants were permitted to live at different trading posts temporarily to trade their goods. Urban centres like Constantinople, Baghdad, and Hangzhou took on a distinctive character, fostering commerce in their urban populations. The city of Baghdad on the East Bank of the Tigris River boasted a population of around 1 million by the eleventh century C.E. This was 'marked by strong rule, successful diplomatic relationships, economic expansion, and a cultural efflorescence' all characterized by a cosmopolitan labyrinth of aqueducts and canals, mosques, public baths, gardens, libraries, and higher education institutions (Broilo 2019, p. 334). During the Song Dynasty, its capital of Hangzhou grew to a formidable population of around 1–1.5 million, known for a vibrant marketplace for handicrafts, textiles, salt, and tea production. Other examples of large cities during the Middle Ages included Fez and Polonnaruwa. Fez, Morocco was a bustling city of nearly 250,000 people by 1160 C.E., known for its tiles (or flagstones), leather and ceramic goods, and its University of Al Quaraouiyine, which was founded in 859 C.E. (Redman 2014, p. 78). Polonnaruwa, the capital of Sri Lanka, boasted a population of nearly 100,000–250,000 and was a vibrant city filled with temples, palaces, parks, and gardens.

In particular, the merchants and explorers were interested in travelling further distances and improving sea navigation. Sea travel was a culturally significant presence, expressed creatively through poetry and art through the Middle Ages. Though literacy rates were still low, poetry and storytelling were viewed as an art form and as an essential form of entertainment in regions throughout the world (Cupane & Krönung 2016; Luo 2015). Seafaring was written about in the epic Old English poems Beowulf (eighth century C.E.) and The Norse Sagas (eighth to eleventh century C.E.). Tang dynasty poet (701–762 C.E.) Li Bai wrote about adventure, travel, and sailing the Yangtze River. Though not much is known about Kakinomoto Hitomaro, the Japanese poet described seafaring and marine life.

Foundational navigation tools like the hourglass and water clock enabled some measurement of time but were 'not enough for journey at sea' (Selbesoğlu, Barutçu, & Çökelez 2021, p. 15). Sailors made use of early maps and geographic coordinate systems, navigation points like large rocks, the direction of the winds, and the position of the sun. Yet it was the first known compass dating back to the Chinese Han Dynasty, invented around 202 B.C.E.–220 C.E., that would greatly

improve navigational accuracy. The Chinese compass was first designed for divination purposes and later adopted for navigational use. There is, however, very little recorded history about how the compass, as a technology diffused and advanced, 'which spread over many geographies and was developed by different people after the Middle Ages and the period of discoveries' (Selbesoğlu, Barutçu, & Çökelez 2021, p. 18). Shipbuilding also improved, making them better suited for longer voyages, with galleys replaced by sails, and with larger holds built to store more food, water, and goods for sale.

The variety of products grew more varied and geographically widespread, and so did the demand. In particular, there was a growing demand for quality assurance. There were increased efforts at standardization in the quality of products, and treatises were drawn on 'how to compare weights, measurements, and coins across different cultures' (Cartright 2019). Craft guilds also ensured that high-quality products were being made, signifying new ways in which product designers were educated in their respective crafts.

The Life and Education of the Pre-industrial Designer

The demand for designers continued to grow as pre-industrial societies advanced and there was an increasing need for organizations of workers who were trained in different product and craft specialities. In response to these changes, designers took on specialized roles in pre-industrial society, working as craftspeople, artisans, artists, engravers, and decorators (Cipolla 2003).

In early craft production-based education models, apprenticeships were frequently managed within guilds and were a common position for the transfer of professional knowledge between an experienced product designer and a novice (Bosshardt & Lupus 2013, p. 65).

In nearly every part of the world, some type of guild or organization of craftspeople existed. Associations were widespread, 'found for thousands of years in many economies across the world: Ancient Egypt, Greece, and Rome; mediaeval and early modern India, Japan, China, Persia, Byzantium, and Europe; 19th century Latin America and the Ottoman Empire', as well as in indigenous pre-Columbian America (Ogilvie 2020, p. 2). They were built on principles of practical learning, responded to consumers' needs, typically would have a master or a leader, and simultaneously enabled craftspeople and merchants to work together. European and East Asian guilds shared some similar hierarchical features, although guilds in Japan and Korea were more tightly controlled by the government. In Japan some guilds were 'temple-sponsored'; the temple would oversee a wide range of 'goods and services' like paper, fish, and sake (Adolphson & Ramseyer 2009).

Economic historian Sheilagh Ogilvie (2020) described that craft and trade guilds might also have limited admission as an 'entry to its occupation', providing quality assurance between producers and consumers with different types of 'guild quality certification' (p. 1).

Through the Middle Ages, the education of a 'designer' might begin with an indenture as an apprentice around the age of 12 or 13 or younger, at which one would be bound to years of technical training under a master. Later, as rates of literacy improved, some contracts of indenture would be extended to include several years of schooling in reading and writing. While guilds frequently incorporated the apprentice model, Ogilvie (2020) noted that apprenticeships 'existed widely without guilds' too, and 'private apprenticeships' were more common in England and the Netherlands than in other parts of Europe. For those who participated in guild-sponsored apprenticeships, it might look somewhat like this description by William Bosshardt and Jane S. Lupus (2013):

> Guilds were organized so that workers would learn skills from others connected with the guild. Members traditionally advanced through the stages of apprentice, journeyman, and finally master. An apprentice was a young person, most often male, who learned a trade by working for a guild master. Apprenticeships often began at age 12, and commonly lasted from two to seven years. Apprentices frequently lived at their master's house and were given room and board, but earned no money. After finishing an apprenticeship, the worker could become a journeyman.
>
> (p. 65)

While this was a generalization of what a guild might look like across many cultures, there were nuances in the social construction of guilds across different cultures. Craftspeople from the West African Dyula guild (which originated around the eleventh century C.E.) could achieve a high social status by making drinking horns, clay vases, and statuettes, and established themselves in major trade networks and trade hubs like Timbuktu. The Dyula's craftwork and merchant activities were largely structured around family and ethnic lineage, or in what can be characterized as a 'merchant caste' (Conrad & Frank 1995). Merchant castes were also common in India and Southeast Asia. In India, for example, the Banias, the Melwaris, and the Gujaratis were prominent. In Southeast Asia, the Chulia, Jewa Pekan, and the Peranakan were known for their skills in craftwork, trade, and commerce.

Guilds were also developed in pre-Columbian America, prior to European contact. Like the merchant castes, Mesoamerican 'guilds' were generally organized by kinship lines and family relationships. Among indigenous Mexican craftspeople (the Aztec and the Nahuas), young men could study at a commoner's school called a 'tēlpochcalli' where they specialized in a single craft called a 'calpulli' unit, with

some of the elite craftwork including 'metal smiths, flower workers, feather workers, lapidaries, and makers of rabbit hair embroidered cloth' (Brumfiel 1998, p. 146).

In contrast, many Native American societies structured craft and trade 'groups' and 'organizations' based on familial specializations along with their spiritual practices and beliefs. The Mandan tribe of the Great Plains was a great trading nation that sold meat and corn in tribe-to-tribe relations and whose artisans made distinctive goods including moccasins, quillwork, parfleche, and pottery (Schneider 1983). Women's roles varied by tribe and geographic region in North America. For some women in the Mandan tribe, pottery making was a protected right, 'practiced by only a few women in a community' (Wilson, Wood, & Lehmer 1997, p. 97).

The advantages and disadvantages of guild education for designers are still debated among scholars Ogilvie (2020). High economic output was not necessarily correlated with the strength of a guild. In some regions where guilds were weaker, in the southern Netherlands and parts of France for example, there was some documentation of faster urbanization (Ogilvie 2020, p. 21). Guild and apprentice systems discriminated in terms of who they admitted. Ogilvie (2020) described that:

> Virtually all guilds excluded women, Jews, gypsies, Muslims, Orthodox Christians, and Anabaptists. Guilds excluded Protestants in Catholic places and Catholics in Protestant ones (Kluge 2007). Guilds in German-speaking central Europe and in Iberia imposed particularly onerous entry barriers based on ideas of honour and defilement. Thus a number of Spanish guilds excluded boys whose skin was the wrong colour (in one case anyone 'darker than quince jam'), whose parents practised a 'vile' occupation, or whose ancestors had been slaves or religious converts.
>
> (Klein 1932; La Force 1965)

At the same time, improvements in design and engineering paved the way for a period of exploration known as the Age of Discovery beginning in the fifteenth century C.E. This also marked the start of European colonization of Africa, Asia, and the Americas which was a prolonged and difficult time for many indigenous groups in these countries. The design studio setting took on a more definitive educational identity as a multidisciplinary setting that embraced a range of technologies, tools, and production methods in a world with diversifying needs, wants, and personal aesthetics. For product designers working as craftspeople, the quest to perfect new time-saving techniques became more urgent.

PART 4

INDUSTRIALIZATION AND THE SOCIO-ECONOMIC IMPACTS OF DESIGN

8

Industrialization

Colonialism and Design

Part 4 of this book examines complex and nuanced topics such as industrialization, colonialism, and the rise of consumer culture. Towards the start of the period known as the Industrial Revolution, which would take place between the eighteenth and

FIGURE 8.1: A silver sugar box for storing the expensive refined sweetener. Sugar was described by Mary Elliott and Jazmine Hughes (2019) as a 'deadly commodity' that powered the slave trade in the Spanish Americas and the Caribbean. Sugar was introduced as a luxury item in close parallel to products like tea, chocolate, coffee, and tobacco, 1673–1674, London.

nineteenth centuries C.E., there were significant changes around how products were made, and specifically what products were in demand. It was a period defined by global exploration, scientific discoveries, and stark social inequalities. Large sailing ships called galleons were modified to meet the needs of trans-oceanic travel. This modification made long voyages and the transport of goods more feasible (Lardas 2020, p. 8). Monarchs ruled in many parts of the world, and evidence has suggested that income and wealth inequality grew 'almost everywhere in Europe'. This was also evident in late Tokugawa Japan – though the data remains largely incomplete (Alfani 2021, pp. 1, 18).

An interest in learning continued to gain momentum, and the number of universities around the world nearly doubled between the seventeenth and eighteenth centuries C.E. While these institutions of higher learning were still relatively small, they offered the opportunity for more advanced study in the sciences, mathematics, theology, law, and medicine. Some of the first institutes dedicated to the study of design and engineering incorporated the study of mechanical engineering, mining, and military construction design. The institution-based study of design expanded traditional guild-sponsored education.

In search of new opportunities, the 'Age of Discovery' signified an increase in 'colonization', where control by global powers was exerted over-dependent areas and groups of people (Blakemore 2019). The discovery of the 'New World' combined with population growth and 'inflows of precious metals' contributed to a Great Inflation, and in some regions, the price of food, therefore, increased (Edo & Melitz 2023, p. 25). Specifically, during the sixteenth and seventeenth centuries C.E., the population grew in much of western Europe, India, and China. England's population nearly doubled between 1550 and 1750, and France, Germany, Italy, and Spain also saw significant population increases (Roser et al. 2013, p. 11). Naples, Italy had grown into one of the largest cities in Europe, as well as one of the poorest (Campell 2011, p. 6).

Through the sixteenth and seventeenth centuries, western European powers established colonies in North America, South America, the Caribbean, Asia, and Africa. European contact with the western Hemisphere radically reshaped indigenous cultures and economies all over the world. National Geographic Society (2022) described that while Native Americans 'resisted the efforts of the Europeans to gain more of their land' through a mix of diplomacy and warfare, they were vulnerable to precarious alliances with European settlers. New diseases like smallpox quickly 'decimated' indigenous populations. Outside of western Europe, the Ottoman Empire, the Mughal Empire, and the Russian Empire also engaged in territorial expansionism seeking to build colonies and grow their territories.

The motives for colonialism were complex. Competing powers, especially European powers, sought to secure resources like gold, silver, sugar, spices, and timber to gain more wealth and ensure lasting control over these resources (see Figure 8.1).

Colonization offered the opportunity to further cement political and military control over trade routes along with building new military bases and manufacturing operations. Colonization also offered a means to spread specific ideologies and values to foreign groups of people and offered new lands to emigrate as an approach to dealing with overpopulation and inflation. In reference to colonization, author Erin Blakemore described that (2022):

> Spain and Portugal became locked in competition for new territories and took over indigenous lands in the Americas, India, Africa, and Asia. England, the Netherlands, France, and Germany quickly began their own empire-building overseas, fighting Spain and Portugal for the right to lands they had already conquered. Despite the growth of European colonies in the New World, most countries managed to gain independence during the 18th and 19th century, beginning with the American Revolution in 1776 and the Haitian Revolution in 1781. However, the Eastern Hemisphere continued to tempt European colonial powers. Starting in the 1880s, European nations focused on taking over African lands, racing one another to coveted natural resources and establishing colonies they would hold until an international period of decolonization began around 1914, challenging European colonial empires up to 1975.

The 'colonial mentality' that flourished from the fifteenth and sixteenth centuries C.E. into its peak in the nineteenth and twentieth centuries was particularly damaging. It was not a new way of thinking – civilizations like Egypt and Rome had a long history of exerting power over others. However, there were a number of troubling circumstances to be considered, such as the slave trade and interest in cheap labour, a 'military revolution' to maximize the use of weaponry, and new cultural and racial hierarchies that shaped rigid views about how people viewed human rights. Susanne Lachenicht (2023) observed that 'colonization in the early modern period was as much about religious missions, about "the harvest of souls," as it was about expanding territorial boundaries and economic resources'.

Authors Mary Elliott and Jazmine Hughes (2019) pointed out that the trans-Atlantic slave trade, starting as early as the fifteenth century, 'introduced a system of slavery that was commercialized, racialized and inherited'. Enslaved people were treated as products or 'commodities'. Elliott and Hughes (2019) described that approximately 'one out of 10 slave ships experienced resistance, ranging from individual defiance (like refusing to eat or jumping overboard) to full-blown mutiny'.

Textiles and spices continued to be in high demand, and new products like sugar, tobacco, and cotton further motivated the use of enslaved labourers. These labourers were subjected to long work days, dangerous working conditions, and shortened life spans (see Figure 8.2). These abhorrent conditions particularly impacted those working in the sugar cane plantations. In response to slavery, abolitionist movements

FIGURE 8.2: An oil painting depicting slave traders capturing a man on the coast of Africa by English painter George Morland, 1788. Collection of the Smithsonian National Museum of African American History and Culture.

gained momentum in the United States and many parts of the world including the United Kingdom, Brazil, and parts of Europe. A revolution and slave rebellion in Saint-Domingue, led by Toussaint Louverture, resulted in Haiti's independence by 1804 (Pontius-Vandenberg 2020). In the United States, prominent abolitionists like Frederick Douglass, Anna Murray Douglass, Sojourner Truth, and Harriet Tubman played pivotal roles in anti-slavery activism. In 1863, President Abraham Lincoln drafted The Emancipation Proclamation, thereby freeing about 3.5 million African American slaves. Sadly many enslaved people were unaware of their freedom for several years.

Following the European precedent trade guilds were established in colonial urban centres throughout the Americas (Bosshardt & Lopus 2013). In British North America, as much as 'forty to seventy-five percent' of White European immigrants experienced a 'period of indentured servitude', though the indenture system would be largely dissolved after the American Revolution (Iacobacci, p. 10). Some craftspeople also established their own family businesses and some women, particularly wives or widows of craftsmen, were empowered to learn a trade. Quilting,

which was recognized as a female or domestic craft, was important to learn, as it was necessary in order to make bedding. Women in the New England colonies used their designs to 'document their lives' and share their beliefs and ideas (MacDowell 2020, p. 3).

While apprenticeships continued 'in name', authors Patrick Ainley and Helen Rainbird (2014) observed that the education required for craftspeople gradually became less restricted, with the gradual abandonment of the 'mutually binding nature of indentures' and an 'increase in scale of operations'. This led to less supervision from master artisans which was previously needed for their craftspeople and apprentices (p. 17). Having acquired new skills and more control over their creations, craftspeople started to establish the foundations of modern design as a profession (Hollis 1994, p. 97). In the history of work and education in design, these changes also signified the birth of a new style of apprenticeships that combined design with engineering. This marked a turn in the product designer's role, evolving more towards commercial work suited to meet the needs of growing populations in increasingly fast-paced societies.

The Industrial Revolution

For centuries there was a deep interest in mechanizing work processes such as improving speed and output and replacing heavy manual labour tasks with the use of machines. Some early, experimental steps were taken to harness different types of energy sources. Since prehistoric times coal has been used as fuel for cooking and heating. As early as 200 B.C.E., Nehbandan windmills were designed in present-day Iran to harness the power of wind energy and convert it into mechanical energy capable of grinding grains and pumping well water (Zarrabi & Valibeig 2021, p. 1). By the first century C.E., the Greek engineer 'Heron (or Hero) of Alexandria' is credited with designing a simple steam turbine design known as the 'aeolipile' (Papadopoulos 2017, p. 2). Waterwheels proved to be highly effective in powering machinery in early manufacturing but were susceptible to poor weather conditions and lacked a reliable water source. After centuries of experimentation, improvements in the late eighteenth century saw rapid technological advancements.

Many historians acknowledge that the beginning of the Industrial Revolution in Great Britain was related to several key inventions, including the spinning jenny (created in 1764 or 1765) and the steam engine (see Figure 8.3). Between 1764 and 1765, a cotton weaver named James Hargreaves invented the 'spinning jenny', a hand-operated machine that could simultaneously spin up to eight spindles of thread. Hargreaves' simple yet 'ingenious' design was arguably a 'macroinvention', a highly impactful new technology that also set off 'a long trajectory of advance

FIGURE 8.3: An engraving depicting a spinning jenny by Wilson Lowry, London, 1811.

that resulted in huge increases in productivity' (Styles 2020, p. 195). The British Library (n.d.) described that while the spinning jenny was initially designed to use 'eight spindles onto which the thread was spun', it would be 'increased to eighty' and drive the impetus for the creation of factories that could 'employ nearly 600 people'.

Craft workshops with limited production capabilities were strained to meet demand, and business developers saw that they could use larger industrial buildings that could employ more workers and create more goods. To accommodate demand, some of these smaller multi-level apprenticeships and guilds had already transitioned from independent workshops to 'state-owned manufactories' – like France's Gobelins Manufactory (which expanded in the seventeenth century) and the Meissen porcelain factory near Dresden, Germany (established in 1710) (Raizman 2003, p. 17). Specifically, demand in the cotton industry had grown after The British Parliament issued the Calico Act – once in 1700 and again in 1721 – to restrict the import of cotton textiles and boost the domestic wool industry. In comparison to wool, cotton was light and comfortable, and large amounts of Calico cotton and intricate fabric

designs called palampores (or hand-painted fabrics) were imported from India to Great Britain by the East India Trading Company (Sanyal 2012).

Shortly after the spinning jenny was invented in 1769, the water frame was invented. This used water power to drive the spinning machinery. The invention of the spinning mule in 1779 combined features of both the spinning jenny and the water frame. In 1794, a machine called the cotton gin was invented by Eli Whitney, which made the removal of seeds from cotton fibre more efficient. Together these innovative products made it possible to simplify and automate tasks and to create greater quantities of textiles. Their emergence was also closely timed with the development of a more efficient steam engine.

The first steam-powered pump, which was used to pump water out of coal mines, was designed and patented in 1698 by a military engineer Thomas Savery. Coal and black coal (or 'coke' fuel) would replace wood fuel and would yield major increases in smelting and iron production required in the making of machine tools and hardware, construction materials, cooking implements, and machinery. However, coal mining was a dangerous profession where machine accidents, mine collapses, and flooding were common problems. The Savery engine, as an early iteration, had a number of flaws and was further developed by Thomas Newcomen by 1712. The Newcomen Engine was more adept at pumping water out of coal mines, nevertheless, the design was inefficient. Scottish engineer James Watt began working on a model of Newcomen's engine, concluding that 'heat losses caused useless condensation' (Mitrovic 2022, p. 1). Watt modified Newcomen's design to include a 'separate condenser', and steam could be condensed into a separate chamber (see Figure 8.4). He later enhanced the engine design with a rotary motion that saved even more energy.

These advancements happened in a relatively short period of time and on the whole, the Industrial Revolution was characterized by unprecedented technological breakthroughs that led to a period of sustained economic growth, cultural change, and greater availability of goods and services. Further refinements to the Watt design enabled the engine to automate tasks like driving 'machinery in paper, cotton, flour and iron mills, textile factories, distilleries, canals, waterworks, and also drive an early steam locomotive' (Waterloo n.d.). By 1769, Nicolas-Joseph Cugnot designed and built the first self-propelled steam vehicle. This design was the basis for the automobile and was later developed into an internal combustion engine in 1826. By around 1787, John Fitch had built the first steam-powered boat by 'scraping together private investments and racing ahead of his competitors' (PBS n.d.). An array of steam-powered tools was designed following the engine, including the power loom, the steam hammer, and the steam-powered printing press.

The Industrial Revolution also brought on a more systematic and large-scale organization of work. As mass production processes widened, the use of pattern

FIGURE 8.4: A Watt-type steam engine, called a beam engine, used to drive coining presses in the Royal Spanish Mint between 1861 and 1891.

books, containing instructions on product design specifications, became fairly widespread. Collections of motifs and patterns were applied to various products and it became increasingly hard for 'individual customers to specify requirements', thanks to the move towards product standardization (Sanyal 2012). Standardization processes began with some of the earliest known factories like Derby Silk Mill and the Cromford Mill, spreading to Europe and the United States. In 1861, Eli Terry designed a 'clock small enough to set on a mantel or shelf'. It was one of the first widely used, mass-produced items when brass was substituted with wood. Terry demonstrated that designs could be highly economical.

Similar principles to save time and material costs were implemented across early mass-produced products. 'Silverplating' made the mass production of silverware more affordable by applying a thin layer of silver to a less expensive substrate. The Coalbrookdale foundry used sand-casting processes to speed up the production in making cast iron materials and their well-known cooking pot. In Josiah Wedgwood's factory, standardized moulds and a division of labour made it ossible to mass produce dinnerware and tea sets, Jasperware, stone, and creamware. Factory-produced

papier mâché furniture and household goods were also shaped using moulds and could mimic more expensive, aesthetically similar-looking products (see Figure 8.5). The art of crafting with paper was also common in Mexico and parts of Central America for the purposes of sculpting, even though the Spanish banned the use of 'amate' bark-derived paper after their conquest of Mexico.

Modern businesses and their consumers were increasingly literate. American colonists read newspapers like The *Boston News-Letter*, founded in 1704, and the *Pennsylvania Gazette*, which was founded in 1728 and acquired by Benjamin Franklin in 1729. The British read the *London Gazette*, founded in 1665 and exchanged 'trade' cards. These were about the size of a business card and advertised a variety of goods, from clothing brands to food and household products. The growing popularity spoke to several trends. Business-related communications were becoming more complex, and with more access to public education systems, purchasers were becoming more discerning and more sensitive to text-based communications materials. It also highlighted when technologies were automated, products that were labour-intensive

FIGURE 8.5: A papier-mâché tableware design by Jennens & Bettridge, 1816–1864, Birmingham, England.

became more affordable. As a result, media outlets increasingly served as a way for customers to differentiate between competing businesses. The demand for printed media increased so much that paper shortages resulted. However, replication techniques became more manageable with steam power.

While there was a clear leap forward for many societies, others were fundamentally left behind. Consumer demand for products drove many traditional crafts to factory processes that made parts of the craftsperson's job obsolete or less essential. Consumers could revel in more competitively priced, factory-made goods at some of the earliest modern department stores. This enabled access to Arnold Constable in New York in 1825, Le Bon Marché in Paris in 1838, and Falabella in Santiago, Chile in 1889. Countries that were colonized, or experiencing a combination of political and financial problems in the late eighteenth century and nineteenth century were arguably less likely to adopt new technologies of the Industrial Revolution.

The magnitude and importance of the Industrial Revolution have remained central to an ongoing debate on the 'timing, location, and cause' of this series of developments (Clark 2012, p. 85). Some scholars cite 'incentives for economic growth', while others think it was a result of particular growth in cultures and ideologies, and others still argue for a hybrid of both sets of factors (Clark 2012, p. 86).

Following the British and American industrial revolutions, industrialization occurred in Germany and spread as far as Mexico, Brazil, and parts of South America in the late nineteenth century. The twentieth century saw sporadic industrialization in Africa and rapid industrialization in South Korea, Taiwan, and Singapore after World War II. It was not until the 1980s that China quickly industrialized, initially finding demand for its production of textiles, furniture, toys, and varied consumer goods. Eventually, they produced higher-value goods.

As modern industrial societies around the world continued to grow, the role of craftspeople, and commercial and applied artists developed and broadened, and as a result, so did the education and professional skills required (Efland 1990, p. 45). There was a need for a new type of designer. The changing times called for an 'industrial designer' skilled in working with a variety of materials and manufacturing technologies to create products that were more uniform, functional, but also visually appealing. Technological advances were vital to the 'rising' field of product and industrial design. Along with advancements with product design came the birth of the modern education systems, consumer culture, growth in rail transport, and the beginning of electrification.

9

Design, Social Reform, and a Technological Revolution

Design and Social Reform

The Second Industrial Revolution, which started around the 1870s and lasted through 1914, witnessed a continuing technological revolution as design capabilities expanded to steel and chemical production, railroads, electrification, and the growth of telecommunications. It was known as the 'Industrial Age' and the 'Machine Age'. Design and mass production trends to standardize products became more widely implemented. Manufacturing capabilities spread from Great Britain to Belgium, France, Germany, the United States, and Canada. Japan underwent its own industrialization period (during the Meiji Restoration) as the country returned to imperial rule in 1868. The advisors to the young Emperor Mutsuhito toured twelve countries and developed a plan to become a modern state with a strong economy (Woods 2004, p. 116).

New techniques in the mass production of steel enabled the construction of railways and bridges, and goods could be more easily shipped overland. Factories expelled smoke, and layers of smog hovered over London, Manchester, and Pittsburgh (USA), and the stench of industrial pollution was so great in London that it was known as the 'Great Stink'. Industrialization made affordable mass-produced products more readily available, and also saw the growth of poorer working conditions and lower wages, presenting a quandary (see Figure 9.1). This, in turn, led to a number of important social reform movements to improve working conditions, and education, and secure more rights for women and children, and former slaves known as 'freedmen' and 'freedwomen'.

Through this period, there was a good deal of immigration to large cities and overseas in search of economic opportunities where people were driven by various 'push' factors like famine and persecution. Passenger ship services had vastly expanded and in spite of dire conditions, the ships carried new waves of southern and eastern European, Jewish, and Asian immigrants who were headed to new countries and faraway frontiers in pursuit of a new life. Colonial land incentives, provided

FIGURE 9.1: A wood engraving by Winslow Homer depicting factory life at a textile mill. Factories were initially viewed as places where 'mostly women – could earn a decent income and make a contribution to the nation's industrial transformation'. By the late nineteenth century, factories increasingly hired immigrant populations, but paid them lower wages (Smithsonian American Art Museum 2011), New England, 1868.

in the form of 'land grants', motivated settlers to farm in countries like Brazil and Argentina (Chambouleyron & Arenz 2021, p. 227). Land grants also incentivized the design and construction of railways in Australia, Canada, and New Zealand. For a small registration fee, the US Homestead Act of 1862 awarded 'citizens' and 'future citizens' 160 acres of public land to live and cultivate. Pioneers helped build new states, towns, and schools (Schamel & Potter 1997).

Mining was also a powerful incentive to immigrate. Through the mid to late 1800s, people flocked to Australia, South Africa, and California to create mining settlements. 'Gold rush' jewellery, ornaments, and keepsakes became popular sought-after products (see Figure 9.2). The goldfields drew in miners and entrepreneurs from different parts of the world, and incidents of racial discrimination and segregation were not uncommon. Chinese miners lived in separate camps from Europeans on the Australian goldfields, and forced labour was routinely used to operate South African mines (Lawrence 2005, p. 287). Westward expansion and the discovery of gold displaced Native Americans who were relegated to reservations

FIGURE 9.2: A belt buckle manufactured by the California Jewelry Co. After gold was discovered in California, items like buckles, rings, hair combs, and 'tourist trade' ornaments grew into popular jewellery products, San Francisco, 1868.

and were denied bargaining power. Needless to say, the tribes resisted. Sitting Bull, who died in 1890, was one of the Native American chiefs who resisted European American settlement in indigenous lands along with the imposition of a reservation system.

The wave of immigration to the United States, in particular, was unprecedented. Nearly 36 million immigrants entered between '1820 and 1924', and many immigrants were simultaneously drawn to ideals like American prosperity, religious freedom, and democratic values (Hirota 2018). Curator John Grinspan (2021) highlighted that 'American democracy held revolutionary new promise'. The United States boasted a new system of government that promised to empower the working class and was 'one of the first in world history to give decisive political power to people without wealth, land or title' (Grinspan 2021).

Nevertheless, in contrast to this 'new promise', many workers including men, women, and children routinely found jobs in 'sweated industries' like textile manufacturing and food processing where working hours were long and pay was low. African workers in British, French, Belgian, and Portuguese colonies were routinely exploited and paid nothing or little at all (Hodgson 2015). The same industrial technologies that made products more readily available also contributed to poor work conditions as well as the degradation of the environment. Many of these workers possessed some of the trade skills of a product designer and could make textiles, apparel, pottery, furniture, and mass-produced crafts within the fast-paced factory setting. In his 1776 book *Wealth of Nations*, economist and philosopher Adam Smith questioned the rising manufacturing system, asking if 'in every country, it always is and must be the interest of the great body of the people to buy whatever they want of those who sell it cheapest'.

In the aftermath of global abolitionist movements, there was increasing momentum to gain more rights for African Americans, women, and children. These vulnerable populations were still excluded from organizations, unions, and labour law protections, and continued to be exploited and coerced in the new industrial age. The suffragists believed in social reforms and would spend decades fighting for women's rights and their right to vote. Likewise, labour activists like Florence Kelly fought to see better workplace conditions and more liveable state minimum wage laws. From the mid-1800s through the early twentieth century, these activists shaped a number of 'radical' and 'reform movements' to campaign for universal suffrage, child labour reform, accessible public schooling, and more democratic systems.

A Technological Revolution

As sprawling and disorderly commercial centres expanded, competition soared between businesses designing and selling products. It was a consumer revolution closely intertwined with a technological and scientific revolution. Technical innovations were exploited to enhance mass-produced products, and a 'consumer society' was born (Church 2000, p. 622).

To the disappointment of some traditionalists and preservationists, a multitude of these new consumer products was put on display at the *Great Exhibition of 1851* held in Hyde Park, London. The event brought together approximately '14,000 producers' from around the world and drew an astounding six million guests. On view were eclectic items such as new kitchen appliances; an early prototype of a voting machine; a telescope; Māori crafts from New Zealand and Sunar crafts from India; the daguerreotype (the first publicly available photographs); tin-glazed majolica pottery; steel-making machines; and an American grain reaping machine. The sheer demonstration of manufacturing power and the range of goods was distressing to designers who were part of a growing Arts and Crafts movement that questioned industrial manufacturing processes and argued for preserving traditional craftsmanship. Augustus Pugin and John Ruskin publicly challenged the quality of industrial goods at the *Great Exhibition of 1851*, campaigning for environmental protections, and warned the public about the overproduction of manufactured products (Fuad-Luke 2009, p. 37). In many ways, their concerns went unheeded.

This sheer display of industrial power spoke to the new demands on product designers, who found themselves working in factories and commercial workshops in collaboration with machinists, entrepreneurs, and scientists. Driven by growing industrialized economies and the need to support the manufacturing industry, Great Britain, France, and Germany created trade schools and academies to train designers to meet these industry needs. The Geneva Drawing School was established, and the Ecole des Arts Decoratifs in Paris was expanded to include furniture design, textiles, and metalwork specializations. In 1837, the British House of Commons founded the Government School of Design to continue supporting commercial growth and the Aesthetic Movement (Efland 1990, p. 58).

The curriculum at the Government School of Design known as the South Kensington system, taught a 23-stage course of instruction that, above all, favoured accuracy and the 'habit of correct observation' (Kantawala 2012, p. 213). With the goal of 'extending a knowledge of the Arts and the Principles of Design among the people (especially the manufacturing population) of the country', designs could be created to meet the needs of a new 'middle-class consumer culture' (Raizman 2003, p. 51). The South Kensington method was replicated in the United States by art educator Walter Smith who was hired as the art supervisor for the city of Boston and the state of Massachusetts in 1871 (Efland 1990, p. 96). While Smith helped bring his South Kensington method to the United States and Canada, other 'South Kensingtonians', such as educator David Philip Blair, helped carry this method of instruction to British colonies, including South Africa, Australia, and New Zealand (Chalmers 1985). This method continued to spread globally, introducing some level of standardization into design curricula. These practices went hand-in-hand with the rapid industrialization in varied communication, chemical, and infrastructure sectors.

By the late nineteenth century, new ways of communicating information were quickly becoming central to carrying out daily functions. The first commercial telegraph was invented in the 1830s, first as a needle telegraph, and then as an encoded system by Samuel Morse, Joseph Henry, and Alfred Vail (see Figure 9.3). The Morse

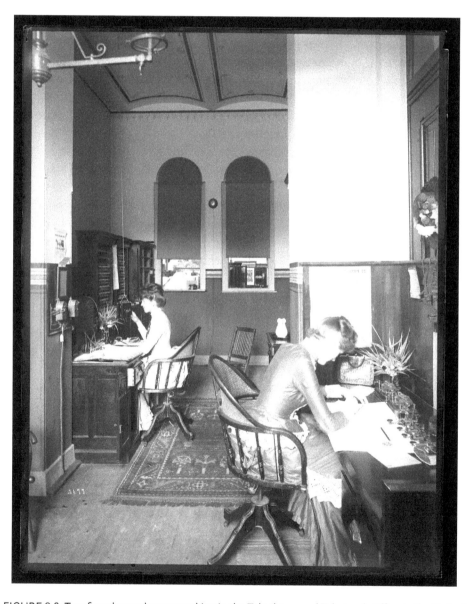

FIGURE 9.3: Two female employees working in the Telephone and Telegraph Office in the United States. National Museum, 1880s, Washington D.C.

system, using a code made up of dashes and dots, was transmitted using electric signals and could rapidly transmit news. Importantly, it also included a way for railway systems to allow communication between trains which enabled the expansion of railroads. Telegraph systems became a central part of colonial governance, and in part expanded in response to mounting discontent across colonies. This discontent materialized with the 'Indian Rebellion of 1857' against the British East India Company sparked by issues like pay inequality, taxation, and the attack of traditional Indian culture (Gershon 2023). The telegraph also provided women with job prospects. Women were able to increasingly find work in specific 'information labour' roles as typists, telegraphists, and general office administrators (Hindmarch-Watson 2020, p. 17). It was still rare for women to find technical design work outside of textile design, with some exceptions like Henrietta Vansittart's design of the marine screw propeller blade (for use in steamships), and Sarah Maria Guppy's patented design for suspension bridge foundations (Warren n.d.).

The print industry simultaneously grew into one of the largest industries, and advertising became recognized as an effective means to sell products (Jury 2012, p. 202). Competition among publishers and advertisers ensued as newspapers, magazines, and posters steadily entered into mainstream consumption. The design of publications was soon elevated by the use of commercial photography and by the typewriter. A Milwaukee-based newspaper printer Christopher Latham Sholes invented the first commercially successful typewriter, the Sholes & Glidden Type Writer. While consumers found the typewriter to be somewhat cumbersome at first, it would gradually be adopted for publishing, legal, and business communications.

Advances in chemical industries produced a wide range of synthetic materials making products more affordable. The discovery of synthetic dyes, beginning with the purple dye mauveine in 1856, made it possible to 'democratize' women's wear, making clothing more accessible (Vettesse Forster & Christie 2013, p. 2). Brightly coloured garments, once mainly for the wealthy, could be easily designed with new synthetic textile dyes and 'colour preferences became a dominant feature of fashion' (p. 11). Dyes were also used to enhance the colours in photographs and printed materials and to modify the colours of canned fruits and vegetables, meat products, and jams. Along with synthetic dyes, synthetic materials like nylon, rayon, and Bakelite were invented in the late nineteenth century (see Figure 9.4). In 1905, chemist Leo Baekeland created the first fully synthetic plastic as a replacement for shellac – a resin from the lac insect that had been used for centuries in Thailand and China.

By 1875, the petroleum industry achieved better oil processing techniques, including 'continuous distillation' that allowed mass production of refined oil. New techniques in oil processing led to the creation of products like kerosene, gasoline, as well as paraffin wax, and asphalt. Kerosene, also described as paraffin or lamp oil, became a fundamental household fuel that was used for lighting and heating.

FIGURE 9.4: A length of taffeta coloured with fuchsine, one of the first synthetic dyes, in France, in the nineteenth century.

Gasoline would quickly become a 'priority product' with the 'fast expansion of electricity and motorization' (Alfke, Irion, & Neuwirth 2000, p. 209). At the time, crude oil production and refining was largely based in Pennsylvania and other parts of the United States, though new oil discoveries would expand production to Russia, the Netherlands, and Great Britain (Council on Foreign Relations n.d.).

One of the most important innovations of the Second Industrial Revolution came with electricity. Several breakthroughs in the nineteenth century made electrification possible, including the design of the dynamo and the invention of the 'transformer' that enabled electrical distribution. Electricity made daily life more comfortable. It extended possible work hours, and it was safer and more efficient than decades of gas lighting and centuries of oil lamp and candle use. After spending his formative years as a bookbinder and laboratory assistant, British physicist Michael Faraday designed 'a device that can be regarded as the very first electric motor' in 1821 and the first working dynamo around 1832 (Al-Khalili 2015, pp. 3–4). Faraday's work was foundational to American inventor Thomas Edison who was able to figure out how to transmit electricity over longer distances, and how to create a longer-lasting incandescent bulb.

At the start of his career, Edison had worked as a telegraph operator. Later on, he opened his telegraph office in Newark, New Jersey. This also enabled him to pursue his own inventions as he worked on developing 'long-distance telegraphy' in the United States where the use of underground lines had not yet become a common practice (Israel 2002). On New Year's Eve of 1879, Edison demonstrated the design of a new incandescent lighting system, where each bulb could 'operate for about 125 hours' (National Museum of American History n.d.; see Figure 9.5). By 1880, the lamp

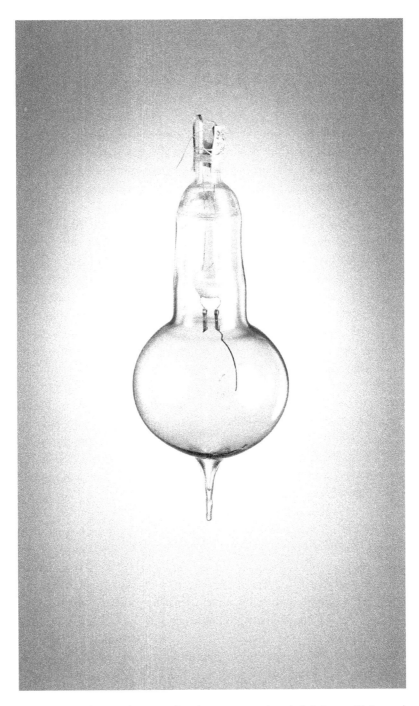

FIGURE 9.5: An incandescent lamp used to demonstrate electric lighting on 31 December 1879 at Thomas Edison's Menlo Park Laboratory, New Jersey.

was improved to operate for 'about 600 hours'. In 1882, Edison and his team would also design and install 'America's first electric plant' in New York, thus successfully building the foundation for the modern electric power industry (Fiell & Fiell 2016, p. 245). Among some of Edison's other great inventions were the longer-lasting alkaline battery, the phonograph, and the first motion picture camera.

The Second Industrial Revolution was a time of rapid technological change where more affordable varieties of household items were within the reach of low-income people. It was also a time of social and ideological complexities where people were increasingly interested in democratic values and more personal freedom. Depending on where a person lived, modern life offered improved infrastructure, communication systems, and better transportation.

There were also improvements in formal education systems, including in the education of product designers. Some designers had the opportunity to enter into government-funded programmes and newly created trade schools. Adapting to technology change and increasingly globalized business needs, the skills required of designers expanded to create a wider array of mass-produced products from fabrics and household items, to print media, and cutting-edge services in telegraphy and electric lighting.

Nevertheless, societies experienced innovative new technologies in a disproportionate fashion, and in many ways so did the designers who worked with them. On one hand, designers were empowered to work in new workshop environments that fostered experimentation with emerging technologies, tools, and processes. On the other hand, product 'designs' could be efficiently broken down and 'subdivided' into many small repetitive tasks with workers often doing only a single task. This method was in stark contrast to the work of specialized craftspeople who 'had the satisfaction of seeing a product through from beginning to end' (Library of Congress n.d.). The industrial workplace looked very different from that of the workshop. The Library of Congress (n.d.) described that:

> In the century since such mechanization had begun, machines had replaced highly skilled craftspeople in one industry after another. By the 1870s, machines were knitting stockings and stitching shirts and dresses, cutting and stitching leather for shoes, and producing nails by the millions. By reducing labour costs, such machines not only reduced manufacturing costs but lowered prices manufacturers charged consumers. In short, machine production created a growing abundance of products at cheaper prices.

Design and production had once mainly been local. In newly industrializing countries, mass production methods and an emerging factory system, in spite of its flaws, also offered a path towards a new standard of living. Yet the question of how to create a design and production system free of exploitation and environmental harm would be immensely troubling.

10

Modernism, Consumer Culture, and Warfare

Warfare and Social Change

The start of the twentieth century saw the growth of consumer culture and increases in educational and professional opportunities. Businesses and 'factory output' continued to expand, and an emerging middle class benefited because there was more time for recreation and they had greater purchasing power. New innovations, like an affordable automobile, broadcast radio, and the beginning of human-powered flights, pushed the boundaries in terms of imagination and physical mobility. Simultaneously, new modern ideas and aesthetics evolved against the volatility and brutality of colonialism and two world wars.

The development of new technologies was critical to World War I, which began on 28 July 1914, when Austria–Hungary declared war on Serbia, and quickly drew Europe into a web of alliances. Factory systems were reconfigured for the 'mass production of weaponry', and the pressures of war powered the rapid acceleration of production capabilities (Fiell & Fiell 2016, p. 255). The war saw significant leaps in military technologies such as the development of Japanese naval fleet designs and air carrier designs, German fighter tri-planes, trench warfare, radio telegraph messaging for military communications, and 'quick-firing artillery' (The National Museum of the WWI Museum and Memorial 2022). An ongoing debate continues concerning what factors contributed to World War I outbreak. One of the main triggers was the assassination of Austrian Archduke Franz Ferdinand and his wife. The formation of the 'Triple Entente' (an agreement between the Russian Empire, the French Third Republic, and the United Kingdom of Great Britain and Ireland) was intended to counter rising German power, and the period saw disputes over territories and colonies, and rising economic competition.

On 'home fronts' around the world, women began to enter the workforce in manufacturing and agricultural positions and also served as contract surgeons, yeomen farmers, and X-ray operators alongside physicists and chemists like Marie Curie. Moreover, for the first time, African American women also entered factory

and office positions. Towards the end of the war, the Great Influenza Pandemic caused nearly 50 million deaths worldwide, and much of the progress of industrialization was temporarily halted. Around nine million people died fighting, while five million civilians died – ravaging Europe widely, as well as parts of Asia and Africa. Britain called on the support of its colonies, including the British Indian infantry and the Egyptian army, who hoped to see independence thanks to their service.

At the height of its rule, the British Empire had established colonies, dominions, mandates, protectorates, and territories over around 23 per cent of the world's population, making it the largest. Second to the British Empire in size (and its closest colonial rival) was the French colonial empire, followed by Germany and Portugal (Fichter 2019, p. 8). Heavily colonized African and Asian countries and the Caribbean largely served European economic interests . Many countries under colonial rule did not see gains in the adoption of new technologies or modern industries. Through European Colonial expansion, Ethiopia remained one of the few independent nations, and its resistance at the Battle of Adwa symbolized that Africa did not exist purely to be colonized but also could be a 'land of defiance, victory, and pride' (Milkias & Getachew 2005, p. 1). Throughout Asia, the British colonized India, Singapore, Sri Lanka, Malaysia, and Myanmar. They also exerted 'foreign occupation rights' in China through the establishment of 'Treaty Ports', which were easier to maintain by having a military presence and colonial administration in Hong Kong (Nield 2010, p. 124).

Tourism in the colonies also became an increasingly desired pastime, and passengers would travel overseas for weeks to reach their destinations. Tourist products like guidebooks, the first mass-marketed cameras, and postcards became sought-after items (Thompson 2006, p. 8). The National Museum of African American History and Culture (n.d.) described that the 'colonial postcard' was especially popular at the start of the twentieth century for promoting tourism and to show that colonial 'subjects' were 'capable of assimilation into European ways of life' (see Figure 10.1). The postcard also served as a way to celebrate the invention of photography and to showcase the 'political triumphs of European conquest and expansion' (African American History and Culture n.d.). Yet novel technology and travel-related products could not calm the growing discontent with social conditions.

Through the leadership of suffragists, abolitionists, and labour organizers, a number of social movements gained momentum at the start of the twentieth century. Fighting for the right to vote and for equal rights, suffragists organized meetings and lectures, garnered media attention and practised civil disobedience (see Figure 10.2). As a result, they coped with 'censure' from their families and communities even as membership in suffrage associations grew (Lumsden 1997, p. 3). To show solidarity and strengthen their message, suffragists created iconic posters and banners, and wore imaginative and brightly hued costumes to 'disguise

Martinique — Type et Costume Créole

FIGURE 10.1: A 'colonial postcard' featuring an unnamed woman in the French Caribbean. Martinique, 1908–1930.

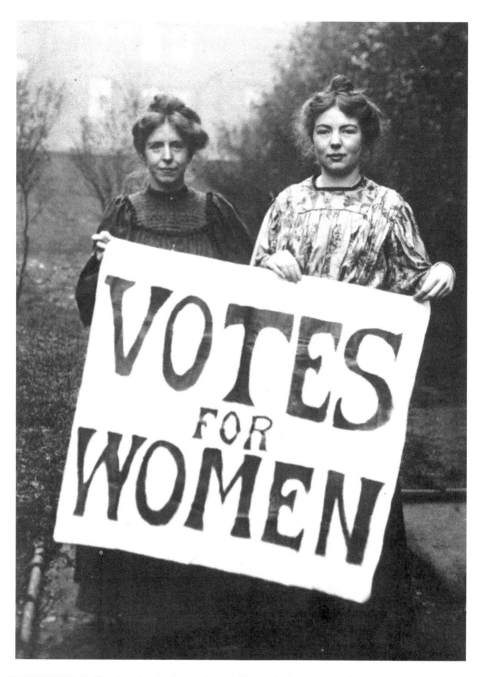

FIGURE 10.2: Suffragists Annie Kennedy and Christabel Pankhurst (one of the daughters of Emmeline Pankhurst) holding a protest banner in 1908. In 1903, Emmeline Pankhurst founded the Women's Social and Political Union in Manchester, and together Emmeline and the Pankhurst family played a central role in gaining the women's right to vote in the United Kingdom.

their true identities to avoid arrests' (Kociołek 2018, p. 83). Some of the first places to enact the women's right to vote included New Zealand in 1893, and the colony of South Australia in 1894. In 1918, women over the age of 30 who met a 'property qualification' were granted the right to vote in the United Kingdom, but it was not until the Equal Franchise Act of 1928 that women gained the same voting rights as men (UK Parliament 2023). Between 1919 and 1920, the nineteenth amendment was passed in the United States to grant all women the right to vote. While in theory, the nineteenth amendment guaranteed the right to vote, state laws, like Jim Crow laws and literacy tests, denied suffrage to African Americans for decades to follow (Keele, Cubbison, & White 2021).

Abolitionists and suffragists also decried colonialism and imperialism seeing them closely linked to slavery and unjust labour systems. W. E. B. Du Bois, the prominent African American sociologist and civil rights activist, researched types of colonial systems and wrote about 'suggestions to end colonialism', seeing it as 'loathsome' (Gott 1976, p. 2). Du Bois' *The Souls of Black Folk*, published in 1903, described the 'crazy imperialism of the day' that deemed 'human beings as among the material resources' (p. 46). In the aftermath of World War I, unrest in colonial territories intensified with anti-colonial nationalist movements, supply shortages, and the inability to demobilize imperial soldiers who were now veterans in want of greater 'rights and freedoms' (Kitchen 2014, p. 7). Already, an independence movement had formed in India with the formation of the India National Conference, and the idea of sovereignty had gained traction throughout parts of Africa. During the Bambatha Rebellion of 1906, the Zulu in South Africa battled the British colonial administration in response to a poll tax also known as a head tax (Redding 2000, p. 34). This widespread discontent across the colonial systems would intensify into World War II.

Modernism and Consumer Culture

World War I had left behind a complicated web of debt and rivalries contributing to World War II within 20 years. Society had become more sensitive to the hardships of modern warfare and social injustices. In the aftermath of World War I, through a recession and into a Great Depression, consumers around the world desired even more products that could be 'consumed quickly and easily'. They oriented themselves to a machine age, photography, and film, and embraced new visual and intellectual concepts.

Modernism emerged as an artistic, cultural, and philosophical movement in reaction to Victorian-era art and design practices. As the modernist movement spread, there was a simplification of the intricate motifs of the Arts and Crafts

Movement. Modernism integrated universal forms in design, and modern materials like steel, glass, and concrete. The new language of design included the elimination of traditional forms; integrated geometric shapes, primary colours, and sans serif typography; and popularised using rational and systematic methods such as as grid systems and formal analysis. The Victoria & Albert Museum (n.d.) described that:

> At the core of Modernism lay the idea that the world had to be fundamentally rethought. The carnage of the First World War and the Russian Revolution led to widespread uto-pian fervour, a belief that the human condition could be healed by new approaches to art and design. Focusing on the most basic elements of daily life – housing and furni-ture, domestic goods and clothes – architects and designers set out to reinvent these forms for a new century.

A number of sub-movements of Modernism formed. In 1909, the Futurism movement emerged, and by 1917 Russian Constructivism and De Stijl movements followed suit. Other movements included Art Deco and Streamline Moderne, Expressionism, Dada, Cubism, and Surrealism. The Deutsche Werkbund (German Association of Craftsmen) was formed in 1907 and was foundational to the Bauhaus. The Werkbund was a state-sponsored association of product designers, architects, and manufacturers utilized to improve Germany's global competitiveness in design. Historian Despina Stratigakos noted that women made up about '5 percent of the total' Werkbund membership. Among members there were discussions about the importance of the female consumer and household decisions about whether to purchase Schund or 'trash' low-quality products or quality goods (Stratigakos 2003, p. 494).

The aesthetics and ideologies of Modernism were also widely adopted in different countries and industries, and took on culturally distinctive identities. While supplies of 'modernist' materials like steel and reinforced concrete were less adequate in Central and South America, designers and architects were quick to adopt the ideologies of Modernism, and saw it as a means to 'improve public services and lifestyles' (Guillén 2004, p. 7). American modernism reflected industrialization and the changing urban landscape, and was captured by artists like Georgia O'Keefe and Aaron Douglas. Douglas played an influential role in the 1920s and 1930s in the intellectual and cultural movement known as the Harlem Renaissance.

The movement was centred in the Harlem neighbourhood of New York and had footholds in France and the Caribbean. Writer and educator Alain Locke became a force behind the Harlem Renaissance with his edited collection, the *New Negro*. Together with artists and designers like Frank Walts, Richard Bruce Nugent, Gwendolyn Bennett, and Zell Ingram, the movement embodied a message of civil rights, drawing public attention to the horrors of lynching and racial discrimination

(Alcalá 2017). In contrast to a more typical 'streamlined' and minimal aesthetic, where excess detail and colour were removed, Harlem's visual culture was colourful, fashion-forward, and also integrated African textiles.

Yet, one of the most important breakthroughs of this time period was the democratization of massive auto-mobility. In 1908, the first mass produced automobile entered the market. The Ford Model T was an affordable vehicle that was built on a moving assembly line and available 'for between $260 and $850' (Ford n.d.; see Figure 10.3). The mass production of inexpensive goods on an assembly line would be termed 'Fordism'. Henry Ford, who began his career as an apprentice machinist in Detroit, before rising to the role of an engineer, industrialist, and businessperson, wanted cars to be 'affordable, simple to operate, and durable', and tested the Model T by taking it on a hunting trip from Wisconsin to northern Michigan (Ford n.d.).

Ford's early design team included chief designer Childe Harold Willis (born in 1878), who was also the designer of the Ford logo, interior designer Sidney Houghton, and experimental designer Joseph Galamb, who also developed submarines and

FIGURE 10.3: Photo of an advertisement for the first mass-produced automobile, the Ford Model T, 1910.

tractors. Ford's wife, Clara Bryant Ford was active in the suffrage movement, and was vocal about issues like the importance of education and healthcare, and environmentalism. She also had an influence on company ideals. She promoted urban gardening among Ford employees during the Great Depression and developed roadside markets to employ women. By the end of World War I, Ford had accommodated both auto and war supply industries, and Detroit became 'one of the main destinations for thousands of Southern Black migrants', and Ford employed 'over 8000 black workers' (The Henry Ford Organization 2013). While many of Ford's African American employees worked as janitors, or in the blast furnaces and foundries, some were employed as skilled machinists, factory forepersons, or in other white-collar positions. Ford, unlike many companies, paid equal wages for equal work, with 'Blacks and Whites earning the same pay in the same posts' (The Henry Ford Organization 2013).

Around the time of Ford's success, there was a rise in commercial aviation. During World War I, aircraft production and manufacturing had massively accelerated. In 1914, the first fixed-wing aircraft was flown between St. Petersburg and Tampa, Florida. By 1919, the first trans-Atlantic flight traversed the Atlantic. Civilizations had also long dreamed of flying, with kite designs travelling from China to India and Japan as well as around the world. Hot air balloon designs achieved major breakthroughs in eighteenth-century Brazil led by Bartolomeu Lourenço de Gusmão, and in France by brothers Joseph-Michel and Jacques-Étienne Montgolfier (Uri 2023).

After several designs, Orville and Wilbur Wright pioneered the first sustained human-controlled flight that took off on 17 December 1903 (Uri 2023; see Figure 10.4). The brothers, who had previously designed and manufactured multiple models of bicycles like the Van Cleve and the St. Clair, had several failures before the success of this flight. On this breakthrough event in aviation, editor John Uri (2023) described that

> The flight lasted just 12 seconds, traveled 120 feet, and reached a top speed of 6.8 miles per hour [...] The brothers completed three other flights that day, taking turns piloting, the longest traveling 852 feet in 59 seconds. The highest altitude reached in any of the flights was about 10 feet.

While there was a lot of hardship at the start of the twentieth century, it was also an inventive period where living standards rose, and people took pleasure in new types of entertainment. Beginning in the 1920s, radio became a main form of entertainment in what was called the 'Golden Age of Radio'. The first live television broadcast aired in 1926, and the 'Roaring 20s' also saw the development of 'talkies', which were films with sound. More affordable 'streamline moderne' style products were fashioned in the essence of aerodynamics and speed, celebrating the success of aeroplanes,

FIGURE 10.4: Image of the first sustained and self-propelled flight in 1903 by the Wright brothers in Kitty Hawk, North Carolina.

trains, and automobiles. From toasters to furnishings, products manufactured in a modern, streamline aesthetic expanded to include materials such as Bakelite plastics and enamels giving them a glossy, futuristic finish (McCourt 2014).

Companies have also developed an interest in consumer psychology and finding new ways to persuade consumers to buy products. Principles of applied psychology and 'consumption economics' were published in books like *The Theory of Advertising* (1903) and *Principles of Advertising* (1910) and by consumer economist Hazel Kyrk (Scott 1903; Starch 1910). Kyrk's foundational works in home economics included the co-authored book *The American Baking Industry, 1849–1923* (1923) and the *Economic Problems of the Family* (1933). This research reinforced the idea that consumers' intake of media and advertisements, through radio and newspapers, could 'augment and accelerate' purchasing (Higgs 2021). Historian Kerryn Higgs (2021) described that:

> In the 1920s, the target consumer market to be nourished lay at home in the industrialized world. There, especially in the United States, consumption continued to expand [...] though truncated by the Great Depression of 1929 [...] Electrification was crucial for

the consumption of the new types of durable items, and the fraction of U.S. households with electricity nearly doubled between 1921 and 1929, from 35 per cent to 68 per cent; and a rapid proliferation of radios, vacuum cleaners, and refrigerators followed. Motor car registration rose from eight million in 1920 to more than 28 million by 1929.

An understanding of product design also began to expand. While the word 'design' had existed for centuries, it arguably gained more appeal through the *Practical Draughtsman's Book of Industrial Design* (1853) and through Joseph Claude Sinel, who identified as an industrial designer. Sinel designed everything from calculators and typewriters to book covers. According to Simon King and Kuen Cheng (n.d.), Raymond Loewy could also be considered the 'Father of Industrial Design' who had 'designed everything from streamlined pencil sharpeners to Coca-Cola vending machines, Studebaker automobiles, and NASA spacecraft interiors'. While designers like Sinel and Loewy would be widely credited for foundations in industrial design, female designers like Eileen Gray, Charlotte Perriand, and Belle Kogan would also make considerable contributions. While Gray and Perriand designed furniture, Kogan experimented with plastics to create jewellery, silverware, clocks, and dishes (McLaughlin 2018).

In Europe, recovering from the destruction of the war, some designers and architects like Swiss-French architect Le Corbusier and German American designer and architect Ludwig Mies van der Rohe embraced a logical approach to design, 'arguing that machines were the key to promoting hygiene and workplace efficiency' (The Art Story n.d.). At the same time, the Russian Constructivist movement welcomed a Communist society that emphasized the sciences. The glass and steel prismatic forms of an international style were adopted by Brazilian architect and urban planner Lúcio Costa and Indian architect B. V. Doshi. Later, they were adapted to corporate skyscraper aesthetics and to Brutalist designs that were used in low-cost British social housing and in the design of institutional buildings, campuses, courts, and city halls worldwide.

The Bauhaus

Trying to find harmony between the arts and the sciences, the German school, the Bauhaus, was established in 1919 by Walter Gropius. The Bauhaus sought to uphold an education philosophy that blended art, design, and technology to erase the 'boundaries between craft instruction and fine art training' (Droste 2016, p. 15). Gropius called for collaboration between craftspeople and artists in his *Bauhaus Manifesto*. Drawing from the work of the pre-Raphaelites, German Expressionism, and the Modernist movement, Gropius proposed a student-centred model for art and design

education. This multifaceted 'tripartite' model, which combined training in 'drawing, crafts, and academic theory' was developed and modified between 1919 and 1933, and has been widely publicized and studied in regard to its interdisciplinary approach (Droste 2016, p. 22). Over time the school curriculum integrated a model defining 'Art into Industry'. This model emphasized the creation of designs for mass production (Winton 2007).

Historian Magdalena Droste (2016) remarked that the Bauhaus model was a sort of 'phenomenon', defying other established apprenticeship, academy, and vocational design education models (pp. 1–22). The Bauhaus integrated studies in art, design, architecture, typography, industrial design, interior design, and the weaving of textiles.

The Bauhaus stance on science and technology was heterodox and embraced influences such as Einstein's Theory of Relativity and the approach to psychology of the Gestaltists (Moynihan 1980, p. 294). Some iconic products include the Wassily Chair, the Brno Chair, a tea infuser, a table lamp, and nesting tables (see Figure 10.5). The metalworking and cabinetmaking workshops were especially popular. Alexandra Griffith Winton (2007) described that Marcel Breuer's cabinetmaking workshop essentially 'reconceived the very essence of furniture, often seeking to dematerialize

FIGURE 10.5: Wassily Chairs designed by architect and furniture designer Marcel Breuer, Berlin, 2008.

conventional forms such as chairs to their minimal existence'. Breuer's experimentations resulted in lightweight chair designs made of bent tubular steel, including the notable Wassily chair and the Cesca chair.

Nevertheless, even in an experimental learning environment, female students enrolled at the Bauhaus, like Marianne Brandt and Lydia Dreisch-Foucar, had to fight to establish themselves among their male peers. Brandt (in Droste & Friedewald 2021, p. 50) described:

> At first, I was not accepted with pleasure: there was no place for a woman in a metal workshop, they felt. They admitted this to me later on [...] Later, things settled down and we got along well together. Gradually, through visits to the industry and inspections and interviews on the spot, we came to our main concern: industrial design.

Brandt became the first woman to be accepted as part of the metalworking workshop and designed products like a tea infuser with a strainer, an electric lamp, and silverware. Dreisch-Foucar, after studying ceramics at the Bauhaus, went on to work in a porcelain factory and later worked as both a sculptor and advertising designer (Droste & Friedewald 2021, p. 50).

Despite the success and growing global recognition of the Bauhaus school, the rise of Nazism in Germany led to the termination of the Bauhaus in 1933. Some of the school's faculty, including Walter Gropius, Josef and Anni Albers, and Lazlo Moholy-Nagy, were able to escape the country, moving to the United States.

The Nazis would establish an alliance with Italy's National Fascist Party led by Benito Mussolini, and the expanding empire of Japan (known as the Axis powers). Then, on 1 September 1939, Germany invaded Poland and World War II began. Two days later, Great Britain and France declared war on Germany.

During Franklin D. Roosevelt's third term, the Japanese attacked Pearl Harbor, and the United States officially declared war on Japan. In December 1941, the United States entered the war against Germany and the Axis powers. By August 1942, the Manhattan Project was underway and experts gathered in New Mexico to make the world's first atom bomb, which ultimately would result in the atomic bombing of Japan, marking the start of an Atomic Age. Also in 1942, Germany's Security Police began to initiate their 'Final Solution', the mass genocide of European Jews. While some Jewish refugees managed to escape, emigration into the United States and other countries was a complex matter. 'Between 180,000 and 220,000' European refugees, most of them Jewish, immigrated to the United States between 1933 and 1945 (United States Holocaust Museum n.d.). The majority of persecuted Jews in German-occupied countries were murdered. Some notable Jewish designers who emigrated included typographer Berthold Wolpe and architect Berthold Lubetkin.

Otti Berger, a textile designer who studied at the Bauhaus, was unable to secure a teaching visa to join other Bauhaus expats in the United States. After returning to Zmajevac, Croatia, she was deported to Auschwitz, where she and her family were murdered along with 'approximately six million European Jews and at least five million prisoners of war'. Included in this horrific list were Romany and Jehovah's Witnesses, those considered to be intellectually disabled, homosexuals, and other victims (United States Holocaust Museum n.d.).

This devastation of lives and property incurred by World War II was concluded on 2 September 1945 when Japan surrendered (Germany had surrendered in May). The destruction of the war lasted for years as millions of displaced people either repatriated or resettled in other countries. Numerous Holocaust museums and memorials were designed and built around the world in order to share and preserve Holocaust history and the horrors of World War II.

Through the first half of the twentieth century, societies were exposed to the brutalities of war and the use of atomic weapons. The public also acclimated to changing consumer cultures, access to more mass-produced goods, and new modernist ideologies that eschewed the past. The influential ideas of the Bauhaus were adopted into other schools like Black Mountain College, the Yale School of Art, and the New Bauhaus School. In search of democratic ideals, women, people of colour, and colonized people fought to be heard and campaigned to gain equal rights and sovereignty. The development of new computing technologies, and ideas related to education, psychology, and philosophy would influence the decades to come, steadily moving to embrace an Information Age.

PART 5

THE INFORMATION AGE

11

Post-World War II

Technological Advancements after the War

Post-war recovery was characterized by years of rebuilding critical infrastructure and the development of new technologies. There was a surge in mass consumption after years of destruction, rationing, and austerity. Many societies after World War II valued capitalism and consumerism. At the same time, there was a great deal of apprehension about the start of a Cold War and Soviet bloc expansion into eastern Europe (see Figure 11.1). The division of Korea into two separate occupation zones was also of great concern. These apprehensions were escalated by African activists' calls for the decolonization of Africa which was affirmed through the language of the Atlantic Charter. The Atlantic Charter, written in 1941, stated that citizens should have a right to 'self-determination'. It served as an important 'anti-colonial political

FIGURE 11.1: The 'Baker' bomb detonated in the South Pacific on 25 July 1946; photographed by the US Army Photographic Signal Corps. This detonation occurred after World War II when a US–Soviet arms race began.

tool', and in the decades after the war, dozens of African and Asian colonies would gain independence through sustained resistance, protests, and negotiation (Inyang & Edit 2019, p. 10).

In the post-war climate, there was also a sense of competition with an arms race, a space race, and new electronics and information technologies. The war effort had driven the development of a wide array of innovations and inventions, including the jet engine and the cavity magnetron, which saw leaps forward in the development and manifestation of many practical applications. Medically related technologies also advanced. This advancement produced techniques necessary for scaling up vaccinations which would eradicate certain diseases (Keenan 2020). This included the mass production of penicillin, the creation of human blood substitutes, and significantly improved vaccines. Around the world child mortality plummeted, and the population boomed.

The advancement of jet engine technology during the war also enabled the creation of an airline industry capable of offering economical, long-distance flights to passengers eager to explore the world. The first commercial jet airliners to take off in 1949 were the British-designed De Havilland DH.106 Comet and the Avro Canada C-102 Jetliner (see Figure 11.2). The Comet 1 prototype first took flight on

FIGURE 11.2: The first commercial jet airliner to fly was the de Havilland DH.106 Comet. Early design challenges included susceptibility to the weather and structural fatigue. Berlin, 1969.

27 July 1949. The Canadian C-102 was the first jet airliner prototype to fly in North America on 10 August 1949. Jet engine propulsion enabled 'mass jet travel' and the airline industry blossomed into a style-conscious industry (Lovegrove 2000, p. 36). By 1954, Boeing debuted the Dash 80, which was '100 miles per hour faster than the de Havilland Comet and significantly larger' (National Air and Space Museum n.d.).

The cavity magnetron, a high-power vacuum tube, had vastly improved the use of radar systems during World War II and was the 'heart of most Allied radars' (Stephan 2001, p. 737). Radar systems, or radio detection, were used to identify aircrafts and other approaching objects, giving an early warning to the Allies and, therefore, providing a significant advantage during the war. The magnetron became the technological basis for the commercial microwave, seen in early models such as the Radarange 1161. By the 1950s, commercial microwave ovens became emblematic of convenience and 'labour-saving techniques' in the household expanded to freezers, dishwashers, and an automatic washing machine.

While design innovations marked progress for societies, the development of nuclear technologies incited fear and immediately launched an ongoing nuclear arms race. A looming Cold War between western countries and the Soviet bloc caused a 'Red Scare' and as historian Charles S. Maier wrote (1972), 1941–1945 turned out 'to be a prologue to America's more fundamental conflict with Communism thus igniting global fears of nuclear war'. Amidst Cold War tensions, many organizations and households developed civil defence projects including the creation of the 'do-it-yourself home fallout shelter', stockpiles of different products, and began conducting evacuation drills (Lichtman 2006, p. 40). In light of US-Soviet tensions, African American activists and writers pointed out the hypocritical behaviour of US officials 'for presenting itself as a beacon of liberty while systematically oppressing African-Americans' (Rigoglioso 2017). The Cold War also fostered a culture of surveillance, and people with Socialist or Communist ties, civil rights leaders, and activists, as well as ordinary citizens, became more susceptible to appearing on a 'watch list' (Aid & Burr 2013).

Finding ways to creatively grapple with the implications of the development of nuclear technology and the aftermath of the war, product designers experimented with an 'Atomic Age' design aesthetic which was incorporated into products like apparel and signage, Googie architecture (named after a coffee shop in West Hollywood), and entertainment media (see Figure 11.3). Atomic Age design was popular from the 1940s through the 1960s and engaged with themes of outer space and technology, and favoured asymmetry and futuristic motifs. Geometric atomic patterns appeared on textile designs, dishware, and wallpaper. André and Jean Polak and André Waterkeyn designed and constructed the Atomium for the 1958 Brussels World Fair. The 59-foot stainless steel encased representation of nine iron atoms was intended to send a message about the peaceful use of atomic energy. While it

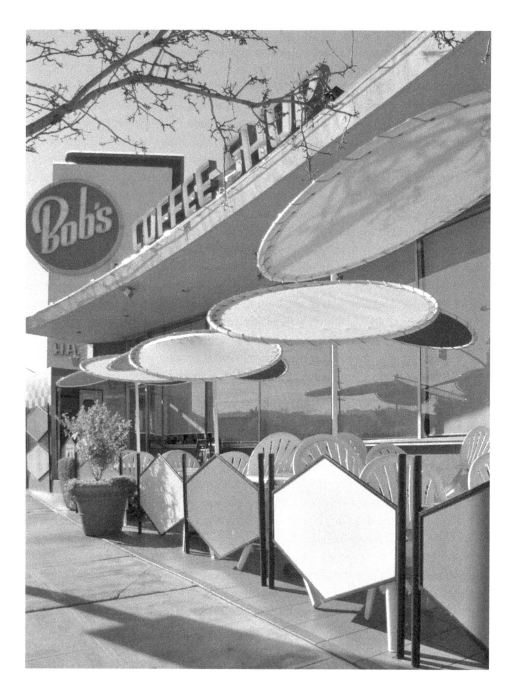

FIGURE 11.3: Googie-style furnishings at the Burbank location of Bob's Big Boy built in 1949, in California. Googie-style products and architecture incorporated futuristic elements inspired by the Atomic Age and Space Age.

was only intended to be a temporary project, it was restored in the 2000s and has remained a cultural, tourist destination in Europe's capital, drawing hundreds of thousands of visitors per year (Atomium 2022).

Through stories and images, manga, graphic novels typically from Japan, served as a medium to preserve and make sense of post-war Japan's 'memory of war' (Kajiya 2010, p. 128). In 1949, manga artist Machiko Hasegawa created the series *Sazae-san* about a cheerful feminist creating a modern family after the war. Hasegawa was born in 1920 and was a disciple of Tagawa Suiho. *Sazae-san* was published in the Asahi Shimbun (newspaper) from 1949 until 1974. She was also the founder of Shimaisha Publishing Company which published approximately '20 million paperback copies of her cartoons' (Kirkup 1992). In 1952, manga author Osamu Tezuka launched the science fiction series *Astro Boy*, a story of a pacifist robot named Atomu which also served as a warning against 'human arrogance in abusing modern technology' (Szasz & Takechi 2007, p. 738). *Astro Boy* was popular in Japan and the United States, and was also adapted into a TV series in the 1960s. Both Japanese manga artists/writers were groundbreaking, with Hasegawa standing out as a female innovator.

One of the most significant wartime technology advancements was the modern computer. While steps towards personal computing had accelerated during the war, civilizations had conceptually wrangled with the idea of a computer for centuries. In Ancient Greek civilization, for example, the Antikythera mechanism was an orrery used to predict astronomical positions and was arguably the first analogue computer. In Islamic society during the Middle Ages, a maritime astrolabe was designed to calculate latitude and altitude, a crucial tool for navigation. Centuries later, in the years before World War II, the practical implementation of Boolean logic in universal logic gates enabled the transformation of 1s and 0s from input wires. Nevertheless, it was a slow and laborious process, later to be replaced by integrated circuits or 'chips' (Nordhaus 2001).

A commercially viable computer in a modern sense emerged from a number of projects related to military work. The purpose of this was to increase national defence capabilities during and after World War II. Some early computers included the German Z3 Computer (1938–1941), the decryption machine known as the 'Bombe' or 'Agnes' (1940), and Bell Labs complex number calculators and relay computers designed between 1939 and 1949. These were a few of the major milestones in the history of computer science that led to further development.

Female programmers played important roles in the early field of cryptography, hand-operating these large machines. Early 'programming' was considered tedious, and women were frequently tasked with code-breaking secret messages. In England, women in the Royal Naval Service, employed as cryptanalysts, worked from Bletchley Park. Included amongst these women were Dorothy Du Boisson, Elsie Booker, and Mavis Batey (see Figure 11.4). In 1941, they broke a message being transferred from Berlin to Belgrade on the heels of the Battle of Cape Matapan.

FIGURE 11.4: Dorothy Du Boisson (left) and Elsie Booker (right) operating the code-breaking computer Colossus Mark 2, 1943, England.

While it was decades before high-tech computer products and services would be widely accessible, the mid-twentieth century and post-war climate of innovation was a major precursor to the Information Age.

Post-War Mass Consumerism

After the war, the hope for a brighter future was infused by the promise of new technologies and a greater availability of different types of products. Household products were more affordable in the new age of mass consumption. The use of new materials in product design further separated product design from its traditional material origins. This allowed the creation of synthetic, science-based designs that embraced 'abstract and sculptural aesthetics as well as lower prices' (Goss 2004).

New substrates were used to build post-war products as well. Some of these materials had been used on a mass scale in war supplies production with materials like 'plastic, fibreglass, and plywood' used in furniture designs. A mass market developed for Earl Tupper's plastic storage containers called 'Tupperware', and people celebrated plastic as a symbol of 'modern living' (Bonomo 2000, p. 164).

Charles and Ray Eames, a married couple collaborating as a design team, worked to make functional and stylish furnishings more affordable, 'popularized moulded plywood furniture in the 1940s and '50s', creating everything from chairs and folding screens to coffee tables and ottomans (Eames 2022; see Figure 11.5). After the invention of polypropylene, the stacking chair known as the 'Polyprop', a one-piece moulded chair, would go on to be one of the most successful mass-produced pieces of furniture.

Post-war consumer spending in the United States was praised as 'patriotic', and Americans wanted 'televisions, cars, washing machines, refrigerators, toasters,

FIGURE 11.5: An Eames plastic chair on an aluminium stand, first appearing for sale in 1950. The chair was designed for the 'International Competition for Low-Cost Furniture Design' to make economical furnishings more accessible after World War II, 2010.

and vacuum cleaners that would help them modernise their lives' (Higgs 2021). The adoption of time- and labour-saving household technologies continued to climb, and the share of women in the workforce increased. Gautam Bose, Tarun Jain, and Sarah Walker (2022) noted that 'women used their new income to advocate for the purchase of goods that facilitated their dual roles as breadwinners and home-makers' (p. 12).

The United Nations was established in 1945 to aid international cooperation and promote free trade and stability. The European Recovery Plan, called the Marshall Plan, was launched by the United States to reconstruct European cities outside of the Communist sphere of influence. Events like the 1948 London Olympics and the 1951 Festival of Britain helped to boost morale (Victoria and Albert Museum 2022). Educator and researcher Jo Littler argued (2006) that the Festival was 'emblematic of post-war hedonism' and fundamentally marked a rise in a 'mass-market commodity aesthetic' (p. 1).

Countries such as Japan, West Germany, Austria, Italy, and Argentina were deemed 'economic miracles' for their rapid recoveries after the war. Japan organized an integrated system of 'keiretsu' organizations and a main bank system. This system managed a 'development strategy' including manufacturing industries (Ozkan 2011, p. 39). Vertical and horizontal keiretsu groups were formed to enable 'close inter-firm relationships', risk-sharing, and 'cross-subsidization' (p. 42). Post-war period innovations included the first mass-produced rice cookers sold by Mitsubishi, and the first operational high-speed 'bullet train' (the shinkansen). Shinkansen operations began in 1964. Likewise, in West Germany, there was a period of rapid reconstruction described as a Wirtschaftswunder. A product most symbolic of Germany's recovery was the Volkswagen Beetle which 'developed into a phenomenon under the guardianship of Heinz Nordhoff, the VW boss for two decades' (Copping 2018).

Post-war globalization also led to the growth of an international marketplace for design that saw the aesthetics of different countries merging together. A post-war consumer-centric climate helped foster the growth of Pop Art as designers and artists rejoiced in everyday objects and commercial imagery. After working as an illustrator for *Vogue*, Andy Warhol rejected typical, traditional artistic subject matter in favour of reproducing images of manufactured goods – famously Campbell soups – that he reproduced for decades. Pauline Boty, one of the founders of British Pop, created collages and paintings about femininity and sexuality and also included collages and paintings of well-known celebrities.

The Pop Art movement also inspired the creation of handicrafts and furniture like lamps and sofas. The Marshmallow sofa, an iconic piece of modernist furniture, fashioned after small dots used in commercial printing processes, was designed by Irving Harper in 1954 as a mass-produced and customizable design. Dorothy

Grebenak appropriated logos and elements of consumer culture into rug designs. The Pop Art movement also became a vehicle for exploring social issues. For example, Beatriz González used imagery from magazines and newspapers to investigate political and social unrest in Colombia.

One common trend with mid-twentieth-century product design made to be consumed by the masses had disregarded environmental concerns in favour of plastics and new materials and encouraged the mentality that products were disposable or short-lived. Depicting the situation of plastic production, journalist Laura Parker (2019) described that 'production and development of thousands of new plastic products accelerated after World War II, [...] transforming the modern age'. On one hand, plastics had 'revolutionized medicine with life saving devices, made space travel possible, lightened cars and jets – saving fuel and pollution – and saved lives with helmets, incubators, and equipment for clean drinking water', but they had also fomented a carbon-intensive 'throw-away culture' (Parker 2019).

In the decades following World War II, mass production and demand also led to the growth of corporations like Coca-Cola, Boeing, IBM, Johnson & Johnson, Kellogg, and General Electric. General Motors (GM) stood out as the largest company in 1955. GM, which produced large amounts of vehicles, ornaments, and aircraft during World War II, grew into a multinational corporation through the twentieth century, initially expanding to England and Australia. At the same time US-based firms, like Herman Miller Furniture and Knoll International, developed advanced manufacturing capabilities, and created inexpensive, well-designed furniture, that worked particularly well in offices and suburban communities.

Mass consumption was closely coupled with mass media. As the 'Golden Age of Capitalism' thrived, so did a 'Golden Age in Advertising'. In this new wave of global consumer culture, large-scale advertising campaigns aggressively promoted 'Americanism' as a reaction to communism. Firms like Young & Rubicam and Ogilvy & Mather opened firms on Madison Avenue in New York City and internationally. Ogilvy opened only three years after the war ended and quickly rose to international fame, shaping advertising as a profession through a 'striking succession of advertising campaigns', including American Express, Dove, and Merrill Lynch (Roman 2010, p. 89). Dentsu became a leader in Japanese advertising after the war. Brazilian media, including the magazine *Manchete*, also saw a boom between the 1950s and 1960s. Advertisements reached global audiences, and by the 1960s and 1970s, brand-name consumer goods began to achieve more uniformity with more standardized approaches to retailing. In a period shaped by growth and productivity, the world was more interconnected than before, while also becoming more keenly aware of social injustices.

12

A Social and Digital Revolution in Design

Activism and Design in the 1960s

After a period of reconstruction following World War II, the 1960s proved to be a tumultuous and vibrant period where mass mainstream consumerism and advances in new technologies developed in stark contrast to civil rights and counter-culture movements. The Civil Rights movement was a global movement, with a large focus centred on combating continuing racial discrimination against African Americans and people of colour in the United States, South Africa, Latin America, and different parts of Europe including the United Kingdom and Northern Ireland. Combined with an ongoing Decolonization movement, a gay rights movement, and a second-wave Feminist movement, the 1960s developed into a decade grounded in social activism.

In 1963, feminist writer and activist Betty Friedan (1963) wrote about the discontent of women in her seminal work *The Feminine Mystique*, helping to reinvigorate the Feminist movement and address 'ingrained sexism' (Muñoz 2021). She observed that many women felt limited by their expected roles as wives and mothers, which could not be solved by material goods like a secure, domestic life in a suburban home with a 'new electric waxer' and a 'new washing machine' (pp. 18–27). By 1964, it was already the ninth year of the Vietnam War, and students across the United States had recently launched the 'May 2nd Movement' with plans of an anti-war demonstration. Several African countries had recently achieved independence, including Nigeria (1960), Tanzania (1961), Algeria (1962), and Kenya (1963). It was also the year that the Civil Rights Act of 1964 was passed, and Martin Luther King Jr. was awarded the 1964 Nobel Peace Prize for his non-violent campaign against racism. In his acceptance speech (1964), King appealed for recognition that 'nonviolence is the answer to the crucial political and moral question of our time – the need for man to overcome oppression and violence without resorting to violence and oppression' (see Figure 12.1).

King was a minister and an activist who believed that the foundation for a successful civil rights movement was grounded in nonviolence. King, inspired by

FIGURE 12.1: Hundreds of thousands gathered in Washington, D.C. for the March on Washington for Jobs and Freedom on 28 August 1963. The march advocated for the civil and economic rights of African Americans. During Martin Luther King Jr.'s speech 'I Have a Dream', he called for the end of racism in the United States.

Gandhi and Thoreau's *Essay on Civil Disobedience*, led the Montgomery bus boycott that resulted in the court decision that segregation on buses was unconstitutional. He also led the 'Black Christmas Boycott' to abstain from buying products from businesses that engaged in discriminatory practices, and encouraged diverting these funds to charities (Parkin 2020, p. 163). In the 'March on Washington for Jobs and Freedom' hundreds of thousands of people had gathered in Washington, D.C. to advocate for the civil and economic rights of African Americans.

Boycotts proved to be successful in a number of independence movements. Given that the design, production, and sales of products often played a central role in political tensions, measures like the Montgomery bus boycott, the Black Christmas boycott, and Gandhi's Swadeshi movement were impactful. During the war of independence in Algeria, psychologist and philosopher, Frantz Fanon, encouraged the boycott of buses and 'imported commodities' to 'bear on the forces of colonialism' (p. 66). South Africans living in exile helped to spur a global movement boycotting South African products – which rose in prominence between 1959 through to the end of apartheid and the formation of the new democratic government in 1994 (Gurney 2010). Decolonial steps were not only material but also intellectual. While studying at Ahmadu Bello University towards the end of British colonial rule, printmaker and artist Bruce Onobrakpeya co-founded the Zaria Art Society whose mission included decolonizing the visual arts. At the society, Onobrakpeya developed a strong interest in African traditions.

The 1960s also saw increasing momentum for indigenous rights. The Chicano/a movement, El Movimiento, was launched to combat institutional racism against Mexican and Central Americans. It began in 1965 and lasted for a decade. As part of the movement, civil rights activist Caesar Chavez founded the National Farmworkers Association with labour leader Dolores Huerta. This would later become part of the United Farm Workers labour union to improve wages for farmworkers. Part of the movement was also about preserving 'Mexican heritage' and ideologies (Delgado 1995, p. 446). Faced with their own challenges, Indigenous Australians, or the Aboriginal and Torres Strait Islander people, fought against forced cultural assimilation. To support the Aboriginal rights movement, college students erupted in protest and launched a 15-day 'Freedom Ride' to call out 'policies of separation, segregation, and exclusion' (Curthoys 2012, p. 25).

Fuelled by the fight against racism and social injustice, and growing attention to social injustice, a unique aesthetic emerged during the 1960s that was colourful and curvilinear, and borrowed from Indian culture and elements of nature. In essence, in the 1960s design questioned materialism and mainstream ideas and embraced communal living, 'love-ins', Rastafari culture, and sexual liberation.

In some cases, 1960s design applications were somewhat contradictory. It celebrated art and spirituality and promoted pacifism, but was also simultaneously

co-opted into more mainstream products and décor. In homes around the world, a 'psychedelic' aesthetic that embraced a hippy youth movement, was adopted into festivals and album covers, fashion, and home interiors including furniture and wall-paper, and deeply inspired by a global music scene. Textile designer Celia Birtwell experimented with fabrics and haute couture that celebrated 1960s culture, draw-ing inspiration from Modernist art.

Music was undergoing a major ideological transformation. *Meet the Beatles!* was on the top of the popular album chart since the start of 1964. For many listeners, the Beatles, Bob Dylan, Janis Joplin, Jimi Hendrix, and Ravi Shankar represented empowerment, social mobility, and a counterculture movement that rejected commercialism (see Figure 12.2). The Woodstock Art and Music Festival in 1969 drew in around 400,000 attendees and was opened by Indian guru and teacher, Swami Satchidananda who appealed for peace (see Figure 12.3). Designer Klaus Voorman collaborated with the Beatles to make their album art for their seventh studio album *Revolver*. Voorman experimented with psychedelic and grotesque themes inspired by Aubrey Beardsley. He also once shared a flat with them and was a long-time friend.

FIGURE 12.2: Jimi Hendrix performing at the Gröna Lund in Stockholm, Sweden on 24 May 1967. Hendrix's stage clothing was frequently designed by Michael Braun.

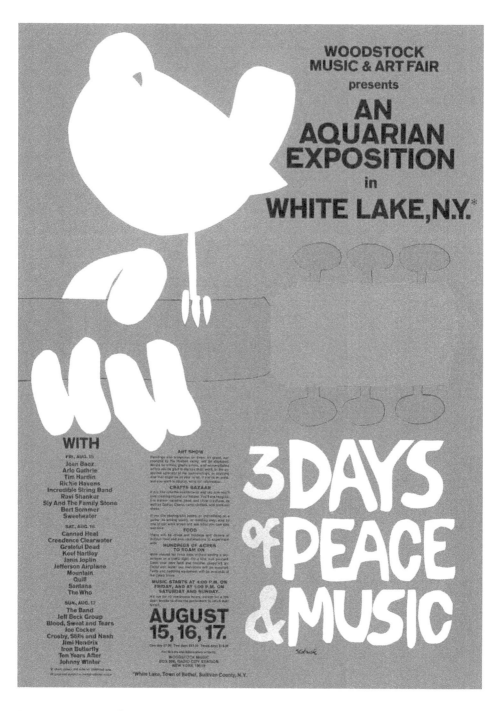

FIGURE 12.3: Poster for the Woodstock Music and Art Fair in New York, 1969, designed by Arnold H. Skolnick.

Designer Michael Braun, with a background in industrial design and fashion, went on to create much of Hendrix's iconic clothing.

In addition to the growth in mainstream and counter-culture aesthetics, consumer goods, music, and political ideologies, computer technologies pushed the imagination even further than ever believed possible. In one view, there were some deep reservations and resistance to efforts to 'scientize' design. These concerns were amplified by growing concerns about plastics and pollution and 'techniques used by manufacturers and advertisers to convince consumers to buy more, and more' (Fiell & Fiell, p. 430). Rachel Carlson, who would be influential to a number of product designers, warned that 'for the first time in the history of the world, every human being is now subjected to contact with dangerous chemicals, from the moment of conception until death' with much of this now coming from 'an industry for the production of manmade or synthetic chemicals' (p. 17).

In another view, influential designers like Nigel Cross (2001) declared the 1960s as a 'design science decade'. Architect and design technologist Buckminster Fuller not only reinforced this by arguing in favour of rationalism and a new age of electronics but also believed that Earth's resources could be divided up to meet the needs of a growing global population (Cross 2001, p. 1; Scherling 2020, p. 48). One of Buckminster Fuller's collaborators, Isamu Noguchi, believed that design and technology should also be situated in an ecological framework, and wrote his views on art, design, and nature in his 1968 publication, *A Sculptor's World*.

In 1964, Canadian media theorist Marshall McLuhan considered the 'outbreak' of a digital age, noting that a coming 'electric implosion' would compel 'commitment and participation, regardless of any point of view' (1964, p. 5). Later, Neil Postman, a cultural critic and a disciple of McLuhan, predicted that 'new technologies' would 'alter the structure of our interests: the things we think about' – essentially shaping humans instead of vice versa (p. 20). McLuhan (1964) wrote in his seminal work, *Understanding Media: The Extensions of Man*:

> Rapidly, we approach the final phase of the extensions of man – the technological simulation of consciousness, when the creative process of knowing will be collectively and corporately extended to the whole of human society, much as we have already extended our senses and our nerves by various media.
>
> (pp. 3–4)

McLuhan (1964) envisioned a global networked society as the 'natural adjunct of electric technology', or fundamentally an early conception of the internet (p. 5). He also posited that the electronic age would fuse human beings with information in ways never imagined (p. 350). As computer technologies advanced towards more

practical home and business use applications, predictions by McLuhan turned out to be true (Cross 2001, p. 1).

A Digital Revolution

Through the 1960s–1970s, many households owned televisions, preferring them to radio, and home entertainment options vastly expanded. Products like Kodak's carousel projector released in 1961 brought new ways of accessing photographs into the comfort of one's home (Hansen 2017, p. 10). By 1963, the design of touch-tone telephones, with the first push-button systems, enabled consumers to 'dial a destination telephone number directly without having to talk to a telephone operator' (Macneil 2019). Portable record players also became more affordable and electronics expanded to the videocassette recorder shortened to VCR (1969–1971), cellular mobile phones (1973), and portable cassette players (1979). Though many new electronics were intended for an 'upscale' market, the idea that consumers could use products to selectively capture media for their own long-term storage was a novel one (Dawson 2007, p. 525).

Importantly, on 7 April 1964, the IBM 360 Series, the first computer with a wider range of scientific and commercial capabilities, was announced (see Figure 12.4). Reporting for the *NYTimes*, William Smith (1964) described:

> The giant of the electronic data processing industry, the International Business Machines Corporation, took a giant step yesterday. It introduced a new generation of computing equipment, the 360 system, which it contends represents a sharp departure from computer concepts of the past [...] More than 100,000 businessmen were introduced to the system at the same time through presentations in 165 cities. It also was announced yesterday in more than 80 foreign countries.

The IBM 36, though powerful, was mainly inaccessible for public use. At 771 kg and 5 feet by 2 feet and 6 feet tall, it was formidable in weight and size. The 360 series, which was sold up until 1978, could do a number of things not seen before with earlier computer models, including bulk data processing, transaction processing, and running consumer statistics. After years of manual data processing, this was a revolution in digital computing capabilities and set the stage for a data revolution.

Through the 1970s, the decreasing cost of hardware and increasing 'miniaturization' of electronics helped to create a consumer-facing computer market (Computer History Museum n.d.). Specifically, miniaturization research and development meant that electronics could be made smaller, at a higher density, and could operate at higher speeds. Low-cost Do-It-Yourself (DIY) desktop computers like the Edu-8, the Datapoint 2200m, the Altair 8800, and the 'mini' were smaller, more affordable, and

FIGURE 12.4: IBM 360 Series was a mainframe computer series and commercially successful. Its chief computer architect was Gene Amdahl.

practical options. DIY microcomputers saw a surge in consumer interest, especially after the release of Steve Jobs and Steve Wozniak's Apple I in 1976.

Jobs was only 21 years old when he began collaborating with Wozniak and they named their company Apple after an apple orchard (Bendeich & Wendlandt 2011; see Figure 12.5). Computer hobbyists began purchasing DIY kits to assemble their own computers. Mainframe computer 'timeshares' increased accessibility, particularly in offices. Nevertheless, companies continued to ponder how to convince consumers that they needed a computer at home and what features and capabilities would be a priority. Even with advancements in microprocessor designs, companies like IBM did not immediately begin making personal computers. Generally speaking, buying a personal computer was a pricey and somewhat complex endeavour. Technology historian Benj Edwards (2015) described the experience of what it was like to buy a computer in the 1970s:

> In the late 1970s and throughout the 1980s, if someone wanted to buy a personal computer, they had to make a trip down to a local computer store to physically check

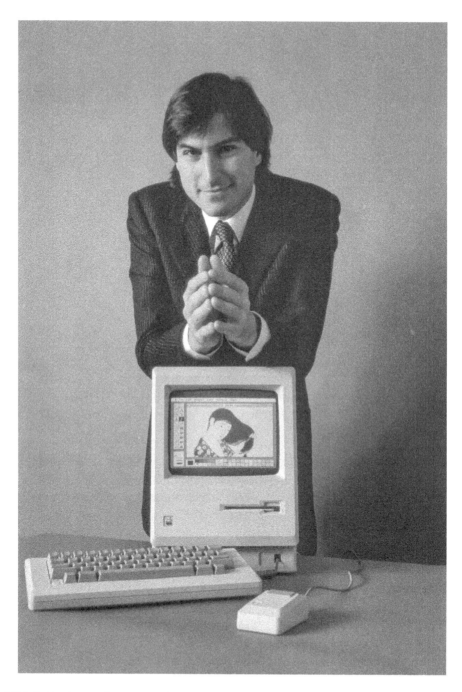

FIGURE 12.5: Steve Jobs poses with the first Apple Macintosh released, in January 1984, Bernard Gotfryd. Pictured on the computer screen is the graphic 'A Woman Combing Her Hair' by print artist Goyō Hashiguchi.

out what was available. Once there, customers typically encountered a dizzying array of incompatible platforms with widely varying capabilities. [...] Depending on the era, think of computers with brand names like Apple, Atari, Commodore, Osborne, Texas Instruments, Radio Shack, Tandy, IBM, NEC, Sinclair, Panasonic, and more.

Through the late twentieth century, a mass market for computers, software, and computer accessories began to form as interest started to rise. Adobe Systems and AutoCAD were both founded in 1982. Microsoft Word was released in 1983. Desktop printing also became more accessible. Beyond its business potential, households began to feel more compelled to buy a computer to be integrated into 'family life' as a means for experimentation and entertainment (Haddon 1992, p. 86). Through the 1980s–1990s, a visually distinct postmodern aesthetic emerged through grunge design, cyberpunk and rave culture motifs, and an electronics-infused style of eclecticism surfaced in design, media, and advertising. Open debates on race and sexuality took place as the world grappled with an AIDS epidemic, and LGBTQ activists made significant civil rights advances. The 1990s pan-internationalism infused itself into consumerism through dance and celebrity culture. Product design, including fashion and apparel, reached new global audiences through hip-hop and rap culture and Black youth culture (Brown 2019). Designer Grace Fussell (2021) described that the '1990s Design Scape' was difficult to generalize since it also celebrated individualism and 'big brands', and it also catapulted design into a state of 'hyper capitalism'. These changes were also closely aligned with patterns of digital and corporate globalization. Therefore, there were many growing concerns about globalization, the loss of small businesses, a rise in income inequality, and an increase in outsourced sweatshop labour that resulted in a series of globalization protests (Kristof & WuDunn 2000).

Officially, the Macintosh was announced through the '1984' commercial during Super Bowl XVII (see Figure 12.5). The idea was that a Macintosh personal computer, unlike other computers on the market, would have a more approachable user interface design and was bundled with useful software like MacWrite word processing, MacPaint for graphical generation, Microsoft, a calculator, and chess. The Macintosh was also released with many of its signature user interface icons (e.g. the paintbrush, the trash can, and Moof) that were created by designer Susan Kare. In terms of usability, the new 'Mac' differentiated itself in several important ways. 'Large Mac screens and graphics-friendly Mac software' made 'life easier for architects, publishers, artists and fashion designers', and ultimately refashioned the way that people communicated, worked, shopped, and listened to music (Bendeich & Wendlandt 2011). It was the start of a digital revolution.

This was a pivotal moment for product design as digital, computer-aided capabilities broadened the definition of what exactly a product was. To an extent, at the onset

of digital product creation, the design of electronics and the design of interfaces were 'separated' into different areas of interest. Designers were presented with the challenges of how to 'beautify the new machines' and create an engaging and 'emotional' experience (Overbeeke & Hummels 2011). For designers accustomed to hands-on processes, computer-based processes included thinking about how to use command line inputs, tablet commands and drivers, digitization of imagery, and new production processes between designers and manufacturers (Scherling 2020, p. 49). It also required more designers who, beyond making typical designs like a toothbrush or a microwave, were able to design software and hardware products, from sleek enclosures and buttons to complex interfaces.

Digital product design further expanded with the launch of the World Wide Web in 1991 and subsequent widespread commercial internet use. In the United States, internet adoption and 'going digital' happened relatively fast, with countries like Canada, the United Kingdom, Australia, and Japan following closely behind. The internet went from an early pioneering phase in the 1980s to a growth phase in the mid-1990s. By the late 1990s, America Online (AOL), a pioneer of internet services, was adding millions of internet users 'every month or two' (Case 2011).

It is estimated that there were around 150 million live websites in 1997. Many of these were created by designers who rapidly responded to a digital paradigm shift. This triggered a new 'dot-com' sector, which 'bubbled' with start-up enterprises like Webvan, an online grocer; Pets.com, a virtual pet supplies company; and the web hosting service Yahoo!GeoCities. The same year that Google registered as a domain, Netflix was founded, and Jonathan 'Jony' Ive was promoted to the position of Senior Vice President for Apple's industrial design group. With these changes, it was clear that product design was undergoing a major transformation.

The creation of new digital tools led to the use of new hardware, software, and digital typefaces. Through computer-aided design, products also became more ergonomically friendly, with the growing need for more attention to design for the 'computerised work environment' (Houser 1993). In some ways, internet-based technologies pose a potential threat to centuries of traditions in product design. In other ways, internet use and globalization of goods and services developed new connections and information sharing. Through the civil rights movement and decol-onization the consumer identities continued to shift.

13

Digital Products and Immersive Technologies

The Internet and Digital Products

By the start of the twenty-first century, product designs had taken on a distinct identity impacted by the growth of expanding digital technologies and a rise in global waste. Concerns about a counter-globalization movement put the integrity of the system of manufactured goods into question. There was also an escalation in global terrorism after the September 11 attacks and bombings in Madrid and London that brought on feelings of instability. Some leaned towards embracing a techno-optimistic outlook in light of these attacks and addressing concerns about the environmental and labour-related impacts of globalization. Scientist and futurist Ray Kurzweil (2005) argued that people would eventually move towards telecommuting and immersion in virtual reality (VR) and that societies decentralized by new technologies would be less vulnerable to terrorist and military attacks. Media and communications professor Lisa Nakamura (2007) questioned cyberspace utopianism and pointed to unprecedented 'vulnerability to techno-surveillance' (p. 125). Others watch with caution as security products and systems were bolstered by a digital age, co-existing with social media platforms and multiplayer video games (Der Derian 2003, p. 444; also see Lovink 2003).

Firms, start-ups, and consumer goods companies made the transition to integrate digital technologies and new digital tools into their workflow. By the early 2000s, people were using social media sites and mobile phones. As a precursor to social media, forums, chat rooms, and dating sites, like match.com, became popular platforms for online communication. Social networks were a place to make new friends, meet groups of like-minded people, and arrange a date.

Internet users realized the vast potential of virtual networking and website creation and the 'low cost of aggregating information' online (Shirky 2008, p. 150). E-mails and voice-over-internet tools like Skype supplemented the use of landline phone calls, and blogs became a popular medium for expression and self-promotion. Wikipedia, launched in 2001, demonstrated that user-generated content could serve

as a plausible alternative to physical dictionaries and encyclopaedias. As an important part of the movement towards knowledge-sharing, Wikipedia also has offered an 'informal collaborative learning environment' where contributors could digitally 'learn how to behave, write, and be a member (in good standing) of the community' (Hara, Shachaf, & Hew 2010, p. 2099; see Figure 13.1).

Product designers, who were educated in everything from plastic arts to furniture design to graphic design, now also considered careers in making digital products and services. Design programmes in schools and universities worked to accommodate digital technology change. This required an adjustment of their pedagogical practices to integrate new best practices for product design, and navigating how to address the 'design' of digital technology. The goal was to 'embed necessary information in the design of the [digital] object' while simultaneously upholding traditional tactile approaches to designing or the 'craft aspects of design' (Gosling 2016; Meikle 2001, p. 202; Scherling 2020).

For many product designers and design students, it was especially alluring to get a job creating a digital mobile app or join an internet start-up in the Californian hub for high-tech development, Silicon Valley. Initially, Silicon Valley had responded to the need for electronics after World War II, expanding to a regional focus on integrated circuits, personal computers, and later internet-related products (Henton & Held 2013, p. 545). However, contrary to the success of internet services and web-based products, researcher Gabrielle Athanasia (2022) called out that the Valley has also undergone 'unsustainable growth' contributing to the 'San Francisco Bay Area's increasing unaffordability and declining quality of life'. Another challenge was the lack of diversity, with very few workers of colour brought into recruiting and hiring pipelines (Beasley 2017). Other 'tech' hubs to emerge included Silicon Wadi in Tel Aviv and Bangalore (the Silicon Valley of India). Bangalore, once designated as a 'military aerospace base and the place for other public institutions', grew into a home for the Karnataka State Electronics Development Corporation (KEONICS) before expanding to an information technology district (Collato 2010, p. 54).

Even in the early years of social media networking, the sheer volume of users and amount of global traffic was astounding. By 2005, Myspace boasted 25 million users and social media networking sites Qzone and Renren were launched in China. Orkut, launched by Google, would become largely popular in Brazil and India. Meta, formerly known as Facebook Inc., conceived by Mark Zuckerberg, Eduardo Saverin, Andrew McCollum, Dustin Moskovitz, and Chris Hughes, had acquired over a million users by the end of 2004. Initially, the site began as an invitation-only college-focused project, expanding to colleges and universities in the United States, Canada, Mexico, and Europe before being launched as a fully public platform in 2006. The size and overall reach of the social network reached such a large user population that author David Kirkpatrick (2011) called it 'The Facebook Effect'. Kirkpatrick (2011)

HomePage

Welcome to WikiPedia! We're writing a complete encyclopedia from scratch, collaboratively. We started work in January 2001. We've got over 1,000 pages already. We want to make over 100,000. So, let's get to work! Write a little (or a lot) about what you know!

Some questions you might have are answered below, but why not first explore a few links?

PhiloSophy -- MathematicsAndStatistics -- ScienCe -- PhysIcs -- BiologicalSciences -- AstroNomy -- ChemIstry? -- BioChemistry -- MolecularBiology? -- BotAny? -- ZooLogy? -- EarthSciences?

CountriesOfTheWorld -- HiStory -- LinguisticS & LanguagE -- PoLitics -- EconomicS -- AnthropOlogy? -- ArchaeOlogy? -- PsychOlogy? -- SociOlogy? -- HistoryOfScienceAndTechnology? -- AnomalousPhenomena?

TechnologY -- ArchitecturE -- EngineerIng -- ComputinG -- TransporT -- BusinessAndIndustry -- BusinessAndEconomics -- TheLaw -- AgriculturalScience? -- EduCation -- CommunicAtion? -- LibraryAndInformationScience? -- HealthSciences? -- FamilyAndConsumerScience? -- PublicAffairs? -- *HumanComputerInteraction (this link should be moved when the Lewis and Clark class is done with it)*

ArtsandEntertainment -- MuSic -- DanCe -- FiLm -- LiteraryArt -- ReLigion -- ReCreation -- SportS -- ClassIcs? -- CriticalTheory? -- VisualArtsAndDesign -- PaintIng -- SculpTure? -- PerformingArts? -- TheaterAndDrama? -- GameS? -- HobbieS? -- TourIsm?

The above reflects only one of WikiPedia's CategorySchemes.

Want to learn about something? Add the topic to our list of RequestedArticles.

You're wondering

- WhatIsaWiki?
- HowDoesOneEditaPage? *Quick hint: press the "Edit text of this page" link at the bottom of every page!* Practice editing pages in our SandBox.
- WhatsTheRelationshipBetweenWikipediaAndNupedia?
- What are your NewTopics?

Other questions? Just ask on the WikiPediaFaq. See also WikiPediaProcess and WikipediaL.

Read WikiPediaAnnouncements to stay on top of the latest developments!

Techie links:

- GNUStufF
- WhichWikiShouldWeUse
- BritannicaPublicDomain

The contents of the WikiPedia is covered by the GNUFreeDocumentationLicense.

If you are interested in the general concept of HomePage, look here: HomePageDefinition.

HomePage | RecentChanges | Preferences
Edit text of this page | View other revisions
Last edited February 14, 2001 11:57 am by LarrySanger (diff)
Search:

FIGURE 13.1: The 2000 website layout of the 'HomePage' of Wikipedia in December 2001.

stated that Facebook groups would become a fundamental platform in a variety of situations, whether political or safety-related. In another study, Xiaomeng Hu et al. (2017) pointed out the 'Facebook Paradox'. Using the site simultaneously led to a reduction in loneliness and feelings of bonding, while also triggering feelings of envy and dissatisfaction (p. 2).

By 2008, Facebook overtook Myspace in users, just as a rivalry began between Apple and Samsung. Working on a top-secret project called 'Project Purple', product designers and engineers, Tony Faddell, Jonathan Ive, and Scott Forstall, worked with Steve Jobs to release Apple's first iPhone in 2007. With the iPhone 1, users could easily access the internet, third-party Web 2.0 apps, Google Maps, and photos. While reflecting on its massive impact, journalist Rani Molla (2017) stated that the iPhone put the 'Internet in everybody's pocket', transformed photography from a 'hobby to a part of everyday life', and greatly increased global media consumption. In tandem, Samsung Electronics introduced a competitor to the iPhone that Apple argued violated their utility patents. What ensued were nearly dozens of court cases, argued in courts across Japan, Korea, Europe, Australia, and the United States.

The design of social networks also led to a rise in 'crowd culture' that offered a vast potential for anybody located around the world to tap into niche communities previously difficult to find and join. Through social media and mobile connectivity, online groups could leverage a crowd culture to mobilize around a cause to donate, participate in user-generated discussions on Reddit, and even organize flash mobs. Some examples of flash mobs included London and Vancouver-based Pillow fight clubs, Seoul-based dance flash mobs, classical music flash mobs, and legal and illegal acts of art, performance, and vandalism. Reflecting on the 'age of social media', marketing professor Douglas Holt (2016) wrote that:

> Today, you'll find a flourishing crowd culture around almost any topic: espresso, the demise of the American Dream, Victorian novels, arts-and-crafts furniture, libertarianism, new urbanism, 3-D printing, anime, bird-watching, homeschooling, barbecue [...] Together, members are pushing forward new ideas, products, practices, and aesthetics – bypassing mass-culture gatekeepers.

By the mid-2000s, it had become more common to use the internet and actively generate amateur content on social media, and blogs, to comment or 'troll' online discussion forums, and to download and interact with rich media such as audio and video. Often the period of the rise of a social media, user-generated led internet is called Web 2.0. An enormous amount of data had been and was continuing to be amassed, and the question of how to use this data and make sense of it became imperative. Companies like Google began to build more expansive internet data centres with routers, switches, and servers, requiring 'raised floors', 'lots of electrical

power', and 'cooling capacity' (Holusha 2000; see Figure 13.2). By the 2010s, seeking to showcase the physical attributes of the internet, Microsoft created video tours of their server farms, and Google created photo galleries to showcase 'artful images of buildings, wires, pipes, servers, and dedicated workers that populate the centres' (Holt & Vonderau 2014, p. 88).

Internet use and computing power also meant that products like computers and mobile phones that were constantly transmitting data between companies and consumers were fundamentally transitioning a number of products into being 'smart objects'. Said objects had built-in sensors and were capable of connecting to the internet. The idea of an 'Internet of Things' or IoT was conceived in 1999 in MIT's Auto-ID Labs, but it was not until more ordinary products were designed to be connected to the internet that the concept of 'IoT' became a more widespread term.

The Ring doorbell, designed and developed by Jamie Siminoff in 2011, was an early example of an IoT product that went beyond a phone or computer connection. The doorbell connects to a smartphone and the user receives a notification on their phone, via Ring App, in order to see the person at the door. In 2007, James Park and Eric Friedman launched the wireless-enabled 'wearable technology' called the 'Fitbit' which when connected to the internet, could monitor activity, heart rate, as well as the quality of sleep. In 2016, Google Nest (previously known as Google

FIGURE 13.2: A server room at Baltic Servers, 2013.

Home) was launched to support 'home automation' tasks such as adjusting home temperature, lighting, security, wireless speakers, WiFi-enabled coffee makers, and digital personal assistants. Some voice-enabled digital assistant products like Siri and Alexa have gained a certain level of ubiquity.

Nevertheless, it has been clear that big data has been a powerful engine driving product innovation along with the use of machine learning and AI in product design. Product designers and researchers continue to prototype bigger and more expansive applications for IoT products, including entire cities such as Dubai, Singapore, and Jakarta, which have taken steps towards having fully networked city transportation, electricity, and communication systems. Concurrently, new applications in agriculture, healthcare, and retail have been developed.

Immersive Technologies and IoT

The rise of an internet crowd culture was also evident in the video gaming culture. In tandem with the development of digital technologies, the online multiplayer game culture grew out of analogue gaming culture. Online gaming environments increasingly offered a place to play games and socialize. Reminiscent of AOL, Prodigy, and Yahoo, which offered chat rooms for spontaneous and anonymous encounters, gamers could escape from everyday stress, and immerse themselves in an alternate reality. Prior to the popularity of home consoles, arcade culture had played a prominent role across a number of countries. Beginning in the late 1980s, South Korean gaming centres known as 'PC Bangs' gained momentum as hubs for socializing for an hourly fee. British youth would gather at Arcade Club, north of Manchester or at the seaside arcades in Blackpool (Meades 2016).

Yet with improving connectivity, the home was also becoming an important location for gaming. Following the success of coin-operated arcade games like Atari's tennis-themed game *Pong* in 1972, and Tomohiro Nishikado's 1978 global success *Space Invaders*, home video game systems began to gain more recognition and popularity (see Figure 13.3). Nishikado's game of 'iconic pixelated alien combatants' was so commercially popular in 1978, that it sold around 'hundred thousand machines in Japan' and another 'sixty thousand units in 1979'. Video game history writer, Simon Parkin (2013) described that it helped to establish 'the systems, rules, and vocabulary that blockbusters like Halo and Grand Theft Auto use today'.

This was followed by the 1985 release of The Nintendo Entertainment System (NES) and an initial suite of seventeen games. These games included Super Mario Bros. and Duck Hunt. Two years prior it was released in Japan as Famicom, along with the 1989 release of the highly portable Nintendo Game Boy. The Game Boy stood apart from earlier products like the Microvision 10, in that Gunpei Yokoi's

FIGURE 13.3: A Sears Tele-Games Atari Pong console released in 1975, Evan Amos. Pong was one of the first arcade games to be created and also the first to be commercially successful. It was designed by Allan Alcorn as a 'training' exercise or test prototype.

design was easier to use, had longer battery life, and was bundled with popular games like Russian mathematician Alexey Pajitnov's puzzle game *Tetris*. In excess of 100 million devices were sold (Joensson 2018; National Museum of Play 2022). After Nintendo's global success, Sony developed the first disc-based console with the 1994 PlayStation. By 2001, Microsoft released the Xbox. Games reached a new level of sophistication once players could connect to other players online.

Early multiplayer game 'mode' could allow up to eight players to connect locally in the tank battle game *Spectre*, released in 1991. *RuneScape* launched in 2001 as an early 'massively multiplayer online role-playing game (MMORPG)', where players could enter a mediaeval fantasy world via internet browser and partake in quests and duelling, trade, online chat, and participate in in-game events like 'drop parties' (Meredith, Hussain, & Griffiths 2009, p. 15). Pushing the boundaries even further was the massively multiplayer game *World of Warcraft* (WoW), designed by Rob Pardo, Jeff Kaplan, and Tom Chilton, released in 2004. Set in the world of Azeroth, the game reached its peak subscription in 2010 with twelve million subscribers.

The 2000s saw a number of advancements take place in multiplayer game design and development. The Xbox Network (formerly Xbox Live) was released in 2002 as an online service, giving the Xbox powerful online functionality to switch between multiplayer games. This helped create a massive adoption of the 3D sandbox game *Minecraft*. Valued for its open-ended format where players can engage in 'survival' mode or 'creative' mode. The Museum of pop culture writer Tony Drovetto (2019) described that ultimately Minecraft's 'community of players has become one of its greatest resources when it comes to educating and entertaining users, new and experienced alike'.

Among one of the major technological developments emerging in the 2000s were digital products. These products aimed to incorporate immersive technologies, and augmented and VR applications in digital environments. Before digital computing, some sensory-focused immersive simulation products which were created by the London Stereoscopic Company's 'snap' stereographic views along with Mattel's View-Master had been designed for general mass consumption.

After British scientist Charles Wheatstone 1838 discovered that 'if you drew two pictures of something [...] from two slightly different perspectives, and then viewed each one through a different eye, your brain would assemble them into a three-dimensional view', David Brewster created a marketable stereographic photo product that was sold through the London Stereoscopic Company throughout England and the world. Thompson (2017) publishers like Wilbur Read in Johannesburg could transport viewers from afar to see what a deep gold mine in South Africa looked like, while American publishers like the Keystone View Company had produced around 40,000 titles by 1940 including 'topographical, nature, events and genre-view scenes' (Stereoscopy Blog 2022). By 1939, the first View-Master system was released, designed by a German American inventor William Gruber, who applied his love of photography into a rotational disc, with some of the first applications being used to view wildflowers and national parks (see Figure 13.4).

Despite the popularity of products like the Keystone View Company's stereoviews and Mattel's View-Master, commercial and public applications for stereographic visual simulators or 'virtual reality' were rare. Increasingly, it was viable in flight or driving simulations through the 1970s and 1990s.

Computer artist David Em created one of the earliest virtual worlds for NASA's Jet Propulsion Laboratory in 1977. While labs like Linden Lab (creator of Second Life) and the US Airforce Armstrong Lab continued to develop VR technologies through the 1990s, commercial applications were only developed in the 2000s. Releases such as the VR headset Oculus Rift in 2012, and the VR platform Google Cardboard in 2014 took place. The Oculus would continue as the most popular VR headset, with their Quest 2 model gaining wider use among Steam gamers. As the devices became

FIGURE 13.4: The View-Master stereoscope was first introduced in 1939 and represented early experimentation with immersive technologies.

'smaller and more fashionable', additions to the extended reality (XR) market would occur (Alsop 2022).

The XR market has notably included augmented reality (AR) and mixed reality (MR) applications. While VR draws users into full computer-generated simulations, AR has emerged as the go-between where computer-generated imagery is superimposed into a screen view of the real world.

The first real mainstream global success for AR came with Pokémon Go, which launched in 2016 and has employed a 'freemium' business model seeing its second most profitable year during the pandemic of 2021. There were more than 904 million in-app purchases from battle passes and poke balls to 'lure modules' that attract pocket monsters. Software developer Tatsu Nomura helped to create Google Maps, and later joined Niantic Labs to direct Pokémon Go. It has received praise for promoting physical activity and social networking but has also received criticisms that

it has distracted users into street and automobile accidents. It has also revealed inequitable situations, or an 'unlevel playing field' that 'for many people of colour in places like South Africa and the United States, the game's goal of wandering and exploration is simply unattainable' (Tekinbas 2017, p. 35).

VR and AR applications like Meta Quest VR games and Pokémon have been well received, but attaining mass marketability remains to be proven. In 2021, Mark Zuckerberg announced a more aggressive development of 'the metaverse – defined most simply as a virtual world where people can socialize, work, and play'. Shirin Ghaffary (2021) argued that 'if the metaverse becomes everything Zuckerberg wants it to be, it could similarly shake up the world, shifting our existence from being rooted in the physical world to one in which our digital presence increasingly supplements our real one'.

Through the start of the twenty-first century, digital technology has re-fashioned how design has been practised, taught, and learned. This vastly changed the skill requirements for product designers. While some product designers were wary of digital technologies and sought to preserve traditional methods, consumers increasingly gravitated toward digital products. Over time, digital technologies have continued to play an outsized role in product design considerations for both physical and digital products. As companies have transitioned to incorporate digital technologies into their existing workflows, but there have been lingering concerns about privacy and data misuse, access, lack of diversity, and environmental impact.

Nevertheless, the growth of social media networks fostered a massive amount of user-generated content, the birth of a 'crowd culture', and heavily influenced the way people interact with each other. All of these interactions would accumulate massive amounts of data and new design considerations. This would impact the development of networked devices, or an 'Internet of Things', and immersive technologies. The Information Age is a new chapter about what is possible for human beings and the products they create.

Epilogue

In recent years the idea of social responsibility, activism, and decentering history has emerged as a shared global concern among designers, scholars, companies, and consumers. By definition, corporate social responsibility is a model that can help a company become more socially accountable. By practising corporate social responsibility or 'corporate citizenship', companies are more conscious of their impact in all aspects of society, including economic, social, and environmental impacts.

When considering historical patterns of design, production, and consumption, there has been a strong drive to make the world a better and more liveable place. Product design can improve the quality of our lives, or do the exact opposite. Products can lead to disputes or even warfare. As designers take on increasingly important and complex roles in organizations, from design studios to major corporations, they can have the ability to influence decision-making processes. The call for more transparency in business standards and operations to the demand for greater impact, influence, and authenticity in brand communications and product management is widespread. Many companies have progressed in committing to ethical and sustainable practices, but there is still a great deal of variance when it comes to enacting real social change. Service Design professor, Yoori Koo (2006) pointed out that 'social responsibility in part originated from the individual ethical values of designers, but it is also a response to the needs of their clients or willingness of the organisation they belong to' (p. 50).

Ethical behaviours in design remain difficult to impart. It's been a gradual shift to make design and manufacturing practices more ethical and sustainable. Throughout product design history, various movements have formed to call out unethical practices. The Arts & Crafts movement challenged unethical manufacturing practices. The Swadeshi movement staged a powerful boycott against colonialism. By the 1970s, the concept of corporate social responsibility was more formally recognized as an initiative by the Committee for Economic Development (CED). The CED stressed the importance of a 'social contract' between businesses and society.

Through the 1980s and the 1990s, concepts of green design and recyclability had become more common, and a decade later these concepts would evolve into

143

'sustainable design' (Koo 2016, p. 50). By the 1990s, some companies began making commitments to improve their environmental performance. IBM was among some of the 'first companies to obtain International Standardization Organization 14000', confirming a suite of standards concerning environmental management. Organizations like KnowtheChain, Verité, Fairtrade International, and The Cooperation for Fair Trade in Africa (COFTA) have also prioritized supporting vulnerable workers who are often women fighting to improve labour and trade conditions for everybody, especially in light of catastrophes like the Rana Plaza Collapse (Chowdhury 2017).

To ensure a sustainable and ethical future, product designers and consumers must ask companies to uphold their social and environmental responsibilities to their workers and the public. Designers can re-examine and affirm how they utilize ethics and activism to 'reproduce, rebuild, and reshape a culture by improving its methods, practices, and tools of communication', and commit to practices that uphold sustainability and fight social injustices (Poshar in ed. Scherling & DeRosa 2020). This can mean establishing values, redesigning existing supply chains, and making it a requirement that consumer goods are ethically designed, sourced, and manufactured.

Product designers, Mohammad Razzaghi and Mariano Ramirez Jr. (2005) outlined the social and cultural impact of designers. They pointed out that the product design process is not exclusively controlled by physical conditions like material properties or production constraints. Design is also influenced by unknown and hard-to-manage factors, such as the designers' own culture and values, their sense of connectedness with the product being designed, their emotions, aesthetical preferences, and other nonphysical aspects (p. 1).

Of course, not all goods are mass-manufactured, and many product designers continue to maintain practices to make goods that are 'artisanal' or handmade. Competition from larger businesses can make it difficult for consumers to purchase products from independent product designers, and artisans of colour, and those historically marginalized must be included equally. National and regional design associations such as Design Indaba in South Africa, the Danish Crafts & Design Association, the Black Design Collective, and the Korea Craft & Design Foundation have supported and shared the stories of professional artisans and designers at fairs, exhibitions, and online, providing scholarship and educational opportunities.

Product designers have also demonstrated their ability to take part in activist movements and to build tools and resources for the public good. The design of social networks and platforms like GoFundMe, Indiegogo, Change.org, and Kickstarter have informed people about important social causes. Grassroots organizations, companies, and student organizers have been empowered by digital products like

Telegram, Bridgefy, and WhatsApp. Californian-based Design Action Collective began distributing Black Lives Matter toolkits for conflict resolution and 'healing justice' an ongoing global movement nearly a decade after Trayvon Martin's murder (Wong 2020). Designer and author, Alistair Fuad-Luke (2009) pointed out that: 'Design activism is design thinking, imagination and practice applied knowingly or unknowingly to create a counter-narrative aimed at generating and balancing positive social, institutional, environmental and/or economic change [...]' (p. 27).

The future of product design requires re-engaging with product design history. By understanding existing products and the way they have previously impacted societies, we can include new perspectives in the history of design, integrating more stories of women designers, designers of colour, LGBTQ+ designers, and designers from indigenous communities. We can more assertively confront pressing global issues ranging from climate change to political upheaval. With this mindset, we can be more attuned to community identities. In product design, measuring 'all-time' importance is, of course, debatable. However, many designers and creative professionals, researchers, and educators across sectors, increasingly view it as their ethical responsibility to be more inclusive in the telling and re-telling of history. As many Asian and African countries gained independence between the 1940s and the 1970s, a 'geopolitical restructuring of the world' took place. Historical narratives were in serious need of redress (Getachew 2020; Jansen & Osterhammel 2017).

Despite the efforts being made, design continues to lack diversity as a professional discipline. Work created by 'non-western cultures', particularly female digital designers and designers of colour, remains largely underrepresented (Design History Society 2020; Khandwala 2019). The need to confront social inequities in design history has been a long-standing challenge. The Design Research Society (n.d.), founded in the United Kingdom in 1966, developed special interest groups on inclusive design, and a Pluriversal Design special interest group that draws on 'research from outside of Europe and North America' in order to foster global design research communities that are challenged with 'de-westernizing' design, projects such as Cite Black Women, and Depatriarchise Design. Jaheed Hussain's Manchester-based Fuse platform has sought to more accurately represent Black, Indigenous, Latina/o, Asian and Pacific Islander, and other designers of colour (Cowan 2020).

Historical research has the potential to change how we contextualize the present to archive and retell the stories of designers from marginalized backgrounds (Khandwala 2019). Stories need to be researched, shared, and revisited in meaningful ways that ensure the messages are both relevant and impactful. Through historical inquiry, we can preserve important information about technological innovations and capture details about individuals' daily lives and relationships to the societies they work and live in. Given the sizable role that digital technologies now play in our lives, sharing histories also enables communities to capture more

information about important products, services, and tools while shaping a global history of design.

Many people feel connected to stories about the products they grew up with and the brands they have enjoyed and valued. By critically approaching product design histories, these stories can increasingly serve as an educational link to social issues, especially when it comes to understanding consumption patterns, social inequalities, and sustainability issues today, all of which are deeply entangled. As discussions about decolonization, human rights in supply chains, climate change, and consumerism are becoming bolder and more public-facing, building on this momentum through historical inquiry is ever more urgent.

Today, a great deal of work is needed to challenge dominant narratives that are embedded in product design history. Information is infused in everything. It is embedded in nearly every imaginable product—digital products, clothing, furnishings, speciality goods, industrial goods, and convenience items. By studying the history of design, we can take a step closer to understanding why carry specific meanings, and biases, and embody nuanced and diverse cultural products references.

References

Acaroglu, L. (27 May 2020). Quick guide to sustainable design strategies. *Disruptive Design*. Retrieved from https://medium.com/disruptive-design/quick-guide-to-sustainable-design-strategie-641765a86fb8. Accessed 21 April 2024.

Adelabu, O.S., Yamanaka, T., & Moalosi, R. (2013). Retraction: Towards Kansei evaluation of African product design-perspectives from cultural aesthetics. *International Journal of Affective Engineering*, 12(2): 135–144.

Adolphson, M., & Ramseyer, J.M. (2009). The competitive enforcement of property rights in mediaeval Japan: The role of temples and monasteries. *Journal of Economic Behavior & Organization*, 71(3): 660–668.

Aid, M.M., & Burr, W. (2013). Secret Cold War documents reveal NSA spied on senators. *Foreign Policy*. Retrieved from https://foreignpolicy.com/2013/09/25/secret-cold-war-documents-reveal-nsa-spied-on-senators. Accessed 21 April 2024.

Akhter, T. (2020). Gender inequality and literature: A contemporary issue. In *6th international conference on social and political sciences (ICOSAPS 2020)* (pp. 593–596). Atlantis Press.

Alcalá, A. (1 February 2017). Looking Harlem in the eye. *Design Observer*. Retrieved from http://designobserver.com/feature/looking-harlem-in-the-eye/39498. Accessed 21 April 2024.

Aldis, H.G. (2011). *The printed book*. Cambridge: Cambridge University Press.

Alfani, G. (2021). Economic inequality in preindustrial times: Europe and beyond. *Journal of Economic Literature*, 59(1): 3–44.

Alfke, G., Irion, W.W., & Neuwirth, O.S. (2000). Oil refining. *Ullmann's Encyclopedia of Industrial Chemistry*. Retrieved from https://doi.org/10.1002/14356007.a18_051.pub2. Accessed 21 April 2024.

Al-Khalili, J. (2015). The birth of the electric machines: A commentary on Faraday (1832) 'Experimental researches in electricity'. *Philosophical Transactions of the Royal Society A: Mathematical, Physical and Engineering Sciences*, 373(2039): 1–12.

Álvarez, V.P. (2015). The role of the mechanical clock in medieval science. *Endeavour*, 39(1): 63–68.

Anwar, M.A., & Graham, M. (2021). Between a rock and a hard place: Freedom, flexibility, precarity and vulnerability in the gig economy in Africa. *Competition & Change*, 25(2): 237–258.

Aoki, K. (1992). Race, space, and place: The relation between architectural modernism, post-modernism, urban planning, and gentrification. *Fordham Urban Law Journal*, 20: 699.

Aridi, R. (2020). Human-made materials now weigh more than all life on earth combined. *Smithsonian Magazine*. Retrieved from http://www.smithsonianmag.com/smart-news/human-made-materials-now-weigh-more-ll-life-earth-combined-180976522. Accessed 21 April 2024.

Arora, A. (1997). Patents, licensing, and market structure in the chemical industry. *Research Policy*, *26*(4–5): 391–403.

Athanasia, G. (10 February 2022). The lessons of Silicon Valley: A world-renowned technology hub. *Center for Strategic and International Studies*. Retrieved from https://www.csis.org/blogs/perspectives-innovation/lessons-silicon-valley-world-reowned-technology-hub. Accessed 21 April 2024.

Atomium. (n.d.). *The origins*. Retrieved from https://atomium.be/discover. Accessed 21 April 2024.

Avendano, R., Bontadini, F., Mulder, N., & Zaclicever, D. (2020). Latin America's faltering manufacturing competitiveness: What role for intermediate services? *International trade series, No. 148, Santiago, Economic Commission for Latin America and the Caribbean (ECLAC)*. Retrieved from https://repositorio.cepal.org/bitstream/handle/11362/45061/1/S1901076_en.pdf. Accessed 21 April 2024.

Barron, L. (2021). The creative influence of history in fashion practice: The legacy of the Silk Road and Chinese-inspired culture-led design. *Fashion Practice*, *13*(2): 275–295.

Barsouk, A., Thandra, K.C., Saginala, K., Rawla, P., & Barsouk, A. (2021). Chemical risk factors of primary liver cancer: An update. *Hepatic Medicine: Evidence and Research 2020*, (12): 179–188.

Beardsley, E. (29 May 2018). In France, the protests of May 1968 reverberate today – and still divide the French. *NPR*. Retrieved from http://www.npr.org/sections/parallels/2018/05/29/613671633/in-france-the-protests-of-my-1968-reverberate-today-and-still-divide-the-french. Accessed 21 April 2024.

Beasley, M. (2017). There is a supply of diverse workers in tech, so why is Silicon Valley so lacking in diversity? *The Center for American Progress*. Retrieved from https://www.americanprogress.org/article/supply-diverse-workers-tech-silicon-valley-lacking-diversity. Accessed 21 April 2024.

Bendeich, M., & Wendlandt, A. (7 October 2011). Steve Jobs, not just a geek but a god for designers. *Reuters*. Retrieved from https://www.reuters.com/article/idUSTRE79549I/. Accessed 21 April 2024.

Bird, D.W., Bird, R.B., Codding, B.F., & Zeanah, D.W. (2019). Variability in the organization and size of hunter-gatherer groups: Foragers do not live in small-scale societies. *Journal of Human Evolution*, *131*: 96–108.

Blakemore, E. (19 February 2019). What is colonialism. *National Geographic*. Retrieved from https://www.nationalgeographic.com/culture/article/colonialism. Accessed 21 April 2024.

Blakemore, E. (21 June 2019). How the GI Bill's promise was denied to a million Black WWII veterans. *History*. Retrieved from https://www.history.com/news/gi-bill-black-wwii-veterans-benefits. Accessed 21 April 2024.

Blanchard, D. (2021). *Supply chain management best practices*. Hoboken: John Wiley & Sons.

Bonomo, J. (2000). Tupperware: The promise of plastic in 1950s America. *The Georgia Review*, *54*(1): 164–167.

Bose, G., Jain, T., & Walker, S. (2022). Women's labor force participation and household technology adoption. *European Economic Review*, *147*: 104181.

Bosshardt, W., & Lupus, J.S. (2013). Business in the Middle Ages: What was the role of guilds? *Social Education*, 77(2): 64–67.

Bowles, S., & Choi, J.K. (2013). Coevolution of farming and private property during the early Holocene. *Proceedings of the National Academy of Sciences*, 110(22): 8830–8835.

Brennan, A. (2015). Olivetti: A work of art in the age of immaterial labour. *Journal of Design History*, 28(3): 235–253.

Broilo, F.A. (2019). Interconnectedness and mobility in the Middle Ages/nowadays: From Baghdad to Chang'an and from Istanbul to Tokyo. In Andrea Acri, Kashshaf Ghani & Murari Kumar J'ha (Eds), *Imagining Asia(s) networks, actors, sites* (pp. 334–357). ISEAS Publishing.

Brookings Institution Press. (2021). Multinational corporations in the 21st century economy. *Brookings*. Retrieved from http://www.brookings.edu/wp-content/uploads/2021/04/GG_Ch1_Summary.pdf. Accessed 21 April 2024.

Brown, E.N. (12 November 2019). Black fashion of the 1990s was groundbreaking. This new exhibit celebrates its rise. *Fast Company*. Retrieved from http://www.fastcompany.com/90421886/black-fashion-of-the-1990s-was-groundbreaking-this-new-exhibit-celebrates-its-rise. Accessed 21 April 2024.

Brumfiel, E.M. (2008). The multiple identities of Aztec craft specialists. *Archeological Papers of the American Anthropological Association*, 8(1): 145–152.

Bulliet, R.W. (2016). *The wheel: Inventions and reinventions*. Columbia University Press.

Burtless, G. (1 September 2001). Workers' rights: Labour standards and global trade. *Brookings*. Retrieved from https://www.brookings.edu/articles/workers-rights-labor-standards-and-global-trade/. Accessed 21 April 2024.

Cambir, A., & Vasile, V. (2015). Material dimension of life quality and social inclusion. *Procedia Economics and Finance*, 32: 932–939.

Campbell, H. (Ed.). (2010). *The emergence of modern Europe: c. 1500 to 1788*. Britannica Educational Publishing.

Capdevila, P.M. (2017). An Italian querelle: Radical vs. tendenza. *Log*, 40: 67–81.

Carozza, L., & Mille, M. (2008). Moving into the metal ages: The social importance of metal at the end of the neolithic period in France. *HAL Open Science*, 003452921–31.

Carson, R. (1962). *Silent spring*. Houghton Mifflin Company.

Cartwright, M. (12 April 2008). Trade in the Roman world. *World History Encyclopedia*. Retrieved from http://www.worldhistory.org/article/638/trade-in-the-roman-world. Accessed 21 April 2024.

Cartwright, M. (14 September 2014). The Inca road system. *World History Encyclopedia*. Retrieved from https://www.worldhistory.org/article/757/the-inca-road-system. Accessed 21 April 2024.

Cartwright, M. (8 January 2019). Trade in Medieval Europe. *World History Encyclopedia*. Retrieved from https://www.worldhistory.org/article/1301/trade-in-medieval-europe. Accessed 21 April 2024.

Case, A. (29 August 2019). Why Elon Musk says we are already cyborgs. *CNBC*. Retrieved from http://www.cnbc.com/video/2019/08/29/why-elon-musk-says-we-are-already-cyborgs.html. Accessed 21 April 2024.

Cathro, R.J. (2005). Tin deposits and the early history of bronze. *CIM Magazine, 98*(1088): 1–14.

Chalmers, F.G. (1985). South Kensington and the colonies: David Blair of New Zealand and Canada. *Studies in Art Education, 26*(2): 69–74.

Chalmin, P. (2019). The history of plastics: From the Capitol to the Tarpeian Rock. Field actions science reports. *The Journal of Field Actions,* (Special Issue 19): 6–11.

Chambouleyron, R., & Arenz, K.H. (2021). Amazonian Atlantic: Cacao, colonial expansion and indigenous labour in the Portuguese Amazon region (seventeenth and eighteenth centuries). *Journal of Latin American Studies, 53*(2): 221–244.

Chappe, R., & Jaramillo, C.L. (2020). Artisans and designers: Seeking fairness within capitalism and the gig economy. *Dearq, 26:* 80–87.

Chemhuru, M. (2017). Elements of environmental ethics in ancient Greek philosophy. *Phronimon, 18*(1): 15–30.

Cheongju Early Printing Museum. (n.d.). The invention of movable metal type: Goryeo technology and wisdom. *Google Arts & Culture.* Retrieved from https://artsandculture.google.com/story/the-invention-of-movable-metal-type-goryeo-technology-and-wisdom-cheongju-early-printing-museum/zgXxwilonG6kIg?hl=en. Accessed 21 April 2024.

Chowdhury, R. (2017). The Rana Plaza disaster and the complicit behavior of elite NGOs. *Organization, 24*(6): 938–949.

Church, R. (2000). Advertising consumer goods in nineteenth-century Britain: Reinterpretations. *Economic History Review, 53*(4): 621–645.

Cipolla, C.M. (2003). *Clocks and culture, 1300–1700.* WW Norton & Company.

Clark, G. (2012). A review essay on the enlightened economy: An economic history of Britain 1700–1850 by Joel Mokyr. *Journal of Economic Literature, 50*(1): 85–95.

Coca Cola. (2020). Our history. Retrieved from https://www.coca-cola.com/in/en/about-us/history accessed 21 April 2024.

Collato, F. (2010). Is Bangalore the Silicon Valley of Asia? Analysis of the evolution and the structure of this Indian local economy organization. *Journal of Indian Business Research, 2*(1): 52–65.

Computer History Museum. (n.d.). 1970s–early 1980s | selling the computer revolution museum. Retrieved from http://www.computerhistory.org/brochures/1970s-early1980s. Accessed 21 April 2024.

Connah, G. (2010). *Writing about archaeology.* Cambridge: Cambridge University Press.

Conrad, D.C., & Frank, B.E. (Eds.). (1995). *Status and identity in West Africa: Nyamakalaw of Mande.* Indiana University Press.

Cook, B., & Werner, A. (24 August 2017). Breathing in London's history: From the great stink to the great smog. *Museum of London.* Retrieved from http://www.museumoflondon.org.uk/discover/londons-past-air. Accessed 21 April 2024.

Copping, R. (2022). *Volkswagen beetle: A celebration of the world's most popular car.* Veloce Publishing Ltd.

Council on Foreign Relations. (n.d.). 1850–2022 oil dependence and U.S. foreign policy. Retrieved from http://www.cfr.org/timeline/oil-dependence-and-us-foreign-policy. Accessed 21 April 2024.

Cowen, K. (3 July 2020). Creative platform Fuse urges the creative industries to 'do better' with its push for inclusivity. *Creative Boom*. Retrieved from https://www.creativeboom.com/news/creative-platform-fuse. Accessed 21 April 2024.

Crawford, J. (2020). Understanding Byzantine economy: The collapse of a medieval powerhouse. *The Collector*. Retrieved from https://www.thecollector.com/byzantine-economy-collapse-medieval-times. Accessed 21 April 2024.

Cross, N. (2001). Design cognition: Results from protocol and other empirical studies of design activity. In C. Eastman, M. McCracken, & W. Newstetter (Eds.), *Design knowing and learning: Cognition in design education*, (pp. 79–103). Elsevier.

Cupane, C., & Krönung, B. (2016). *Fictional storytelling in the medieval eastern Mediterranean and beyond*. Brill.

Curthoys, A. (2012). Memory, history, and Ego-Histoire: Narrating and re-enacting the Australian freedom ride. *Historical Reflections/Réflexions Historiques*, *38*(2): 25–45.

Dartmouth Toxic Metals. (2022). Copper: An ancient metal. Retrieved from https://sites.dartmouth.edu/toxmetal/more-metals/copper-an-ancient-metal. Accessed 21 April 2024.

Dawson, M. (2007). Home video and the 'TV Problem': Cultural critics and technological change. *Technology and Culture*, *48*(3): 524–549.

Delgado, F.P. (1995). Chicano movement rhetoric: An ideographic interpretation. *Communication Quarterly*, *43*(4): 446–455.

Der Derian, J. (2003). The question of information technology in international relations. *Millennium*, *32*(3): 441–456.

Design Research Society. (n.d). Pluriversal design SIG. Retrieved from https://www.design-researchsociety.org/cpages/sig-pluriversal-design. Accessed 21 April 2024.

DiSalvo, C. (2015). *Adversarial design*. The MIT Press.

Dittmar, J.E. (2011). Information technology and economic change: The impact of the printing press. *The Quarterly Journal of Economics*, *126*(3): 1133–1172.

Dong, L.C., & Yu, C. (2020). Globalization or localization: Global brand perception in emerging markets. *International Business Research*, *13*(10): 53–65.

Droste, M. (2016). *Bauhaus*. Taschen.

Droste, M., & Friedewald, B. (2019). *Our Bauhaus: Memories of Bauhaus people*. Prestel.

Drovetto, T. (2019). What's the Big Deal with Minecraft? *Museum of Pop Culture*. Retrieved from https://www.mopop.org/about-mopop/the-mopop-blog/posts/2019/october/what-s-the-big-deal-with-minecraft/. Accessed 21 April 2024.

Du Bois, W.E.B. (1903). *The souls of black folk*. McClurg.

Eames. (n.d.). Wartime. Retrieved from https://eames.com/en/wartime. Accessed 21 April 2024.

Edo, A., & Melitz, J. (2019). The primary cause of European inflation in 1500–1700: Precious metals or population? The English evidence. *Cliometrica*, *17*: 91–124.

Edwards, B. (12 November 2015). Inside computer stores of the 70s and 80s. *PCMAG*. Retrieved from http://www.pcmag.com/news/inside-computer-stores-of-the-70s-and-80s

Efland, A.D. (1990). *A history of art education*. Teachers College Press.

Elliot, M., & Hughes, J. (18 August 2019). Four hundred years after enslaved Africans were first brought to Virginia, most Americans still don't know the full story. *The New York Times*. Retrieved from https://www.nytimes.com/interactive/2019/08/19/magazine/history-slavery-smithsonian.html. Accessed 21 April 2024.

Elnashar, E.A. (2019). Woven seamless of clothes between ancient Egyptian history and future. *Latest Trends in Textile and Fashion Designing (LTTFD), Trends in Textile & Fashion Design, 3*(4): 1–3.

Erb-Satullo, N.L., Jachvliani, D., Kalayci, T., Puturidze, M., & Simon, K. (2019). Investigating the spatial organisation of Bronze and Iron Age fortress complexes in the South Caucasus. *Antiquity, 93*(368): 412–431.

Erdönmez, S.S., & Guneş, S. (2016). Ethic conscience in product design. *New Trends and Issues Proceedings on Humanities and Social Sciences, 2*(1): 157–162.

Eskelson, T.C. (2020). How and why formal education originated in the emergence of civilisation. *Journal of Education and Learning, 9*(2): 29–47.

Ethical Trading Initiative. (n.d.). Gender equity in global supply chains. ETI. Retrieved from http://www.ethicaltrade.org/issues/gender-equity-global-supply-chains. Accessed 21 April 2024.

Eurocities Working Group Food. (2021). Food aid in European cities. Retrieved from https://food-trails.milanurbanfoodpolicypact.org/wp-content/uploads/2021/08/PolicyBrief-Food-Aid-in-European-Cities-EUFoodCities.pdf. Accessed 21 April 2024.

Fanon, F. (1961). *The wretched of the earth*. Grove Press.

Farr, S. (15 February 2017). Starbucks: The early years. Retrieved from http://www.historylink.org/file/20292. Accessed 21 April 2024.

Fashion Revolution. (2021). Fashion transparency index 2021. Retrieved from http://www.fashionrevolution.org/about/transparency. Accessed 21 April 2024.

Fashion United. (3 June 2010). Louis Vuitton bags an advertising ban. *FashionUnited*. Retrieved from https://fashionunited.uk/news/fashion/louis-vuitton-bags-an-advertising-ban/201060331231. Accessed 21 April 2024.

Fichter, J.R. (Ed.). (2019). *British and French colonialism in Africa, Asia and the Middle East: Connected empires across the eighteenth to the twentieth centuries*. Springer International Publishing.

Fiell, C., & Fiell, P. (2016). *The story of design: From the paleolithic to the present*. The Monacelli Press.

Fleming, S.J. (1999). *Roman glass; reflections on cultural change*. University of Pennsylvania Museum of Archaeology and Anthropology.

Flinchum, R.A., & Meyer, R.O. (2017). Henry Dreyfuss and Bell telephones. *Winterthur Portfolio, 51*(4): 173–200.

Ford. (n.d.). The Model T. Retrieved from https://corporate.ford.com/articles/history/the-model-t.html. Accessed 21 April 2024.

Freelancers Union. (2019). Freelancing in America. Retrieved from http://www.slideshare.net/upwork/freelancing-in-america-2019/1. Accessed 21 April 2024.

Freestone, I.C. (2015). The recycling and reuse of Roman glass: Analytical approaches. *Journal of Glass Studies, 57*: 29–40.

Friedan, B. (1963). *The feminine mystique*. W.W. Norton & Company.

Fuad-Luke, A. (2009). *Design activism: Beautiful strangeness for a sustainable world*. Earthscan.

Fussell, G. (24 February 2021). From Raves to Ray Gun: A walk through 90s design culture. *Shutterstock*. Retrieved from https://www.shutterstock.com/blog/90s-design-culture. Accessed 21 April 2024.

Garner, P. (2003). *Sixties design*. Taschen.

Gershon, L. (21 January 2023). The colonial history of the telegraph. *JStor Daily*. Retrieved from https://daily.jstor.org/the-colonial-history-of-the-telegraph. Accessed 21 April 2024.

Getachew, A. (27 July 2020). Colonialism made the modern world. Let's remake it. *The New York Times*. Retrieved from http://www.nytimes.com/2020/07/27/opinion/sunday/decolonization-statues.html. Accessed 21 April 2024.

Ghaffary, S. (24 November 2021). Why you should care about Facebook's big push into the metaverse. *Vox*. Retrieved from https://www.vox.com/recode/22799665/facebook-metaverse-meta-zuckerberg-oculs-vr-ar. Accessed 21 April 2024.

Gilson, R.J., & Roe, M.J. (1993). Understanding the Japanese keiretsu: Overlaps between corporate governance and industrial organization. *Yale Law Journal*, *102*(4): 871–906.

Giovannini, A. (1993). Greek cities and Greek Commonwealth. In A. Bulloch & E.S. Gruen (Eds.), *Images and ideologies*. (pp. 267–287). University of California Press.

Godfrey, L., Ahmed, M.T., Gebremedhin, K.G., Katima, J.H., Oelofse, S., Osibanjo, O., Richter, U.H., & Yonli, A.H. (2019). Solid waste management in Africa: Governance failure or development opportunity. *Regional Development in Africa*, *235*. Retrieved from https://www.intechopen.com/chapters/68270. Accessed 21 April 2024.

Goldense, B. (29 March 2019). A history of product design. *Machine Design*. Retrieved from http://www.machinedesign.com/automation-iiot/article/21837666/a-history-of-product-delgn. Accessed 21 April 2024.

Goldstein, J. (10 August 2011). How much do we buy from China? *NPR*. Retrieved from http://www.npr.org/sections/money/2011/08/10/139388532/only-a-tiny-sliver-of-american-personal-spending-goes-to-china. Accessed 21 April 2024.

Goliński, M. (2022). Cloth merchants vs weavers: Imposed top-down solutions to a permanent dispute (based on examples from Polish cities and their East German analogues in the late Middle Ages). *The City and History (Mesto a dejiny until 2019)*, *11*(1): 26–38.

Gorman, C. (Ed.). (2003). *The industrial design reader*. Allworth.

Gosling, E. (6 September 2016). Art school lessons for professional design practice. *Eye on Design*. Retrieved from https://eyeondesign.aiga.org/art-school-learnings-for-professional-design-practise. Accessed 21 April 2024.

Gott, L.D. (1976). *The reaction of WEB DuBois to European colonialism, 1900–1950 (Doctoral dissertation)*. Virginia Polytechnic Institute and State University.

Gotter, U. (2008). Cultural differences and cross-cultural contact: Greek and Roman concepts of power. *Harvard Studies in Classical Philology*, *104*: 179–230.

Greenman, C. (17 October 1999). When dials were round and clicks were plentiful. *The New York Times*. Retrieved from https://www.nytimes.com/1999/10/07/technology/when-dials-were-round-and-clicks-were-plentiful. Accessed 21 April 2024.

Grinspan, J. (27 April 2021). 19th-Century America's partisan warfare. *Smithsonian Magazine*. Retrieved from https://www.smithsonianmag.com/smithsonian-institution/little-known-story-19thcentury-americas-hyper-partisan-warfare-180977586. Accessed 21 April 2024.

Griswold, E. (23 September 2012). How 'Silent Spring' ignited the environmental movement. *The New York Times*. Retrieved from https://www.nytimes.com/2012/09/23/magazine/how-silent-spring-ignited-the-environmental-movement.html. Accessed 21 April 2024.

Grollemond, L., & Waldorf, S. (15 November 2022). There's no such thing as the Dark Ages. *Getty Museum*. Retrieved from https://www.getty.edu/news/no-such-thing-as-the-dark-ages. Accessed 21 April 2024.

Guillén, M.F. (2004). Modernism without modernity: The rise of modernist architecture in Mexico, Brazil, and Argentina, 1890–1940. *Latin American Research Review, 39*(2): 6–34.

Gunn, T.G. (1982). The mechanization of design and manufacturing. *Scientific American, 247*(3): 114–131.

Gurney, C. (2000). 'A Great Cause': The origins of the anti-apartheid movement, June 1959–March 1960. *Journal of Southern African Studies, 26*(1): 123–144.

Gursoy, D., & Altinay, L. (2021). The Silk Road and the service industries. *The Service Industries Journal, 41*(7–8): 441–445.

Haddon, L. (1992). Explaining ICT consumption: The case of the home computer. In Eric Hirsch & Roger Silverstone (Eds.), *Consuming technologies: Media and information in domestic spaces* (pp. 82–96). Routledge.

Hansen, J. (2017). *Nostalgic media: Histories and memories of domestic technology in the moving image*. The Ohio State University.

Hara, N., Shachaf, P., & Hew, K.F. (2010). Cross-cultural analysis of the Wikipedia community. *Journal of the American Society for Information Science and Technology, 61*(10): 2097–2108.

Harris, J. (2020). *Maya bone tool technologies at Ucanal, Guatemala (Ph.D. dissertation)*. The University of Mississippi.

Haugtvedt, C.P., Herr, P.M., & Kardes, F.R. (Eds.). (2018). *Handbook of consumer psychology*. Routledge.

Henton, D., & Held, K. (2013). The dynamics of Silicon Valley: Creative destruction and the evolution of the innovation habitat. *Social Science Information, 52*(4): 539–557.

Higgs, K. (11 January 2021). A brief history of consumer culture. *The MIT Press Reader*. Retrieved from https://thereader.mitpress.mit.edu/a-brief-history-of-consumer-culture. Accessed 21 April 2024.

Hilton, M. (2007). Consumers and the state since the Second World War. *The ANNALS of the American Academy of Political and Social Science, 611*(1): 66–81.

Hindmarch-Watson, K. (2020). *Serving a wired world: London's telecommunications workers and the making of an information capital* (Vol. 17). University of California Press.

Hirota, H. (2018). Immigration to American cities, 1800–1924. In *Oxford research encyclopedia of American history*. Oxford University Press. Retrieved from https://oxfordre.com/american-history/view/10.1093/acrefore/9780199329175.001.0001/acrefore-9780199329175-e-577. Accessed 21 April 2024.

Hirst, K.K. (29 July 2021). Why do archaeologists call arrowheads projectile points? *ThoughtCo*. Retrieved from http://www.thoughtco.com/arrowheads-and-projectile-points-172919. Accessed 21 April 2024.

Hodgson, K. (2015). French Atlantic appropriations: Montlinot, eighteenth-century colonial slavery, and penal and forced labour schemes between Europe, Africa and the Americas. *Forum for Modern Language Studies*, *51*(2): 116–132.

Hole, F. (2002). Is size important? Function and hierarchy in Neolithic settlements. In I. Kuijt (Ed.), *Life in neolithic farming communities: Social organization, identity, and differentiation* (pp. 191–210). Kluwer Academic.

Hollis, R. (2006). *Swiss graphic design: The origins and growth of an international style, 1920–1965*. Yale University Press.

Holt, D. (1 March 2016). Branding in the age of social media. *Harvard Business Review*. Retrieved from https://hbr.org/2016/03/branding-in-the-age-of-social-media. Accessed 21 April 2024.

Holt, J., & Vonderau, P. (2015). 'Where the internet lives': Data centers as cloud infrastructure. In L. Parks & N. Starosielski (Eds.), *Signal traffic: Critical studies of media infrastructures*, (pp. 71–93). University of Illinois Press.

Holusha, J. (2000). Commercial property/engine room for the internet; combining a data center with a Telco Hotel. *The New York Times*. Retrieved from https://www.nytimes.com/2000/05/14/realestate/commercial-property-engine-room-for-internet-combining-data-center-with-telco.html. Accessed 21 April 2024.

Houser, J.W. (1993). Ergonomics: The investment of the '90s. *College Review (Denver, Colo.)*, *10*(2), 48–58.

Hu, X., Kim, A., Siwek, N., & Wilder, D. (2017). The Facebook paradox: Effects of Facebooking on individuals' social relationships and psychological well-being. *Frontiers in Psychology*, *8*: 87.

Iacobacci, R. (2019). *Fabric of a nation*. Morrisville: Lulu.

Imperial War Museum. (n.d.). Make do and mend, 1943. Retrieved from https://www.iwm.org.uk/history/make-do-and-mend-0. Accessed 21 April 2024.

International Labour Organization. (n.d.). Conventions and recommendations. Retrieved from http://www.ilo.org/global/standards/introduction-to-international-labour-standards/convetions-and-recommendations/lang--en/index.htm. Accessed 21 April 2024.

International Trade Union Confederation. (2019). 2019 ITUC global rights index. Retrieved from https://www.ituc-csi.org/IMG/pdf/2019-06-ituc-global-rights-index-2019-report-en-2.pdf. Accessed 21 April 2024.

Inyang, A., & Edet, B.J. (2019). The Atlantic charter and decolonization movements in Africa. *African Journal of History and Archaeology*, *4*(1): 1–13.

Irwin, Neil (29 June 2021). Markets work, but untangling global supply chains takes time. *The New York Times*. Retrieved from https://www.nytimes.com/2021/06/29/upshot/markets-work-but-untangling-global-supply-chains-takes-time.html. Accessed 21 April 2024.

Israel, P.B. (2002). Inventing industrial research: Thomas Edison and the Menlo Park laboratory. *Endeavour*, *26*(2): 48–54.

Jackson, P. (2004). Local consumption cultures in a globalizing world. *Transactions of the Institute of British Geographers*, 29(2): 165–178.

Jansen, J. C., & Osterhammel, J. (2017). *Decolonization: A short history*. Princeton University Press.

Jia, F., Zuluaga-Cardona, L., Bailey, A., & Rueda, X. (2018). Sustainable supply chain management in developing countries: An analysis of the literature. *Journal of Cleaner Production*, 189: 263–278.

Joensson, W. (2020). *Iconic product design: An illustrated history of the world's most innovative devices*. Skyhorse.

Johnson, B. (26 May 2010). Louis Vuitton ads slammed as misleading. *Marketing Week*. Retrieved from https://www.marketingweek.com/louis-vuitton-ads-slammed-as-misleading. Accessed 21 April 2024.

Jones, J. (1982). My mother was much of a woman: Black women, work, and the family under slavery. *Feminist Studies*, 8(2): 235–269.

Kajiya, K. (2010). How emotions work. In Jaqueline Berndt (Ed.), *Comics worlds and the worlds of comics: Towards scholarship on a global scale. Global Manga Studies* (Vol. I, pp. 245–262). Kyoto.

Kardulias, P.N. (2002). Negotiation in a contested periphery: Indians in the fur trade. In *Paper Annual Meeting on the Political Economy of World Systems* (Vol. 4).

Kaste, M. (26 December 2011). Police say they aimed for restraint with protesters. *NPR*. Retrieved from https://www.npr.org/2011/12/26/144283217/with-occupy-protests-police-aimed-for-restraint. Accessed 21 April 2024.

Kaza, S., Yao, L.C., Bhada-Tata, P., & Van Woerden, F. (2018). What a Waste 2.0: A global snapshot of solid waste management to 2050. *Urban Development © Washington, DC: World Bank*. Retrieved from http://hdl.handle.net/10986/30317. Accessed 21 April 2024.

Keele, L., Cubbison, W., & White, I. (2021). Suppressing Black votes: A historical case study of voting restrictions in Louisiana. *American Political Science Review*, 115(2): 694–700.

Keen, B. (1987). 'Play it again, Sony': The double life of home video technology. *Science as Culture*, 1(1): 7–42.

Keenan, G. (2020). A brief history of vaccines and how they changed the world. *World Economic Forum*. Retrieved from https://www.weforum.org/agenda/2020/04/how-vaccines-changed-the-world. Accessed 21 April 2024.

Khandwala, A. (5 July 2019). What does it mean to decolonize design? *AIGA Eye on Design*. Retrieved from https://eyeondesign.aiga.org/what-does-it-mean-to-decolonize-design. Accessed 21 April 2024.

King, S., & Chang, K. (n.d.). A brief history of industrial and interaction design. *O'Reilly*. Retrieved from https://www.oreilly.com/library/view/understanding-industrial-design/978149192031/ch01.html. Accessed 21 April 2024.

Kirkpatrick, D. (2011). *The Facebook effect: The inside story of the company that is connecting the world*. Simon & Schuster.

Kirkup, J. (14 July 1992). Obituary: Hasegawa Machiko. Retrieved from https://www.independent.co.uk/news/people/obituary-hasegawa-machiko-1533204.html. Accessed 21 April 2024.

Kitchen, J.E. (1914). Colonial empires after the war/decolonization. *International Encyclopedia of the First World War*. Retrieved from https://encyclopedia.1914-1918-online.net/article/colonial_empires_after_the_wardecolonization. Accessed 21 April 2024.

Kitchen, J.E. (2015). Violence in defence of empire: The British Army and the 1919 Egyptian revolution. *Journal of Modern European History*, *13*(2): 249–267.

Know the Chain (2018). Apparel and footwear benchmark findings report. Retrieved from https://knowthechain.org/wp-content/uploads/KTC_AF_2018_.pdf. Accessed 21 April 2024.

Kociołek, K. (2018). London's Suffragettes, votes for women, and fashion. *ANGLICA-An International Journal of English Studies*, *27*(1): 81–95.

Koo, Y. (2016). The role of designers in integrating societal value in the product and service development processes. *International Journal of Design*, *10*(2). Retrieved from http://www.ijdesign.org/index.php/IJDesign/article/view/2462/739. Accessed 21 April 2024.

Krasilnikoff, J.A. (2010). Irrigation as innovation in ancient Greek agriculture. *World Archaeology*, *42*(1): 108–121.

Kristof, N.D., & WuDunn, S. (2000). Two cheers for sweatshops. *New York Times Magazine*, *24*: 6–7.

Kurzweil, R. (2005). *The singularity is near: When humans transcend biology*. Viking Press.

Kyrk, H., & Davis, J.S. (1925). *The American baking industry, 1849–1923: As shown in the census reports* (Vol. 2). Stanford University Press.

Lachenicht, S. (2023). Religion and colonization. *Oxford Bibliographies*. Retrieved from https://www.oxfordbibliographies.com/display/document/obo-9780199730414/obo-9780199730414-0311.xml. Accessed 21 April 2024.

Lardas, M. (2020). *Spanish Galleon vs English Galleon: 1550–1605*. Bloomsbury Publishing.

Lawrence, S. (2005). Colonisation in the industrial age: The landscape of the Australian gold rush. *Industrial Archaeology: Future Directions*, 279–298.

Lee, H.L., Padmanabhan, V., & Whang, S. (1997). The bullwhip effect in supply chains. *Sloan Management Review*, *38*(3): 93–102.

Lenk, K.M., Winkler, M.R., Caspi, C.E., & Laska, M.N. (2020). Food shopping, home food availability, and food insecurity among customers in small food stores: An exploratory study. *Translational Behavioral Medicine*, *10*(6): 1358–1366.

Li, H.H.J., & Tan, K.H. (2004). SMEs' business growth model: A medium to big effort. *International Journal of Management and Enterprise Development*, *1*(3): 195–207.

Li, W., Lu, X., Luo, H., Sun, X., Liu, L., Zhao, Z., & Guo, M. (2017). A landmark in the history of Chinese ceramics: The invention of blue-and-white porcelain in the Tang Dynasty (618–907 AD). *STAR: Science & Technology of Archaeological Research*, *3*(2): 358–365.

Library of Congress. (n.d.). Work in the late 19th century. Retrieved from https://www.loc.gov/classroom-materials/united-states-history-primary-source-tieline/rise-of-industrial-america-1876-1900/work-in-late-19th-century. Accessed 21 April 2024.

Lichtman, S.A. (2006). Do-it-yourself security: Safety, gender, and the home fallout shelter in Cold War America. *Journal of Design History*, *19*(1): 39–55.

Linton, T., & Vakil, B. (5 March 2020). Coronavirus is proving we need more resilient supply chains. *Harvard Business Review*. Retrieved from https://hbr.org/2020/03/coronavirus-is-proving-that-we-need-more-resilient-supply-chains. Accessed 21 April 2024.

Littek, W. (2001). Division of labor. In N.J. Smelser & P.B. Baltes (Eds.), *International encyclopedia of the social and behavioral sciences 1–26*: 8220–8226.

Littler, J. (2006). 'Festering Britain': The 1951 festival of Britain, national identity and the representation of the commonwealth In: Ramamurthy, A. & Faulkner, S. (Eds.), *Visual culture and decolonisation In Britain* (pp. 21–42). Ashgate.

Liu, T.W. (3 May 2022). Shanghai's food shortages spur voluntarism and cynicism. *Foreign Policy*. Retrieved from https://foreignpolicy.com/2022/05/03/shanghai-food-shortages-covid-lock-down-china/. Accessed 21 April 2024.

Locke, R.M. (2003). The promise and perils of globalization: The case of Nike. *Management: Inventing and Delivering Its Future*, 39: 1–39.

Loose, N. (2017). Made-in-country index 2017: An interview with the study's author. *Statista*. Retrieved from https://stat-download-public.s3.eu-central-1.amazonaws.com/Study/1/40000/43370_sample.pdf. Accessed 21 April 2024.

Lovegrove, K. (2000). *Airline: Identity, design and culture*. Laurence King Publishing.

Lovink, G. (2003). *Dark fiber: Tracking critical internet culture*. MIT Press.

Luchs, M., & Swan, K.S. (2011). Perspective: The emergence of product design as a field of marketing inquiry. *Journal of Product Innovation Management*, 28(3): 327–345.

Lumsden, L.J. (1997). *Rampant women: Suffragists and the right of assembly*. University of Tennessee Press.

Luo, M. (2015). *Literati storytelling in Late Medieval China*. University of Washington Press.

MacDowell, M. (2020). Quilts: Unfolding personal and public histories in South Africa and the United States. *Image & Text*, 34: 1–24.

Macneil, J. (18 November 2019). *Touch tone phones are invented*. Retrieved from https://www.edn.com/tone-dialing-telephones-are-introduced-november-18-1963. Accessed 21 April 2024.

Mainardi, P. (2018). Quilts: The great American art. *Feminism and Art History*, 330–346.

Malanima, P. (2020). The Italian economy before unification, 1300–1861. In *Oxford research encyclopedia of economics and finance*. Oxford University Press. Retrieved from https://doi.org/10.1093/acrefore/9780190625979.013.536. Accessed 21 April 2024.

Manyika, J., Madgavkar, A., Tacke, T., Smit, S., Woetzel, J., & Abdulaal, A. (5 February 2020). The social contract in the 21st century. *McKinsey*. http://www.mckinsey.com/industries/publicand-social-sector/our-insights/the-social-contract-in-the-21st-century. Accessed 21 April 2024.

Marouf, M. (2008). Technical analysis of the supplementary weft weaves in archaeological Egyptian textiles. 11th Arab Archaeologists Meeting 18–20 October. Retrieved from https://staffsites.sohag-univ.edu.eg/uploads/511/1536012504%20-%20The%20Supplementary%20weft%20weave%20(1).pdf. Accessed 21 April 2024.

Marrama, O. (2019). Spinoza, Baruch. In M. Sgarbi (Ed.), *Encyclopedia of renaissance philosophy*. Retrieved from http://www.springer.com/gp/book/9783319141688. Accessed 21 April 2024.

Mashao, E.T., & Sukdeo, N. (2018). Factors that influence consumer behavior in the purchase of durable household products. In *Proceedings of the international conference on industrial engineering and operations management* Paris, France, July 26–27, 2018.

Mastny, V. (2016). The Cold War arms race: Forces beyond the superpowers. In J. Thomas Mahnken, Joseph Maiolo, & D. Stevenson (Eds.), *Arms races in international politics: From the nineteenth to the twenty-first century* (pp. 196–197). Oxford Academic.

Mayer, R.M. (2012). *Design with reinforced plastics: A guide for engineers and designers*. Springer Science & Business Media.

McCourt, M. (29 May 2014). When Art Deco is really Streamline Moderne, and what it meant for 1930s auto design. *Hemmings*. Retrieved from https://www.hemmings.com/stories/2014/05/29/1930s-auto-design-art-deco-and-streamline-moderne. Accessed 21 April 2024.

McKenzie, H. (2020). From spinster to career woman: Middle-class women and work in Victorian England by Arlene Young. *Victorian Periodicals Review*, 53(1): 167–170.

McLuhan, M. (1964). *Understanding media: The extensions of man*. Cambridge: The MIT Press.

Meades, A. (2016). Arcade tales 2 – it survived the 80s and we have spare parts. Retrieved from https://repository.canterbury.ac.uk/download/f684b6e8551757a53eb6419b128869f2258f2a956d-b8352a58796264d50c6604/3242504/ARCADE%20TALES%202.pdf. Accessed 21 April 2024.

Meikle, J.L. (2001). *Twentieth century limited: Industrial design in America 1925–1939* (2nd ed.). Temple University Press.

Mendez, L. (7 May 2020). Greenwashing is real—here's how to avoid it. *Architectural Digest*. Retrieved from https://www.architecturaldigest.com/story/greenwashing-and-sustainable-brands. Accessed 21 April 2024.

Meredith, A., Hussain, Z., & Griffiths, M.D. (2009). Online gaming: A scoping study of massively multi-player online role playing games. *Electronic Commerce Research*, 9(1): 3–26.

Meyer, M., Tan, M., Vohra, R., McAdoo, M., & Lim, K.M. (14 June 2021). How ASEAN can move up the manufacturing value chain. *BCG Global*. Retrieved from http://www.bcg.com/publications/2021/asean-manufacturing. Accessed 21 April 2024.

Milkias, P., & Getachew, M. (Eds.). (2005). *The battle of Adwa: Reflections on Ethiopia's historic victory against European colonialism*. Algora Publishing.

Miller, C. (2022). *Chip war: The fight for the world's most critical technology*. Simon and Schuster.

Millet, H., Vangheluwe, P., Block, C., Sevenster, A., Garcia, L., & Antonopoulos, R. (2018). The nature of plastics and their societal usage (pp. 1–20). *Royal Society of Chemistry*.

Mitrovic, J. (2022). Some ideas of James Watt in contemporary energy conversion thermodynamics. *Journal of Modern Physics*, 13(4): 385–409.

Moatsos, M. (2021). Global extreme poverty: Present and past since 1820. *OECD iLibrary*. Retrieved from https://www.oecd-ilibrary.org/sites/e20f2f1a-en/index.html?itemId=/content/component/e20f2f1a-en. Accessed 21 April 2024.

Molla, R. (2017). How Apple's iPhone changed the world: 10 years in 10 charts. *Vox*. Retrieved from http://www.vox.com/2017/6/26/15821652/iphone-apple-10-year-anniversary. Accessed 21 April 2024.

Moynihan, J.P. (1980). *The influence of the Bauhaus on art and art education in the United States*. Northwestern University.

Mull, A. (21 September 2021). Americans have no idea what the supply chain really is. *The Atlantic*. Retrieved from http://www.theatlantic.com/technology/archive/2021/09/pandemic-supply-chain-nightmar-slow-shipping/620147. Accessed 21 April 2024.

Muñoz, J. (2021). The powerful, complicated legacy of Betty Friedan's 'The Feminine Mystique.' *Smithsonian Magazine*. Retrieved from http://www.smithsonianmag.com/smithsonian-institution/powerful-complicated-legacy-bety-friedans-feminine-mystique-180976931. Accessed 21 April 2024.

Nakamura, L. (2007). *Digitizing race: Visual cultures of the internet*. Minnesota: University of Minnesota Press.

Narsimhan, S. (2009). Plants and human civilisation: Indian spices. *Comparative Civilisations Review, 60*(60): 120–149.

NASA. (17 December 2018). 115 Years Ago: Wright Brothers make history at Kitty Hawk. Retrieved from http://www.nasa.gov/feature/115-years-ago-wright-brothers-make-history-at-kitty-hawk. Accessed 21 April 2024.

National Air and Space Museum. (n.d.). Boeing 367-80 Jet transport. Retrieved from https://www.si.edu/object/boeing-367-80-jet-transport:nasm_A19730272000. Accessed 21 April 2024.

National Geographic Society. (20 May 2022). Native Americans in Colonial America. Retrieved from https://education.nationalgeographic.org/resource/native-americans-colonial-america/. Accessed 21 April 2024.

National Museum of African American History and Culture. (n.d.). MARTINIQUE - Type et Costume Créole. Retrieved from http://www.si.edu/object/martinique-type-et-costume-creole:nmaahc_2016.151.5. Accessed 21 April 2024.

Newman, R., Rael, P., & Lapsansky, P. (Eds.). (2000). *Pamphlets of protest: An anthology of early African-American protest literature, 1790–1860*. Routledge.

Ng, S., & Zhuang, J. (7 September 2016). The design of sharing food in a connected world. *Design Observer*. Retrieved from https://designobserver.com/feature/the-design-of-sharing-food-in-a-connected-wold/39377. Accessed 21 April 2024.

Nield, R. (2010). Treaty ports and other foreign stations in China. *Journal of the Royal Asiatic Society Hong Kong Branch, 50*: 123–139.

Nordhaus, W.D. (2001). The progress of computing. *Social Science Research Network*. Retrieved from https://papers.ssrn.com/abstract=285168. Accessed 21 April 2024.

Odokuma, E. (2017). Indigenous tendencies: An interpretation and classification of some of the works of Bruce Onobrakpeya. *Journal of Pan African Studies, 10*(3): 109–132.

Ogilvie, S. (2020). Guilds and the economy. In *Oxford research encyclopedia of economics and finance* (pp. 1–32). Oxford University Press.

Overbeeke, K., & Hummels, C. (2011). Industrial design. Retrieved from https://www.interaction-design.org/literature/book/the-encyclopedia-of-human-computer-interaction-2nd-ed/industrial-design. Accessed 21 April 2024.

Ozkan, E. (2011). The bank-based financial system and Kinyu Keiretsu: Political economy of the bank-centered cross-shareholding system in postwar Japan. *Ritsumeikan Journal of Asia Pacific Studies*, *30*(2011): 38–55.

Papadopoulos, E. (2007). Heron of Alexandria (c. 10–85 AD). *Distinguished figures in mechanism and machine science: Their contributions and legacies Part 1* (pp. 217–245). Springer.

Papanek, V. (1972). *Design for the real world*. Academy Chicago.

Parkin, K. (2020). Marketing justice: The Christmas boycott. *History of Retailing and Consumption*, *6*(3): 162–196.

Parkin, S. (17 October 2013). The space invader. *The New Yorker*. Retrieved from http://www.newyorker.com/tech/elements/the-space-invader. Accessed 21 April 2024.

PBS. (n.d.). John Fitch. Retrieved from https://www.pbs.org/wgbh/theymadeamerica/whomade/fitch_hi.html. Accessed 21 April 2024.

Perry, P., & Wood, S. (2018). Exploring the international fashion supply chain and corporate social responsibility. *Logistics and retail management* (5th ed., pp. 97–128). Kogan Page.

Pfeiffer, S. (2012). The imperial cult in Egypt. In C. Riggs (Ed.), *The Oxford handbook of Roman Egypt*. Oxford University Press.

Pillsbury, J. (2020). Gold in the Ancient Americas. *The Metropolitan Museum of Art*. Retrieved from https://www.metmuseum.org/toah/hd/gdaa/hd_gdaa.htm. Accessed 21 April 2024.

Pirani, D., Harman, V., & Cappellini, B. (2022). Family practices and temporality at breakfast: Hot spots, convenience and care. *Sociology*, *56*(2): 211–226.

Pontius-Vandenberg, J. (2020). Teaching the Haitian revolution. *Social Education*, *84*(6): 355–361.

Porter, J.D. (2019). Slavery and Athens' economic efflorescence: Mill slavery as a case study. *Mare Nostrum*, *10*(2): 25–50.

Poshar, A. (2000). Graphic design and activism: Reflecting on interactions. In L. Scherling & A. DeRosa (Eds.), *Ethics in design and communication: Critical perspectives* (pp. 125–128). Bloomsbury Visual Arts.

Poushter, J., Bishop, C., & Chwe, H. (19 June 2018). Social media use continues to rise in developing countries. *Pew Research Center's Global Attitudes Project*. Retrieved from http://www.pewresearch.org/global/2018/06/19/2-smartphone-ownership-on-the-rise-in-merging-economies. Accessed 21 April 2024.

Prisecaru, P. (2017). The challenges of the industry 4.0. *Global Economic Observer*, *5*(1): 66–72.

Raizman, D. (2004). *A history of modern design: Graphics and products since the industrial revolution*. Hachette.

Razzaghi, M., & Ramirez, Jr, M. (2005). Product design: The reflection of designers' preferences. *Art and Industry Forum of the Iranian Academy of the Arts*. Retrieved from https://doi.org/10.26190/unsworks/455. Accessed 21 April 2024.

Redding, S. (2000). A blood-stained tax: Poll tax and the Bambatha rebellion in South Africa. *African Studies Review*, *43*(2): 29–54.

Redman, C.L. (2014). *Qsar es-Seghir: An archaeological view of medieval life*. Academic Press.

Reynard, P.C. (2000). Manufacturing quality in the pre-industrial age: Finding value in diversity. *The Economic History Review*, 53(3): 493–516.

Richter, F. (4 May 2021). China Is the world's manufacturing superpower. *Statista*. Retrieved from https://www.statista.com/chart/20858/top-10-countries-by-share-of-global-manufacturing-output/. Accessed 21 April 2024.

Rigoglioso, R. (8 March 2017). Stanford scholar tells history of Cold War from African American perspective. Retrieved from https://news.stanford.edu/2017/03/08/cold-war-african-american-perspective. Accessed 21 April 2024.

Roman, K. (2010). *The king of Madison avenue: David Ogilvy and the making of modern advertising*. Macmillan.

Roos, D. (20 September 2021). The Silk Road: 8 goods traded along the ancient network. *History*. Retrieved from https://www.history.com/news/silk-road-trade-goods. Accessed 21 April 2024.

Rose, L.A. (1999). *The Cold War comes to main street: America in 1950*. University Press of Kansas.

Roser, C. (2016). *Faster, better, cheaper in the history of manufacturing*. Taylor & Francis.

Ritchie, H., Rodés-Guirao, L., Mathieu, E., Gerber, M., Ortiz-Ospina, E., Hasell, J., & Roser, M. (2023). Population growth. Retrieved from https://ourworldindata.org/population-growth. Accessed 21 April 2024.

Salen Tekinbaş, K. (2017). Afraid to roam: The unlevel playing field of Pokémon Go. *Mobile Media & Communication*, 5(1), 34–37.

Samuel S. (2019). Witsaja iki, or the good life in Ecuadorian Amazonia: Knowledge co-production for climate resilience. In A. Ahearn, M. Oelz, & R.K. Dhir (Eds.), *Indigenous peoples and climate change: Emerging research on traditional knowledge and livelihoods* (pp. 51–63). International Labour Organization.

Sanyal, S. (22 March 2012). A brief history of supply chains. *The Globalist*. Retrieved from http://www.theglobalist.com/a-brief-history-of-supply-chains. Accessed 21 April 2024.

Schamel, W., & Potter, L.A. (1997). The homestead act of 1862. *Social Education*, 61(6): 359–364.

Scherling, L. (2021). Rethinking sustainable luxury fashion and supply chain design. *Design Observer*. Retrieved from https://designobserver.com/article.php?id=40454. Accessed 21 April 2024.

Scherling, L.S. (2020). Learning during a digital transformation in communication design: Faculty, professional, and student views on changing pedagogical practices (Doctoral dissertation). Teachers College, Columbia University.

Schneider, M.J. (1983). Womens' work: An examination of womens' roles in Plains Indian arts and crafts. *The hidden half: Studies of plains Indian women*, (pp. 101–121). University Press of America.

Scholliers, P. (2015). Convenience foods. What, why, and when. *Appetite*, 94: 2–6.

Schorsch, D. (2017). Gold in Ancient Egypt. The Metropolitan Museum of Art. Retrieved from https://www.metmuseum.org/toah/hd/egold/hd_egold.htm. Accessed 21 April 2024.

Schwellnus, C., Geva, A., Pak, M., & Veiel, R. (2019). Gig economy platforms: Boon or Bane? OECD Economics Department. Retrieved from https://www.oecd-ilibrary.org/content/paper/fdb0570b-en. Accessed 21 April 2024.

Scott, W.D. (1903). *The theory of advertising*. Small, Maynard & Company.

Sebastian, A. (12 July 2021). 5 countries that produce the most waste. *Investopedia*. https://www. investopedia.com/articles/markets-economy/090716/5-countries-produce-mos-waste.asp. Accessed 21 April 2024.

Selbesoğlu, H.Ş., Barutçu, B., & Çökelez, A. (2021). The brief history of early marine-navigation. *Advanced Geomatics*, 1(1): 14–20.

Shirky, C. (2008). *Here comes everybody: The power of organizing without organizations*. Penguin.

Silva, M. (2015). *Type design for typewriters Olivetti* (Doctoral dissertation, MA thesis, University Reading).

Silverstein, M. J., Fiske, N., & Butman, J. (2008). *Trading up: Why consumers want new luxury goods--and how companies create them*. USA: Portfolio.

Sim, T. (2021). *What should decolonization mean for the history of science?* Retrieved from http:// www.hps.cam.ac.uk/files/decolonise-sim.pdf. Accessed 21 April 2024.

Simpson, St J. (1997). Early urban ceramic industries in Mesopotamia. In I. C. Freestone & D. Gaimster (Eds.) *Pottery in the making: world ceramic traditions* (pp. 50–55). British Museum Press.

Singh, M., & Glowacki, L. (2022). Human social organization during the Late Pleistocene: Beyond the nomadic-egalitarian model. *Evolution and Human Behavior*, 43(5): 418–431.

Smit, J.L. (15 December 2019). Ancient civilizations timeline: The complete list from Aboriginals to Incans. *History Cooperative*. Retrieved from https://historycooperative.org/ancient-civilizations. Accessed 21 April 2024.

Smith, A. (1776). *Wealth of nations*. W. Stahan.

Smithsonian American Art Museum. (2011). New England factory life-bell-time. Retrieved from https://www.si.edu/object/new-england-factory-life-bell-time-harpers-weekly-july-251868%3Asaam_1996.63.69. Accessed 21 April 2024.

Smith, K.N. (26 April 2021). Africa's first Iron Age culture had a sweet tooth. *Ars Technica*. Retrieved from https://arstechnica.com/science/2021/04/africas-first-iron-age-culture-had-a-sweet-tooth/. Accessed 21 April 2024.

Smith, R.C., Winschiers-Theophilus, H., Loi, D., de Paula, R.A., Kambunga, A.P., Samuel, M.M., & Zaman, T. (2021). Decolonizing design practices: Towards pluriversality. In *Extended abstracts of the 2021 CHI conference on human factors in computing systems* (pp. 1–5).

Smith, W. (8 April 1964). New I.B.M, System 360 can serve business, science and government; I.B.M. introduces a computer it says tops output of biggest. *The New York Times*. Retrieved from https://www.nytimes.com/1964/04/08/archives/new-ibm-system-360-can-serve-business-science-and-government-ibm.html. Accessed 21 April 2024.

Sojka, R.E., Bjorneberg, D.L., & Entry, J.A. (2002). Irrigation: An historical perspective. In R. L, (ed.) *Encyclopedia of Soil Science* (pp. 745–749). Marcel Dekker, Inc.

Spires, D.R. (2019). *The practice of citizenship: Black politics and print culture in the early United States*. University of Pennsylvania Press.

Starch, D. (1910). *Principles of advertising: A systematic syllabus of the fundamental principles of advertising*. University Cooperative Company.

Stephan, K. (2001). Experts at play: Magnetron research at Westinghouse, 1930–1934. *Technology and Culture*, *42*(4): 737–749.

Stratigakos, D. (2003). Women and the Werkbund: Gender politics and German design reform, 1907–14. *The Journal of the Society of Architectural Historians*, *62*(4): 490–511.

Strong Museum of Play. (n.d.). Video game history timeline. Retrieved from https://www.museumofplay.org/video-game-history-timeline. Accessed 21 April 2024.

Styles, J. (2020). The rise and fall of the Spinning Jenny: Domestic mechanisation in eighteenth-century cotton spinning. *Textile History*, *51*(2): 195–236.

Suresh, P., Vijay Daniel, J., Parthasarathy, V., & Aswathy, R.H. (2014). A state of the art review on the Internet of Things (IoT) history, technology and fields of deployment. In *2014 international conference on science engineering and management research (ICSEMR)* (pp. 1–8). IEEE.

Switzer, H.D. (2018). *When the light is fire: Maasai schoolgirls in contemporary Kenya*. University of Illinois Press.

Szasz, F.M., & Takechi, I. (2007). Atomic heroes and atomic monsters: American and Japanese cartoonists confront the onset of the nuclear age, 1945–80. *The Historian*, *69*(4): 728–752.

Tan, Z.M., Aggarwal, N., Cowls, J., Morley, J., Taddeo, M., & Floridi, L. (2021). The ethical debate about the gig economy: A review and critical analysis. *Technology in Society*, *65*(2021): 101594.

Tedesco, P. (2022). Africa's transitions to the Middle Ages. *Medieval Worlds*, 129–140.

Tempelhoff, J.W. (2008). Historical perspectives on pre-colonial irrigation in Southern Africa. *African Historical Review*, *40*(1): 121–160.

The Art Story. (n.d.). Summary of the international style. Retrieved from https://www.theartstory.org/movement/international-style. Accessed 21 April 2024.

The British Library. (n.d.). The spinning Jenny. Retrieved from https://www.bl.uk/learning/timeline/item107855.html. Accessed 21 April 2024.

The European Council. (2022). How the Russian invasion of ukraine has further aggravated the global food crisis. Retrieved from https://www.consilium.europa.eu/en/infographics/how-the-russian-invasion-of-ukraine-has-further-aggravated-the-global-food-crisis/. Accessed 21 April 2024.

The Henry Ford Organization. (26 February 2013). African American workers at Ford Motor Company. Retrieved from https://www.thehenryford.org/explore/blog/african-american-workers-at-ford-motor-company. Accessed 21 April 2024.

The Metropolitan Museum of Art. (n.d.). Cuneiform tablet: Administrative account with entries concerning malt and barley groats. Retrieved from https://www.metmuseum.org/art/collection/search/327385. Accessed 21 April 2024.

The World Bank. (n.d.). Trends in solid waste management. Retrieved from https://datatopics.worldbank.org/what-a-waste/trends_in_solid_waste_management.html. Accessed 21 April 2024.

Thomas, D. (2019). *Fashionopolis: The price of fast fashion and the future of clothes*. London: Penguin.

Thompson, K.A. (2006). *An eye for the tropics: Tourism, photography, and framing the Caribbean picturesque*. Duke University Press.

Tian, Y., & Stewart, C. (2006). History of e-commerce. In *Encyclopedia of E-commerce, E-government, and mobile commerce* (pp. 559–564). IGI Global.

Tlostanova, M. (2017). On decolonizing design. *Design Philosophy Papers*, *15*(1): 51–61.

Tom, M.N., Sumida Huaman, E., & McCarty, T.L. (2019). Indigenous knowledges as vital contributions to sustainability. *International Review of Education*, *65*: 1–18.

UK Parliament. (2023). Women get the vote. Retrieved from https://www.parliament.uk/about/living-heritage/transformingsociety/electionsvoting/womenvote/overview/thevote/. Accessed 21 April 2024.

United Nations Climate Change. (6 September 2018). UN helps fashion industry shift to low carbon. Retrieved from https://unfccc.int/news/un-helps-fashion-industry-shift-to-low-carbon. Accessed 21 April 2024.

United Nations Conference on Trade and Development. (2017). The least developed countries in the post-COVID world: Learning from 50 years of experience. Retrieved from https://unctad.org/system/files/official-document/ldc2021overview_en.pdf. Accessed 21 June 2024.

United Nations. Climate and weather related disasters surge five-fold over 50 years, but early warnings save lives – WMO report. Retrieved from https://news.un.org/en/story/2021/09/1098662. Accessed 21 April 2024.

United Nations Environment Programme. (2015). UNEP annual report. Retrieved from https://www.unep.org/resources/annual-report/united-nations-environment-programme-annual-report-2015. Accessed 21 April 2024.

University of Bergen. (2016). Humans evolved by sharing technology and culture. Retrieved from https://www.sciencedaily.com/releases/2016/02/160202121246.htm. Accessed 21 April 2024.

University of Bergen. (2020). Blombos cave. Retrieved from https://www.uib.no/en/sapience/140042/blombos-cave. Accessed 21 April 2024.

Uri, J. (2023) 120 years ago: The first powered flight at Kitty Hawk. Retrieved from https://www.nasa.gov/history/120-years-ago-the-first-powered-flight-at-kitty-hawk/. Accessed 21 April 2024.

Van Aelst, P., & Walgrave, S. (2002). New media, new movements? The role of the internet in shaping the 'anti-globalization' movement. *Information, Communication & Society*, *5*(4): 465–493.

Verité (2017). Strengthening protections against trafficking in persons in federal and corporate supply chains. Retrieved from https://verite.org/wp-content/uploads/2017/04/EO-and-%AD Commodity-Reports-Cmbined-FINAL-2017.pdf. Accessed 21 April 2024.

Vettese Forster, S., & Christie, R.M. (2013). The significance of the introduction of synthetic dyes in the mid-19th century on the democratisation of western fashion. *JAIC-Journal of the International Colour Association*, *11*: 1–17.

Vezzoli, C., Ceschin, F., Diehl, J.C., & Kohtala, C. (2015) New design challenges to widely implement 'Sustainable Product–Service Systems'. *Journal of Cleaner Production*, *97*: 1–12.

Victoria & Albert Museum. (n.d.). What was modernism? Retrieved from www.vam.ac.uk/articles/what-was-modernism. Accessed 21 April 2024.

Vidale, M., & Miller, H.M. (1997). On the development of Indus technical virtuosity and its relation to social structure. *South Asian Archaeology*, *1*: 115–132.

Villarca, H. (1 June 2019). Study: Social inequality has been around since the Stone Age. *The Atlantic*. Retrieved from http://www.theatlantic.com/health/archive/2012/06/study-social-inequality-has-been-arond-since-the-stone-age/257894. Accessed 21 April 2024.

Villena, V.H., & Gioia, D.A. (1 March 2020). A more sustainable supply chain. *Harvard Business Review*. Retrieved from https://hbr.org/2020/03/a-more-sustainable-supply-chain. Accessed 21 April 2024.

Warren, J. (n.d.). Britain's greatest invention. *BBC*. Retrieved from https://connect.open.ac.uk/science-technology-engineering-and-maths/britains-greatest-invention. Accessed 21 April 2024.

Waterloo. (n.d.). Boulton & Watt. Retrieved from https://ageofrevolution.org/200-object/boulton-watt-engine. Accessed 21 April 2024.

Watt, A. (1885). *The art of soap-making*. Oxford University Press.

Webb, B. (19 April 2021). Fashion's freelancer problem exposed. *Vogue Business*. Retrieved from https://www.voguebusiness.com/fashion/fashions-freelancer-problem-exposed-financial-instability-mental-health. Accessed 21 April 2024.

Wellum, C. (2022). Oil, culture and modernity. In R. Dannreuther and W. Ostrowski (Eds) *Handbook on oil and international relations*. (pp. 50–65). Edward Elgar.

Wen, Y. (2016). China's rapid rise. *The Regional Economist*, *24*(2): 8–14.

Wilford, J.N. (26 February 2002). When humans became human. *The New York Times*. Retrieved from http://www.nytimes.com/2002/02/26/science/when-humans-became-human.html. Accessed 21 April 2024.

Wilson, G.L., Wood, W.R., & Lehmer, D.J. (1977). Mandan and Hidatsa pottery making. *Plains Anthropologist*, *22*(76): 97–105.

Windsor-Liscombe, R. (2004). Usual culture: The jet. *TOPIA: Canadian Journal of Cultural Studies*, *11*(2004): 83–99.

Winton, A.G. (2007). The Bauhaus, 1919–1933. *The Metropolitan Museum of Art*. Retrieved from https://www.metmuseum.org/toah/hd/bauh/hd_bauh.htm. Accessed 21 April 2024.

Winton, D., Marazzi, L., & Loiselle, S. (2022). Drivers of public plastic (mis) use–new insights from changes in single-use plastic usage during the Covid-19 pandemic. *Science of the Total Environment*, *849*: 1–10.

Woods, C. (2020). The emergence of cuneiform writing. In Rebecca Hasselbach-Andee (Ed.) *A Companion to Ancient Near Eastern Languages* (pp. 28–46). Wiley Blackwell.

Woods, S. (2004). *Japan: An illustrated history*. Hippocrene Books.

Yang, H.I., & Lai, C. (2010). Motivations of Wikipedia content contributors. *Computers in Human Behavior*, *26*(6): 1377–1383.

Yoshimura, H. (21 January 2020). UNIQLO's Tadashi Yanai on his father, his sons, and the clothing business. Retrieved from https://japan-forward.com/interview-uniqlos-tadashi-yanai-on-his-father-his-sons-and-the-clothing-business/. Accessed 21 April 2024.

Zarrabi, M., & Valibeig, N. (2021). 3D modelling of an Asbad (Persian windmill): A link between vernacular architecture and mechanical system with a focus on Nehbandan windmill. *Heritage Science*, *9*(1): 1–11.

www.ingramcontent.com/pod-product-compliance
Lightning Source LLC
Chambersburg PA
CBHW080458190125
20561CB00005B/8